Freeman's

Love

Previous Issues

Freeman's
Love

Est. 2015

Edited by

John Freeman

Grove Press UK

First published in the United States of America in 2020 by Grove Atlantic

First published in Great Britain in 2020 by Grove Press UK, an imprint of Grove Atlantic

Managing Editor: Julia Berner-Tobin
Copy Editor: Kirsten Giebutowski

1 3 5 7 9 8 6 4 2

A CIP record for this book is available from the British Library.

Grove Press UK
Ormond House
26–27 Boswell Street
London
WC1N 3JZ

www.groveatlantic.com

Trade paperback ISBN 978 1 61185 452 7
Ebook ISBN 978 1 61185 891 4

Printed in Great Britain by Bell and Bain Ltd, Glasgow

Contents

Introduction

JOHN FREEMAN

The first time I sent a love letter, I misspelled "love."

Or nearly did.

This would have been around 1979. I was lacing up my shoes to sprint over to my classmate Betsy's house when my mother found me. *Where are you going?* I hadn't yet learned to feel ashamed of myself, so I told her.

I'm going to put a love letter in her mailbox.

Can I see?

My mother spoke that way. Not, let me see; or hand it here. But, *can I see?* I showed her the love letter.

Oh honey, you might want to change this. You spell "love" like this.

She wrote the word down carefully in her perfect looping penmanship. Seeing the way she put down words, like each one was loved, would make me cry years later, after she'd died, at the sight of things she'd written.

I looked at the word. It didn't look more like love now that she'd written it. Rather, it was like she had told me a leaf was bark, and bark a leaf. Did it matter? Who made such arbitrary decisions? Sometimes you just *loev* someone.

I corrected the word, laced my shoes, and ran off—a reverse bank robbery. Leaving something behind, not taking it.

I never heard back—or at least not directly. Perhaps this is why so many five-year-olds' love letters are structured like multiple-choice questions. Maybe I hadn't yet learned that love was something you waited for to return. Like a boomerang. After all, I lived then in love's constant, endless return. I loved my father and sometimes he would walk by and pat my head, like I was a dog. I liked that. My older brother often crawled into my bed at night when he was scared and the warmth of my body made it easier for him to sleep. I liked that too.

As a child I recall feeling so full of love it was natural to constantly give it away. To old people. Strangers. The marching band. They walked right by my house, throwing batons and people in the air. We got pets to have something around us to love, even if they ran away, like all our gerbils. We developed crushes the way rivers grow tributaries. Everywhere I went, love was operating in some constant, unquestionable fashion—like gravity.

Childhood, when it's safe, teaches us to love. I was lucky, so lucky, to have had the kind of childhood I was given. It would be years before I learned that love might endanger me; that love could break me; that I could love someone and they wouldn't love me back. Or maybe they'd use that love against me. When I was lacing up my shoes, I was sending out love into a world that had always, only, returned my love in some fashion or other—an attitude I see in children now and hold my breath.

One fundamental difference between us and children is how we wear these lessons, which accumulate with age. Whether it makes us wary, or skeptical, or hopeful, or estranged, or physically tense. How we move our bodies is shaped by how love has entered our lives. Where the stress fell, where its tenderness

turned a receipt of love into a habit of being. Where its departure left scars. Our body becomes the way we hold these contradictions: love's pleasures and its pain.

Still, no matter how small the weight, or how odd the contradiction, love is too much for any one body to hold, and so we tell stories about love, write poems to it, tell memoirs of its survival. Love is the biggest and most complex emotion, the most powerful, it cannot be held in the palm of our hand—even when it's a child's hand resting there. So we put it into the only container made stronger by such contradictions—a story.

This collection celebrates writing on love, and it also makes a case for the love story to be about more than romantic love. What if love could be felt in more directions than between one human (or two) and another? Louise Erdrich writes a poem from the perspective of a stone to the earth. What knows more about longevity than a stone?

Time alters so much here in its wind tunnel. In Semezdin Mehmedinović's profoundly moving essay, he describes how, caring for his wife in the wake of a stroke, he has to repair time for both of them. Soldering here (Washington, D.C.) with there (Sarajevo); her body (now broken) with her bodies (all the selves he knew through the years), he sings a psalm to the power of love to hold so much together. He plays games to trick her memory back to life, and thus restores to them their great treasure—how love held them, these two people, together, for so many years.

Of course time presents challenges to lovers united in relative health, too. How to love someone when they cannot go where you go, each night, away from the land of Nod? This is Daniel Mendelsohn's great dilemma, as an insomniac. How do you make a spouse know what you feel, Niels Fredrik Dahl's poem wonders, when your words, repeated over the years, have worn a path to

the ear? How do you wear someone else's past, if their troubles—
Maaza Mengiste thinks, entering a world with her elder's name—
are not your own? How do you show it love? What do you owe
it? In her brief piece, An Yu recalls encountering an old woman
who made shoes one night in Shanghai—with her flat hard accent
so reminiscent of Yu's own family, she draws love forth from Yu,
unthinkingly, in the night.

Familiarity cuts so many ways in love. It can give you the
safety to play a game, as Robin Coste Lewis describes her
parents playing, in the sexy poem, "High Fidelity." Or that famil-
iarity can lead to a wizened, shared sense of entanglement. In her
hilarious poem, Sandra Cisneros reminds of how love can feel
like a dance we know the steps to, and cannot resist—even when
we know someone might end up on the floor. In Richard Russo's
short story, a couple conducting an illicit affair confronts the end
of their time together—something which they knew loomed on
the horizon from the very beginning.

How to tell a story when you know the end? How to reengineer
that story so it reflects the ways a tale sometimes unfolds with
one party more *entrapped* than entangled? Gunnhild Øyehaug's
story performs this feat by slipping her yarn—of an older man
and a younger woman—through several trapdoors until it's back
in the hands of the woman who lived the tale, not the man who
prompted it. Valzhyna Mort's poem elegantly skewers the ques-
tion of whose biography matters, the speaker's, which is lived,
or the poet's, whose work he was desperate to hand her. Anne
Carson, who has spent a lifetime in academia, describes the kinds
of interactions that often undergird the power dynamics therein,
driven not only by age and intellect, but also by an accompanying
male entitlement.

* * *

I t's a hard time to believe in love. So many spectacles of its opposite are on display. It is tempting to abandon real love and simply believe in its fantasy, or only in love for the absolutely pure and cute. Dogs, cats, pets of the earth. Matt Sumell has arrived at a version of this, all while holding his integrity in hand like an odd hat. In his heartbreaking piece he describes how he has made a moral choice to love what no one wants to love: the dogs people throw away.

To write love today demands we engage such depths, where anger and shame meet longing and comfort, lest we make a fantasy of love. Hindsight helps, too. In her wondrously honest piece about an ill-advised affair she had in her youth in Paris, Mariana Enriquez marvels at the risks her younger self took for the dream of a French romance. Maybe it's not just in youth that we do this; perhaps we're all just making it up as we go along, pulling from a set of impulses that we discover, as Tommy Orange does, writing about learning to love his family, are so full of danger that to contemplate them for too long could mean giving up on love entirely.

What a joy it is, then, when one finds a love about which one can say—*this I know*. It's as magical as, say, swimming in the snow, as Deborah Levy puts it; or as strange as a one-night stand, as Haruki Murakami's characters experience it. Luminescent, strange, almost holy, but also: how to decide if it is enough? How much light do we need an encounter to contain to be called love? Can a night ventured be called love? Is there a duration required? Must it last a day, a week, a year?

How desperately we need each other, to ask these questions. As siblings, fellow travelers, friends. In an excerpt of Mieko

Kawakami's novel in progress, "Heaven with a Capital H," two pals go to a museum, and love becomes the way they reinforce each other's moods as they try to define what it is that brings them joy. Love is how they allow the other to even ask for it. Similarly, more darkly, in Daisy Johnson's story one sister—who is well—makes a creature of mud and stone for the other, who is dying. The narrator realizes the competition for attention with her sister is running out, that for the rest of time she will be left with a lack. That it is time for her to simply provide the unasked for gift of happiness.

Stories, poems, literature allow us to see love's evolution. Even if we are born to vast, encompassing love, we can learn to appreciate it by seeing how it changes. Whether our parents exist for us or not; whether they stay together or not; whether our own lovers return our care, or not. Whether they survive an illness—or, in the case of Olga Tokarczuk's devastating story—not. These questions almost always are beyond our control. What a vast network of exposure this reveals; we are all, constantly, facing the ravishment love entails. In his series of poems, "swan," Andrew McMillan shows how one way to live in a world of such precariousness is to take over one's own evolution. To say *here, take me like this; or this; or this. Tell me how to be. Watch me evolve for you.*

And anyone who has ever waited for the answer to a message sent across town will hold their breath.

Freeman's
Love

Seven Shorts

A FUTURE HOPE

When I was born, the story goes, my young and inexperienced mother was frightened of the sudden and new responsibilities I represented. It was my grandmother who nurtured me and raised us both until we were able to move into our own as mother and daughter. I was named after my grandmother, a fact of my life that filled me with a strange and glorious feeling. Sharing her name brought me close to something transcendent. It made me feel both young and old: a girl living next to a future version of herself, evident in my grandmother's aged, loving figure. I remember moments of pure delight when a neighbor or a relative would call out my name, and she would answer. That response felt like an answer from my future self to the one in the present. I had no words to articulate this back then, of course. I thought of it as a game, a joyful one.

My grandmother and I were especially close. The first real devastation of my young life was leaving her and my grandfather when my parents, my little brother, and I left Ethiopia for good. She was my first definition of love and compassion, so when she gave me a bracelet when I was twelve years old during one of my visits back, I knew she was giving me tangible, solid proof of

our bond. She asked me to wear it all the time to remember her while I was in America.

The bracelet, a thin and delicate band of gold, had faint scratches that spoke of its age. It pressed gently against my palm as I held it, both fragile and durable at the same time. As I balanced it in my hand, I was so moved that I could not speak except to say, "I'll never take it off, I promise."

My mother was sitting with us. "Let me have it first," she said. "I'll give you the bracelet that your grandmother gave me when I was your age. I'll melt them together and you'll have one piece that's joined and from both of us."

When the work was done a few days later, my mother slipped the bracelet on my wrist and adjusted it. I stared at it, moving my arm up and down, growing accustomed to the new weight. The bracelet was still delicate, but it was fashioned in a braided design as if two ropes were woven together, then melded into one piece. My mother reminded me of my promise, and I vowed to her and to my grandmother both that I would never take it off. It would be a small reminder of the two of them, of Ethiopia and family and the distance that had forced itself between me and so many whom I loved. It was a path back home, becoming a part of me until, as the years progressed, I could not imagine myself without it. It would be, I once said to my husband, like cutting off my arm.

The bracelet stayed on my wrist. It accompanied me through middle school and high school and college. It graduated with me into the work world. And as the years passed and I returned to Ethiopia for visits, I noticed the way my grandmother would look down at my wrist and nod her head. When she held my hand, I often felt her tap the bracelet and smile. My promise was a silent affirmation of our bond; it was the expression of my gratitude for all she had done for me. I knew that my journey to America did

not begin with me. I was well aware that those who leave can do so because of those who stay behind. Every step forward I made came at a cost that was beyond the parameters of money, and often invisible; it was visible in what my American life lacked: those dearest to me. On each trip I made to see my grandmother and grandfather, I felt my conviction strengthen: I would never take the bracelet off, no matter what.

To promise: from the Latin *pro* (forward) and *mittere* (to send). To send forward, send forth, to prepare a path before one's arrival, to push ahead, to charge through, to enter new space, to migrate. A promise is a shift into uncharted territory that we have no way of predicting. It is a claim made on our future selves by the person we are in the present moment. A promise beckons an unshaped world and attempts to control it. It is a willful suspension of disbelief, a naïve assertion that the future will bend in our favor and that what we call our existence is intractable and immutable: predictable. It is hope. It is also foolish.

"What do you mean it doesn't come off?" a TSA agent asked me in an airport in Italy. "Of course it comes off." And she grabbed my arm roughly and held it tight as she tugged at the bracelet to pull it off my wrist.

I felt cold air wash across the back of my head. Every word dropped out of existence except one: "No." I shook my head and tried to pull back my arm but she held on tightly. "No," I said again, becoming immobile. "No."

For years, it had been relatively easy to keep my promise. There had never been a need to take off my bracelet. It became a permanent part of me, like a birthmark. But I was in an airport and this was 2016 and the world had new fears and precautions that I could not have predicted when I had made my vow as a child. That day, in that airport in Italy, it wasn't enough to say, "It doesn't come off." It wasn't good enough to say simply, "No."

"No? What do you mean, no?" And she called someone else to help her even though I was too stunned and shocked to struggle. Even though the bracelet was delicate and held no weight at all. Even though my wrist was caught in her grip and there was nowhere I could go.

How do you say to two agents holding your forearm and your wrist that there are oaths you will not break, even if your arm does? How do you explain that a promise made in childhood can solidify to become as sturdy as the strongest bone? That it will snap before it bends? That certain vows require more from us than others? That they form us and to undo their bind means to unravel completely?

I cannot remember why the agents stopped their attempt to take off my bracelet. Maybe it was because they recognized my deep, muted terror. Maybe they understood something about precious objects that would mean nothing to someone else. Maybe they realized that there was nothing about me to fear. Maybe they saw what they had become in my eyes. As I kept saying no, they stopped. They dropped my arm and as I held my wrist, they told me to get my luggage and go on. I turned around and looked at the first security agent. I could not speak, but I would like to think that I didn't need to.

Since then, I have been asked to step aside for other inspections. I have volunteered to do so before I've been asked. I've said that the bracelet will not come off. I've said that it simply does not come off. I've said that I cannot take it off, and I have seen how those declarations have sometimes prompted recognition in TSA agents who then wave me on. I have tried to prepare myself, though, for the inevitable because one day it will happen.

I made a promise as a child believing that the world would bend to my oath. I did not foresee the many ways that this world would try to inflict so much damage on those words—my words. Back

then, I did not know enough to accommodate for the wreckage that time can exact on everything around me. I imagined that I would stay the same as the moment in which I made that vow: I promise you, I swear to you. And yet: what "I" remains untouched by life?

Several years after my grandmother's death, I found myself standing on my grandfather's veranda. He was dying and had begged to see me once more. I could not travel back to Ethiopia in time to see my grandmother before she died, and he wanted to make sure this would not happen with us. When he opened the door and saw me, he began to weep and call out my name. And as he repeated it, bowed by the weight of the word, I knew that he cried for my grandmother. I knew that when he looked at me, he wept for the other Maaza who was dead. The one who was alive and standing at the doorstep was less real than the one who had left him behind. I cannot imagine what it was like for him to stand in front of me, on his way to dying, on his way to our last shattering farewell, and understand that his utterance of my name would also call forth a ghost. As I watched him struggle to regain his composure, all I could do was grip my bracelet and cry. To promise, to send forth, to migrate. To hope.

—Maaza Mengiste

SLEEPLESS LOVE

Jonas is sleeping: deeply, obliviously. Not I. With him as with all the others, I am the watcher, the wakeful one. This is our fourth date, and as I watch him sleeping, his back to me, the arc of his right shoulder with its oddly hollow, birdlike blade inches away,

the deep furrow that runs down the center of his back, sloping away and disappearing behind the cotton blanket, that landscape that I love so much, I know there will not be a fifth date.

Once again, I have made the same mistake.

For with him as with the others there is not only this landscape, the salty terrain of flesh, the furrows and hills that invite exploration and discovery, there is that other landscape, the one where he cannot join me. As the hours slide through late night to early morning, I feel myself entering this private terrain. First there is the upward slog from the plush dark valley of eleven o'clock, with its dense comfortable underbrush: the magazines piled on the duvet, the whiskey glass gleaming amber on the bedside table, the detritus of the day before, among which I can happily prowl, convincing myself that I am still *of the day*. But as the little wooden mid-century modern electric alarm clock on the nightstand whirs and clicks and eleven spirals away into twelve I feel myself as if hiking, struggling toward the darkly silhouetted peak of midnight; then, on the other side of that crest, the cautious, icy descent down into the valley of one o'clock—still close enough to midnight to feel connected to the day before and, therefore, to some kind of safety. But as one o'clock creeps toward two and then three and finally three-thirty, it is as if I am skittering across a vast floe of ice: the continent of true insomnia, the white place where the sky is indistinguishable from the horizon and the horizon from the ground, where there are no landmarks, no railings or stanchions, no tracks, not even the scratchy tracks of birds. I know that I am completely alone in this place, and when I finally summon the courage to look down at Jonas (or Bill, or Glen, or Greg, or Jake, or Travis, or Rafaël, whoever it may have been over the decades), it is, I imagine, how someone who finds himself aboard a sinking ship might look down from the juddering deck, as the stern rises toward the moon, at some

other passenger who, out of cunning or (more likely) sheer dumb luck, has found safety in a lifeboat and is already curled there at the bottom of the shallow boat in a blanket.

It is like being a ghost and looking at the living.

This is my landscape, the place where I live for seven hours every night of my life. Even when I was a child, I wasn't able to sleep well. In the crib I would turn over constantly, anxiously; in the narrow wooden bed that my father built for me when I was old enough to have a bed of my own, I would read long after we were supposed to turn off the lights, dreading the moment when I would have to put away my book for good and face the blank night. In the college dormitory room I shared with two other students the deep rising and falling of my roommates' breathing was like the sound of surf, but even that wouldn't lull me to sleep; I would count their breaths into the hundreds until, around five-thirty, I would collapse into an hour's shiftless sleep.

It was at university that I slept with (well) another man for the first time, and I realize now that what I was hoping for more than anything—more than the fulfillment of some adolescent fantasy of perfect like-mindedness, more than the sheer plea-sure of sex—that what I was hoping to get more than anything from these lovers was someone to share my sleeplessness with: someone who would, at last, accompany me through the white trackless exile of my insomnia.

And yet, as if by some perfect, cruel asymmetry of the psy-che, every youth, every man I was to fall in love with thereafter would be a profound sleeper. One would collapse so totally into an almost coma-like sleep after sex that, the first time we went to bed together, I was afraid he might have had some kind of cerebral embolism, might even have died; another was so hard to wake up that on our first morning together, so as not to miss an important editorial meeting, I had to leave him sleeping there, and wondered

7

as I took the subway downtown just who he was, actually, and whether my apartment would be intact when I returned home. One would softly cry, like a toddler, when I jostled him awake from a nap, so thoroughly did he inhabit his sleep. "It's like I'm in a beautiful garden and you're pulling me away from it back onto asphalt," he once said to me, unforgiving. But whatever their individual habits, they all shared the ability to fall swiftly into sleep, leaving me beside them to watch the wooden clock and begin my awful journey while they remained unconscious through the night. Which is to say, all of them managed to make me feel alone even when I was with them. Unconsciously, instinctively, like water buffalo in a drought that can smell a standing pool twenty miles away and move sluggishly toward the place where they think it is, only to find dried mud where the water was only minutes before, I have managed over the years to find these perfect sleepers, these companions who are not companions, these partners who cannot accompany me where I go each night.

The fact that I continue to make my nightly journey alone suggests to me, at least, that there are never really "lessons" in love; the place in the psyche that is the source of how we love is so deep that our attempts to reach it, to tunnel down to it and bring light and air there, must always fail. I go to a party, a meeting, a bar; I go online. I see a man whom the conscious part of me beholds and begins to desire; whom my conscious self approaches at the party or meeting or bar or the site or the app and talks to and decides is suitable because this man shares my love of swimming or Mahler or gardening; the conscious part of me will do what we all do, will type his number on my iPhone and wait sickeningly for a text or a call and then, when it comes, will grow giddy and anxious until the moment when we go for a drink or dinner and then, when the drink or the dinner leads back to my place or his place, things will unfold as they do. And it is

only then, when we go to the bed and get in and he falls soundly asleep, curled in his lifeboat while I scan the familiar horizon, the shrubbery of 23:00 and the silhouetted peak of midnight, the valley of 01:00 and the dread frostbitten plains of 03:30, do I realize that the conscious mind is the fool, the rebellious and ultimately powerless servant of the unconscious mind which wants, in the end, and for whatever mysterious reasons, to be alone.

—Daniel Mendelsohn

LIVES OF THE VISITING LECTURER

Pool

The hotel has a pool. The hotel has no pool. The hotel has a pool but it is three strokes long. The hotel has no pool but there is a university pool. The university pool is closed for a swim meet. The university pool is not closed but requires a keycard. There is no university or university pool but there is an ocean, loch, lake, fjord, river, local spa. These are wildly pounding, freezing cold, rocky, muddy, reedy or crazy-expensive nonetheless all will be well, the visiting lecturer knows as she slides into the water. You too are made of stars, someone is saying later as she passes the breakfast room.

Plato's Roaring Darkness

Noticing a poster for a talk (by last year's visiting lecturer) about Plato, she is cast back to the winter as a graduate student she'd fancied herself a demimondaine because her mentor liked to give her suppers at posh restaurants in return for light fondling

in his office. He was a large, monumentally ugly man who had
written important books on Plato. She was unused to attention.
He smelled like dust. She was twenty-two and thought him too
old to worry about, anyway that's how things worked in those
days. Together they attended Emeritus Professor George Grube's
"On First Looking into Plato's *Republic*." She remembers now
nothing of the lecture except that Professor Grube talked into
the microphone and consulted his notes alternately, as he was
so nearly blind he had to bring his face right down to the podium
to read, thus becoming inaudible. It was later that night or the
next day in his office that she and her mentor had a discussion
about flesh and to his asking whether or not she "could see her
way to being kind to him" she had answered no. Some years later,
making notes for a memoir, she will shave the anecdote down.
"After dinner I went to hear an old man, nearly blind, who spoke
of the frustration and despair he found in the central books of
Plato's *Republic*." And she will add, taking things in a different
direction, "Men are allowed to decay in public as a woman is not."

Special Collection
On her free day the visiting lecturer signs up for a tour of the
national museum and finds herself in a frigid storage room, not
open to the public. The curator situates her at a distance from
the paintings stacked around the room, faces to the wall, "each
one an insurrection in itself." The curator gestures. "These, these
are insane objects." The curator has small silver paws atop her
notes, very like the paws of the ermine in the painting *Lady with
an Ermine*, now on display in the nation's other museum, which
the visiting lecturer had been told was not worth visiting. After
the tour they exit the storage room. An older man walks by the
curator's side whispering, "Stop blushing, just be here."

Still Green

Migraine may accompany a visit. She has brought with her Beckett's book on Proust. Sometimes Beckett appears to be just horsing around. But then a sentence is so intelligent she lays the book down, unable to breathe. Flakes fall from her frontal lobes. After the lectures there is Q & A. She hears herself tell the students all storytelling is a cliché, just go down into the lit barking heart of the thing and see how a pineapple is made, to quote Wallace Stevens, and they say, Who's Wallace Stevens? Much remorse follows such a visit. The bunch of green bananas on her kitchen windowsill at home is still green. This makes her think of T.S. Eliot, his infant vows of chastity while writing "big black knotty penis" in letters to friends.

—Anne Carson

SONG OF THE HIGHEST TOWER

He was sitting on the filthy mattress that served as a sofa on the building's patio. I was leaving that same night, and I wanted to see him before I left Paris. I remember with great clarity how I thought: I am not in love. I've only known him a week. I don't even know his last name.

Guillaume opened a pack of cigarettes and reached out his hand. I remember how he wriggled his long fingers asking for something, and I intuited what it was: a pen. He didn't look at me. He wrote his email address on the silver cigarette paper: guillaumejolie1980@hotmail.com. It was the European summer of 2003, and he was wearing a black suit as he sat on that mattress,

with his elusive blue eyes, his hair so greasy it looked wet. I put his address in my wallet, and I didn't tell him 'I'll write you,' and he didn't reach out again for one last caress. He let me go. The night before had been too excruciating. I went up the five flights of wooden stairs to my friend's apartment where my suitcases were already packed, and around the second floor I started to cry and I thought, why is it all so dramatic, why do I want to go down and bury my nose in his white shirt that smells like the sweat of weeks and go with him? *We'll explore together, we'll hunt in the deserts, we'll sleep on sidewalks of unknown cities, without worries, without sorrow.* I took a painkiller, turned on the shower, and told myself again that I was thirty years old, that any love only a week long, overwhelming as it may be, is forgettable, and a boy like that, so young—Guillaume was twenty-three—was a fling, a triviality, a game, something to brag about, the beautiful, gloomy Parisian, Rimbaud on Barbès, my dying boy with his veins dotted with needle tracks and scars from self-inflicted wounds, pale and precise marks, horizontal, recent.

When I got out of the shower and peered out the window, Guillaume was gone from the patio—the *cour*—and nor was his bag on the mattress. I was glad. When I left for the airport my friend went with me as far as the Metro stop: I looked for Guillaume on every block, his blond hair, his black suit. He wasn't waiting for me at the station, either, though the previous night he'd promised he'd be there, before he got angry when I said no, that he should let me go alone, that our time together had been nice. Nice, he repeated. Très jolie.

I didn't mention him to my friend. I didn't talk about Guillaume for the rest of my trip, not with anyone, not even to lessen the story's tragic air. I woke up nauseated every morning I spent in Barcelona, my last stop on that trip. From the other side of the bathroom door, the friend I was staying with asked if I was okay,

and I said yes, just something I ate, too many planes, leftover anxiety. It wasn't leftovers: it was an anxious bit of iron caught in my throat, and the memory of Guillame's legs, oddly hairy for someone so blond—the legs of a faun, of a demon. I looked at myself in the mirror after vomiting phlegm every morning and I downed tranquilizers on an empty stomach.

Still, I didn't write him. I looked at the metallic paper in my wallet and I let it go. I went to the cyber café and sent messages to everyone who didn't matter, boss, friends, ex-husband. I'd call my parents with a card—remember that? You scratched off a soft, lead-grey coating over the code: you had to enter it before dialing the number. Guillame happened in that world, before Gmail, before smartphones, when the phone still rang and there were no social networks and life didn't happen online, when you didn't travel with your computer unless you really needed it, and search engines wouldn't pull up résumés or photos or criminal records. I only have three pictures of him, taken with an analog camera. Two were taken at a party. Today, I just can't understand that world where it was still possible to get lost and where it could also be impossible to find someone again.

I wrote Guillaume the very day I got back to Buenos Aires, exhausted, my suitcase untouched in the middle of the living room. I sat waiting for the reply, picturing him in some all-night cyber café on Rue des Poissonniers, smiling at my message. Refresh. My mouth filled with blood when I saw, in effect, the reply. Too soon. That druggie's inbox is full, I thought. Or maybe he didn't understand my message, my triple language—we spoke a little French, a little English, a little Spanish.

The message said the address didn't exist, that the error was permanent and I shouldn't try again.

It took me a minute to understand. Had Guillaume written his address down wrong? Was it an error with Hotmail? Maybe

I had typed it in wrong? I copied and resent the message. Same result. Sometimes that happens when an inbox is full, I lied to myself. I slept fourteen hours on pills, woke up in a pool of sweat, vomited in the bathroom, and wrote him again with my coffee growing cold beside the keyboard. Same result. Permanent error, a message that you sent could not be delivered.

I remember the vertiginous desperation I felt, so much like panic. I think back to that moment and I'm astonished by the discussions I hear about romantic love, and how if it hurts it's not love. How do you avoid adrenaline when you're in an earthquake? How do you control panic in a house fire? How do you check a pounding heart when test results announce cancer or pregnancy? Who wants to live with all that anesthesia?

I called my friend in Paris. I told her what was happening. 'My emails all bounce back.' I faked a certain amount of calm although I think she sensed my devastation. She said: 'When I see him, I'll ask him for his address again. That kid's always fucked up.' Then she told me about her new job in a gallery in the Marais. I kept sending messages to the guillaumejolie address every day. Jolie. Bonito, nice. Très jolie, he'd laughed bitterly on our last night in that endless discussion full of sobbing and sex. He'd tricked me, the Jolie was his revenge. Why? I didn't ask for his address, I didn't demand contact. Did his ever-fevered body hold malice? I'd caressed his scars with my fingertips. He was always shaking. *A man who wants to mutilate himself is certainly damned*, I thought. 'Let's go to Charleville,' I said one day. 'I hate France,' he replied. He wanted to go to Mali, where the musicians he played with had migrated from.

After several unbearable weeks, my friend wrote me an email full of gossip and news: in just one line she mentioned that she hadn't seen Guillaume again, nor had he ever come back to Rue Myrha. His friends were used to those disappearances. Sometimes

he went back to his parents' house, in the countryside. Guillaume never returned to the building where my friend lived. She moved to northern Paris. She stopped seeing her old neighbors: the Chileans went back to Chile, the Normans who were Guillame's friends went back to Rouen, and she didn't investigate more because I didn't insist all that much, and after all it was only a week and our lives went on and I never heard from him again. I don't know if he's alive or dead, I don't know anything about the Normans, I never again found the band he played with, a search for Guillaume Jolie brings up any number—too many!—of useless and imprecise results, I don't know if that's his last name, my friend forgot my intense romance, and anyway it doesn't matter now. It's possible he doesn't remember me. I know I never threw away the metallic paper with his shaky handwriting, but I don't know where it is: lost somewhere in the house.

I didn't dare throw it out because I'll never have another man like Guillaume. Shooting up in the bathroom with the door cracked so he'll be seen, like a poster child *poète maudit*. His sand-colored hair on the pillow and that sadness when he told me the little I learned about his family: his schizophrenic father, locked in a room because his mother refused him psychiatric help. A small town. The hugely demanding music classes. His disappointment when I told him I hated jazz. 'I don't hate it,' I backtracked to soften the blow. 'I don't understand it, I don't like it.' 'I'm going to explain it to you,' he said, and I replied no, no need, I'm leaving in a week, and he sighed and his enormous, thin hand took mine and rested it on his skinny chest, and he let me look at him. I'll never have another man like that, his weak, moribund youth, a puppy who cannot live and doesn't want to, but who ran away from the mother who should have eaten him and is now a walking suicide, *a master in phantasmagoria*. 'I know it's not healthy,' he told me one night, after taking a pull of

wine straight from the bottle, 'but if you stay maybe I'll feel like living.' That's how he talked: no shame, no fear, in the intimacy of the toxic night. I never mocked his intensity. I wasn't cynical yet. I'm no longer fascinated by being near someone who wants to die; I want to be old, I'm no longer attracted to *those fierce invalids*, I imagine I'm domesticated, I don't think *the best thing is a good drunken sleep on the sand*.

Maybe he changed. Or maybe he's dead, just as he wanted. I was never naked with anyone so beautiful: his sunken belly, protruding hip bones, his back without a single freckle, smooth and soft like a newborn's, his eyes that shone in the dark, his delicious neck with its little rings of dirt.

I forgot to mention how I met him. It was in Norman #1's apartment. There was an impromptu party because we had music and alcohol. Guillaume kissed me after I asked him to pass the whiskey. We started a conversation that lasted seven days. At that party he danced naked at the request of a gay neighbor who crowned him the most beautiful man in the city. Then he put on his pants and led me to a corner and pressed me against the wall, I pulled up my skirt, opened my legs, and we had sex right there, in front of everyone. I don't know if anyone noticed, they were all shouting and I think they were dancing flamenco. I felt tender and sad when, before penetrating me, he wet his fingers with saliva and asked me to help with the condom—best sex practices in the years of plague—and I saw the needle tracks on his arm when he brushed the blond hair from his mouth to kiss me, and we *appraised with clear heads the extent of my innocence*.

—Mariana Enriquez
Translated from the Spanish by Megan McDowell

COTTON SHOES

I didn't know the old woman's name. I hadn't asked her. We'd only spoken once during the two years I lived in Shanghai. I passed by her every morning—she'd be seated on a chair outside her shop, and I'd be racing to catch the subway. Her shop didn't have a name, only a sign that said: "Beijing Style Cotton Shoes for Sale," which reminded me of home. The space was no larger than a bed, and inside was so crammed with shoes and boxes that customers had to stand on the street and point to the ones they wanted to try on, whereupon the old woman would take a long bamboo hook and retrieve them. Apart from attending to the occasional customer, she was always sewing layers of cloth together to make soles. When she sat, her back arched like an old flower.

The one time I spoke to her, or to put it more accurately, she spoke to me, I was drunkenly stumbling home in the middle of a summer night. I turned the corner onto my street, and there was her shop glowing with fluorescent light. She was perched in front, knees squeezed together, clutching a pair of black shoes. Her left shoulder was lower than her right, like a jacket that had been hung up clumsily.

"Girl," she called to me, "can you help me up?"

I still remember her voice. It was like my grandma's: flat and unbreakable. It seemed to me that those from their generation often sounded like that. If the war lived in anything now, I thought, it was in their voices. She spoke with a Beijing accent, much thicker than mine. Years in the south hadn't weakened it one bit.

I steadied myself first before walking over. Then I bent down and pulled her up from under the arm while she pushed with her legs. Both our bodies were damp with sweat, and she was

17

heavier than I had imagined. Perhaps it was the way she forced her entire weight on me, as though she was trying to say, *Look, I'm more than just skin and bones.*

"It's my legs," she explained. "The weather's been too humid." She dusted off her linen pants.

"I have a granddaughter about the same age as you," she said. "She's working in Singapore."

I told her I'd never been.

"My son's family immigrated there when my granddaughter was in high school," she said as she began organizing the shoeboxes.

"They didn't take you?"

"I'm not going anywhere." Those words came out of her mouth so swiftly that it seemed like she had said them countless times before. I imagined it was what she had told her son, when he asked her to leave this place with them.

She checked each box and carefully made sure the sizes were in order. The skin on her hands was warped like water-soaked paper left to dry. I set my purse down on the ground to help her.

"Do they visit you often?" I asked.

Without answering, she clasped the black shoes under her armpit and reached for the light switch. Then, she pointed to a white brick building down the street.

"That's my home. On the fourth floor," she said. "I'm not going anywhere."

We closed her shop together that night. She directed me as I arranged the shoes, adjusted the price tags, and finally, once she let out a pleased sigh, I pulled down the door. After she locked it, she straightened her back as much as she could.

"Closed for the night. Not a single customer since five," she said. "Looks like I really need to stay here to take care of this big business of mine!"

She let loose a bright, playful laugh, which had the purity of a church bell. She had a wide mouth and her smile made her look like a bullfrog. Briefly, it seemed as though she had become a child, waiting to be guided home. She picked up her folded chair and handed me the shoes.

"Here, these should fit you," she said, looking at my feet. "They're very comfortable."

I thanked her, and then she waved at me and walked down the street to her building. As she moved away from the streetlight, she was old again, the shape of her body like a passing cloud in the night.

Weeks later, when the leaves had just started turning golden, she disappeared. Just like that. One morning she was there, the next she was gone. After our brief encounter, we didn't talk again, apart from the occasional greeting. I never found out what happened to her. A few times, I heard neighbors speculating, but to most, her departure seemed as natural as the changing seasons. I went on with my days without much thought until the evening two men came and removed the sign at her shop. They didn't take long—perhaps five minutes—and they were adept at their work, not showing any hesitation as they knocked down the sign with a hammer. I waited around that place for a while, the shop that was no longer a shop.

I'm not going anywhere. I thought about how resolute those words sounded when she spoke them.

Looking over at the white brick building, I found the fourth floor. Only some of the windows were lit.

—An Yu

GUANGZHOU

The hooks in the nexus of my solar plexus rhyme with what remains when I remove them. All my loved ones who love me wrong float like comic ghost tails in my periphery. I don't look like them, and don't look at them directly like I don't look at the sun but see its loose rays. I love my loved ones wrong too. Then like comic genie third wishes I wish for more wishes and for more of everything and am never fed. Hunger is not the word I would use for what I am, though I eat to it. The bridge over which we span is not as connective as we believe it to be. It is so wide as to not be a bridge at all. The expanse does not connect but makes vague our relation. There can be no water under a bridge that is not a bridge, which means we will never forgive each other for not ever being enough. Split pea soup soul that I have no ham hock, no meat or bone soaked flavor but green green blandness. I used to have taste but became too new again. This is all to say that I'm lost but only now know that I am. This is all to say we are unmade and supposed to be. I fold like cardboard on a daily basis, break silent-soft underfoot of people who don't know me, who are supposed to know me most. Best? It's because I've always been hiding and show like I'm open, like I'm willing to be vulnerable-open and honest. These are lies. Almost everything can be. I am vulnerable-open but for reasons they can't see. I am dying. You are too. But I'll never become a ghost because I've always been one. Something is going from me I have begun to early-mourn. Is it more years that I won't have, because of the way I live my life? Do I deserve them, want them? It's not that. I've known they would leave me for some time now. Leaning back against the wall of my mind, posture like I don't give a shit because I do so much give a shit, I know not to show that I do, because of what people do with that, when you tell them you love

them, when you give them what they want it's exactly what they want and they want more. I'll give it all away. I never wanted to keep it. I'll put their hooks back in my sides. I'll drag them if I have to. Where? To Guangzhou. Or to wherever we're all going. Wherever all of what this is has always been going. I'm going too.

—Tommy Orange

GREEN REVERSE

Twice a week I play UNO with a gay Egyptian psychiatrist who, inevitably, without fail, calls me a rat-faced piece of cheating garbage in need of hospitalization before he offers to murder my dog.

"Just leave me a key," he says. "See a movie," he says. "I'll take care of it."

I consider my options and hit him with everything I've got, slow-like, deliberate-like, fuck-you-like: like a yellow three. Then I look him dead in his very kind eyes and say something a hate-crimer might say, or a rat-faced piece of cheating garbage in need of hospitalization might say, and then I say, "You can't kill Seymour. He's a good boy."

"Is he, though?" he says and plays a yellow seven. "Is he really?"

"Oh," I go and blink like a stunned idiot with no arms and dirt in his eyes. "This little dance again?"

"I'm sorry, miss," he says and two-finger folds his ear at me. "What's that?"

"I know what you're doing," I say.

"What am I doing?" he says.

"Psyops, bro. You're doing mind games."

"Am I?" he says in exactly the way that lets me know he is totally doing that. He's asking me leading questions so that I will connect some dots in my brain and realize that Seymour is not only not a good boy, but is in fact an objectively terrible boy with one eye and no joy who wakes me up at five a.m. every morning by shitting in my kitchen and barking at it. I throw down a green seven and go, "Yeah, you are. What are you gonna ask next? Why there's blood in his stool, knowing full well it's because he has a polyp half-an-inch up his colon that the specialist texted me a photo of?" Then I hold up my phone and show him my wallpaper.

He shakes his head and Draw Twos me, then gestures to the pile of cards like it's a cupcake he made and is proud of, but the only thing he actually half bakes are bullshit theories like that I rescued Seymour because I'm trying to save my father, and while I will acknowledge some similarities, my dad is meaner and has one leg instead of one eye and a touch more continence. *Psh*, I go. *Pfffft*. Then I pick up sixes—a red and a blue—and demand to know what lazy, fat-fingered amateur shuffled the deck.

"You did," he says.

"Oh," I say, and grimace my way through the quiet. Eventually he plays a green nine and I get the same idea I get every time he plays a nine, which is that maybe I can get away with playing a six, and then I think maybe I shouldn't do it, but then I go ahead and do it: I play the red six on his green nine and hope he doesn't notice, but he does notice because I try the same thing every game and he always notices. Then he says I'm disgusting. Then he says I should be ashamed. Then he says he is grossed out by me.

"Honest mistake," I say, and pick up the five-card cheater penalty and thumb-point at Seymour on the couch looking like a gargoyle fucked a fruit bat with ulcerative colitis. "Let me guess.

Next you're gonna ask if he ever ruined a party by shitting on a lady."

"Not at all," he says.

"He did. He diarrhea-ed on Maggie Mull and I wet-wiped her legs. Sensually."

"Let's talk about your medication," he says.

"Oh here we fuckin' go," I say and lean back in my chair. "Why? So you can segue into talking about Seymour's? Because we have nothing to hide: Flagyl and Apoquel, phenobarbital and CBD, special eye drops for his eyeball, prescription low-fat dog food or else he gets pancreatitis and goes fugue and stares at the wall for a few days, and I mix canned pumpkin in there because it's good for his turds."

"Sounds expensive," he says and runs a finger across his neck.

"You fuck," I say. "You're probably planning to ask how his seizures are and why his dick is yellow even though you already know the answers are real bad and because he likes to dip it in the pee puddle before he moves on."

"I want to know—"

"If he ate a battery? Yeah. Nine-volt."

"—if you're taking your medication," he says.

"How dare you," I say. "The nerve," I say. "Here's the thing," I say and tap my finger on the table a whole bunch. "No."

Then I avoid eye contact by staring into the ashes in the ashtray for a while, and when I finally glance up he has his cards facedown and his hands steepled and he's giving me this look like he's sympathetically judging me so that I'll question my own choices. But I don't. Instead I look at him like he's a spoon I'm trying to bend with my mind, by which I mean that I know that he knows I'm not taking my meds anymore because I can't afford them because American medicine leverages your pain for your

money and I spend all mine on fucked-up dogs that keep dying on me but—I'm gonna keep doing that.

"Why are you making that face," he says.

"Oh," I say. "Sorry. Your arm hair was bothering me." Then I play a green seven and tell him to choke on it.

He doesn't but Seymour does; he chokes and snorts and grunts because he is very itchy all of a sudden and starts berserking on the new couch—new because he destroyed the old couch when I left him home alone once for like twenty minutes—rubbing himself up it and down it before flipping onto his back with his little Frenchie legs straight up in the air like he's dead except his eye is open and looking around. Eventually he attempts to get upright and rolls right off the edge and thumps onto the floor and shakes himself off like he's wet even though he's not wet, just stupid. Then he jumps back on the couch and stares at me.

"OK fine," I say. "He's the worst dog I've ever had."

"Bingo," the Doctor says.

"UNO?" I say.

"No," he says, and holds up two cards.

"Make it four, you furry geek," I say and mess up his whole deal with a blue Draw Two–blue six power-combo.

Dude doesn't even flinch. He just picks up his cards and counters with a blue Reverse, a green Reverse, a Draw Four, says UNO, and wins on a red two.

"Are you fucking kidding me? I say and throw my cards down. "It's a goddamn conspiracy. Seymour! Are you even seeing this right now?!" And right then the little lump starts stalking the potted ponytail palm on my coffee table and growling at it and I am like, yes, that is correct, fuck that plant. "You tell 'em, Seymour!" I say. "You tell 'em we ain't taking this shit lyin' down!"

Then I walk over and lie down on the couch with him and flip him over and rub his belly. One nipple (three down, passenger

side) is extra-large and weird looking so I pinch it twice and go *bweep bweep*. Seymour positions his head to better see me, and when I scratch his chin he makes these small, expressive sounds and tries to bat my hand away with his little paws. He's totally heinous, but his helplessness is endearing so I tell him not to worry. "I'm not gonna let Doctor Kedorkian kill you."

"It's just—" the Doctor says, "most people have pets that bring them joy, but you keep adopting grief time bombs that smell like piss and make your life more difficult than it has to be."

I think about what he says and on some level I know he's right—that between Seymour and my last few dogs, and my last few relationships, and my father, and my fear of being swallowed up by the bubbling and gurgling wellspring of sadness I feel just underneath the surface of pretty much everything—that maybe I am kind of having a hard time here, and maybe my choices could be better. But the entire reason my choices could be better is because my thinking is bad. I prefer to feel my way through. And what I feel when I look at Seymour, who is looking at me with his lonesome eyeball (it's like a marine mammal's eye: oversized and sincere and vulnerable), is a tremendous tenderness for a mini-jerk doing his bad, terrible, no-good best to be OK but who remains a constant danger to himself and carpeting everywhere.

I admit nothing, especially not that my father smells like piss and has survived on a steady diet of microwaved dinosaur-shaped chicken nuggets and ruining holidays ever since my mom died. Instead I point my pointer finger at the Doctor's nose, then rotate my thumb up and yell, "The boy lives!"

"Does he even want to?" he says. "Seriously."

"I don't know, man." Did Hamlet? Does my dad? Do I? Occasionally. But here we are in the meantime and the best I can think to do is be there for some doggos that need me. "Nurturers gotta nurch, bro."

He furrows his eyebrows and tilts his head and nods, and the effect is that he looks confused and demeans me at the same time. In response I tell him that according to the DSM-5 he has every symptom of mind-your-own-fucking-biz-itis. "And besides," I say, "Seymour can do the best trick I've ever even seen."

I jump up and grab one of his medicated biscuits from the kitchen cabinet, then jog back into the room and yell, "Hey Seymour!" and he immediately perks up and stares at the wall. "He's deaf in one ear and mostly deaf in the other so he can't echolocate," I say. Then I make kissy noises until Seymour turns and stares at my bookshelf, and then I wave my arms over my head and shout his name until he figures it out and plops off the couch and waddles over.

"How long is this gonna take?" the Doctor says.

"Shut the fuck up and be amazed," I say, "because Seymour's about to dial up a little razzle-dazzle. Ready, buddy? Here we go: Uno . . . dos . . . *three*—"

The biscuit is pumpkin-colored and shaped like a cartoon bone and I watch it freefall flat-side down while—in the blurry background—Seymour's eye widens with anticipation. What I don't see is him shift slightly back before he launches himself upwards to expedite the biscuit's delivery by an inch or two. The reason I don't see that is because, unlike other, fancier, healthier dogs, Seymour doesn't do that. What Seymour does do is patiently wait for the biscuit to plonk off his bowling ball head because, while depth perception is possible in monocular individuals, it's very limited inside of certain distances, which explains why Seymour falls off the couch and down stairs so often and—if we don't walk the block counterclockwise—why he stumbles off curbs and donks his head on street signs and trash cans. In short, the little guy can't catch. But what he can do, and what impresses me so much, is he can show the fuck up anyway and let the things he

loves hit him in the face before he scrambles around looking for where they bounced to. I think it's a great trick, maybe even *thee* trick, to everything, and I laugh and tell him what a good boy he is. "The best boy," I say. "The number onest guy!"

The Doctor is not entertained. He is already scrolling his phone in search of a horned-up stranger with Magnum P.I. tits. I, on the other hand, announce that I am taking Seymour around the block before he shits on my floor again.

"I'll walk out with you," the Doctor says and stops scrolling, and I know that instead of sexing a guy he's going to his parents' house, to check on them, which he does on the nights we play cards, because his mom is sick and his dad is depressed and they live around the corner.

We make our way to the front door, on the back of which hangs Seymour's leash and collar and the collars of all the hard-luck cases I've lost over the last few years, each of them sweet and doomed, each of them dealt terrible and unfair hands by whichever lazy, fat-fingered amateur you choose to believe in. Or, if you're like me, none. Just bad luck. What I do believe in is standing between them and worse luck, and every time I reach for a collar I'm reminded of just how worse it can be.

Bacon's was purple, Chancho's blue, Sparkles's orange, Tink's red. Seymour's collar is green, and sometimes I even let him wear it, but most days I mix up which one he gets. I think I do it because I like the idea of taking them with us on our walks somehow, of bringing them back out into a world I liked a whole lot better with them in it.

At the bottom of the stairs the Doctor puts his hand on my shoulder, tells me he's worried about me. "If I got you some samples," he says, "would you take them?"

"Probably not," I say. Because—while often excruciating—I've been trying to listen to my feelings instead of bury them. I'm

tired of burying things. I do appreciate his offer, though. He's a good friend to me.

We hug it out and say our goodbyes, and after he exits the downstairs door I give Seymour's leash a tiny tug, to coax him out onto the sidewalk, but the little guy refuses. Because of course he refuses. Instead he sits down and growls at me or the wall or the night or some other grievance. I almost get mad, but I let him have this one, and instead of dragging him out by a rope around his neck, I sit on a stair and shush him. Tell him it's fine. Tell him he's a good boy. Tell him I love him. I just try to comfort him, because if my father's taught me anything it's that grievances can keep you going for years.

—Matt Sumell

Born in Osaka Prefecture in Japan, MIEKO
KAWAKAMI made her literary debut as a poet in
2006. Her first novella *My Ego, My Teeth, and the
World*, published in 2007, was awarded the Tsub-
ouchi Shoyo Prize for Young Emerging Writers.
The following year, Kawakami published *Breasts
and Eggs* as a novella, and won Japan's most pres-
tigious literary award, the Akutagawa Prize. In
2016, she was selected by *Granta* Japan for the
Best of Young Japanese Novelists issue. Kawakami
is also the author of the novels *Heaven, The Night
Belongs to Lovers*, and the newly expanded *Breasts
and Eggs*, her first novel to be published in English.
She lives in Tokyo.

SAM BETT is a writer and a translator. His trans-
lation of *Star* by Yukio Mishima (New Directions,
2019) won the 2019/2020 Japan-U.S. Friendship
Commission Prize for the Translation of Japanese
Literature. Awarded the Grand Prize in the 2nd
Japanese Literature Publishing Project's Inter-
national Translation Competition, he has trans-
lated work by Yoko Ogawa, Fuminori Nakamura,
Haruomi Hosono, and NisiOisiN. With David Boyd,
he is co-translating the novels of Mieko Kawakami
for Europa Editions.

DAVID BOYD is Assistant Professor of Japanese
at the University of North Carolina at Charlotte.
He has translated novels and stories by Hiroko
Oyamada, Masatsugu Ono, and Toh EnJoe, among
others. His translation of Hideo Furukawa's *Slow
Boat* won the 2017/2018 Japan-U.S. Friendship
Commission Prize for the Translation of Japanese
Literature. With Sam Bett, he is co-translating the
novels of Mieko Kawakami for Europa Editions.

"Heaven with a Capital H"

Excerpt from *Heaven* by MIEKO KAWAKAMI
TRANSLATED FROM THE JAPANESE
BY SAM BETT AND DAVID BOYD

The next morning, I left my house with enough time to arrive fifteen minutes early. I told my mom I was heading to the big library one town over.

I was waiting nervously beside the ticket machine when Kojima showed up, 9 a.m. on the dot. Her hair was the same as always, and so were her sneakers, but she was wearing a beige skirt that went down to her calves and a Hawaiian shirt.

Far from being upstaged by her head of hair and her bunchy skirt, the Hawaiian shirt was enormous, covered with pointy leaves and red fruits that looked like mangoes. Kojima had tied the corners of the hem into a tight knot at her belly button. This was the first time I'd seen anyone wearing a Hawaiian shirt in real life, but I knew what it was instantly. When Kojima spotted me, she jogged over, waving one hand. In the other she had a floppy bag with a drawing of a kitten's face that almost looked like it could be a photograph.

"You ready?" she said as she came up to me, smiling, kind of shyly. I was feeling the same way, but I put on a straight face and told her yeah. Now that she was closer, I could see the glass beads on the clip she used to pin her bangs up.

"I woke up super early," she said, scratching at her eyebrow.

"What time?"

"Four."

"Whoa," I said. "You're not sleepy?"

"No, but I was earlier," she said, "at like seven. Hey, what's wrong with your voice?" She gave me a suspicious look. "You sound different."

"I bit my tongue."

"When?" She squinted at me.

"Yesterday."

"You must have bit it pretty hard."

"Yeah," I said, "I did."

"Did it hurt?" She squinted even harder.

I said it hurt.

"Did you cry?"

"No," I said.

She said that if it hurt so bad I should have cried. I told her that in my opinion hurting and crying were different things.

"You think?" she said, tilting her head, then stepped back like she was startled and looked me up and down. "I've never seen you wear anything other than your uniform. Look at you."

"I'm totally normal. Don't look at me like that," I said. "I mean, look at you."

"This?" She bent her neck to look at herself. "It's my tropical outfit."

"Cool."

"It's like my someday best."

"Your someday best?" I asked. "What's that mean?"

"What do you mean?" she asked back. "You don't say that?"

"I don't think so . . ."

"Well, how can I put it, it's the clothing you wear on really special days."

"Oh," I laughed. "Did you mean Sunday best?"

"Sunday best? That means the same thing?"

"I think so."

"Whoa." She took another look at her Hawaiian shirt. I was staring at it too.

"It really feels like summer," I said.

"Yeah," she said and looked up at me in a really nice way. "It is. It was still dark when I woke up, but I instantly knew it was summer. Summer starts today."

We were waiting on a bench on the platform when the dark green face of the train rolled into the station. It made a sound like when a big animal blows air through its nose. The doors slid open in unison, and once we were aboard, the train rolled slowly ahead.

Aside from an old couple, some businessmen, and a woman with long hair, we had the car to ourselves. The train wobbled a little, side to side. Kojima and I each sat quietly, watching the world pass by the windows, but inside my heart was pounding at the thought that she and I were leaving town like this.

After a bit I looked over at her, and so far as I could tell she was excited too. Her face was glowing in a way it never did at school, and even brighter than the time we met up in the fire stairwell. When I looked at her, the nervousness I had been feeling burned off in the glow, and I felt an upwelling of relief. This was going to be fun.

Sitting next to her, way closer to her face than usual, I had no idea where to look and got a little flustered. Kojima didn't seem concerned about it. She looked me right between the eyes, the way she did whenever we met, and talked about all kinds of things, elaborating with her hands. When she got excited her voice got louder. I kind of liked it, but when she realized she was

33

almost yelling she got self-conscious and dropped into a whisper. Before long she was yelling again, and when I saw her realize we both laughed.

"Happamine."

"What's that mean?"

"It's, like, dopamine that comes out when you're really happy."

"Oh yeah?"

"And when you're really hurting," she explained, "that's called hurtamine."

"What about when you're lonely?" I asked.

"Lonelamine!" she laughed.

When the conversation lulled, Kojima turned and looked over her shoulder out the window, placing her hands on the bag in her lap. As if she could feel its fur, she petted the picture of the kitten with her pointer finger.

The train shot through tunnels of houses into long stretches of farmland. We were barreling headfirst into an entire summer.

Kojima told me all kinds of stories about the cat they used to have, about how black and soft her fur was, and about the mutt they had, and how smart and nice he was.

She said when she was really little, they used to have a bunch of different animals at the house. Her real dad got a kick out of having them around.

"I liked the dog and cat, but my dad's more into little stuff like goldfish, turtles, loaches, carp, things like that. We had so many."

"Where'd you keep them?" I asked.

"Well, aquariums cost a ton. We were broke then, but my dad found this enormous styrofoam tub somewhere, the kind that has a lid. We could only see in from above, but we made it into the best aquarium ever. Sometimes we walked to the store and

picked out something new, like a bridge for the goldfish, or one of those spinny things. I was always making the turtle swim around the tub. Doesn't your family have any animals?"

"No," I said. "I don't think they've ever really thought about animals."

"You mean they don't like them?" Kojima asked, eyes wide. Her eyebrows jumped like they had a life of their own.

"It's not like that," I said, "at least not for me. I've never really been around animals. I'm not sure about them either way."

"Yeah," Kojima said. "I can tell."

"But I feel like I might be able to get into them," I said. "I bet living with animals is really different from living with people. I mean, they can't talk."

"How would that be different?"

"I dunno. Like, it would actually be quiet, I guess."

"You mean how people are noisy, even when they're being quiet?"

"Sort of. People are always thinking about things. Animals seem different, just more quiet overall."

"But they bark and stuff."

"That's just barking."

"So you're not talking about actual sound?"

"I guess not."

"Okay," Kojima said. "I think I get it. It's like how when you're asleep, you dream, and when you wake up, you can think about the dreams. Noisy like that. I wonder if you can actually stop thinking."

"I bet you can," I said, "at least for a couple seconds."

"If that's all," Kojima said, chewing through a little yawn, "it's like you can't, though, right?"

The warmth of the sun was hitting our necks. It felt good. I looked at Kojima's face for a second. She looked sleepy. As we

rode through the rice fields, the train chugged along, keeping basically the same rhythm all the way.

"Sometimes I wonder what it would be like if we didn't have words," I found myself saying.

"Yeah, I mean, we're the only ones who need them," Kojima said, looking me straight in the eye. "Dogs don't, and neither do things, like uniforms, or desks, or vases."

"You're right. Look at everything else in the world," I said. "We're completely outnumbered."

"If you really think about it," Kojima said, "it's kind of stupid. Human beings are the only ones talking all the time and making problems and everything."

She snorted. I nodded.

The train replayed its script of sounds between the evenly spaced stations. Each time we came to a halt, the conductor called out the name of the stop. When he switched off the mic, it made a ticklish popping sound that made Kojima giggle. The rich green rice fields linked together, and little houses shot up between them. Keeping pace with the train, the sharp light flickering off pointed stalks flew into streaks.

"Hey, Kojima," I said. "This paradise we're going to . . ."

Kojima glared at me and shook her head.

"It's not paradise. It's Heaven."

"Heaven?"

"Yeah. Heaven, with a capital H."

"Heaven," I repeated.

Kojima smiled. "That's right. But I'm not saying any more. You'll see when we get there. Sit tight."

I nodded, and Kojima nodded back like she was satisfied. In silence, we gazed out the windows at the passing scenery while the train made us wiggle.

"That thing you said earlier," Kojima finally said. "I think I know what you mean. When a desk or a vase gets scratched, it doesn't show you how it's hurting."

"Because desks and vases don't use words?" I asked. "That what you mean?"

"I don't know, maybe. More like, desks and vases probably don't get hurt," Kojima said. "Even when they're broken," she added softly.

"Yeah," I nodded.

"People are different, though," she said even softer. "Sometimes you can't see the scars. But there's a lot of pain, I think." After that, she was quiet.

She never stopped stroking the face of the kitten on her bag. I watched her silently. The train stopped at the next station. The doors opened. A few people got off, and a few more people came aboard, replacing them. Then the train rolled off again. A minute later, Kojima asked me something else, like she needed to make sure.

"Hey . . . if we keep doing this, just saying nothing, no matter what they do, think maybe we'd become things, too?"

I didn't know how to respond and stared at the floor. Light beamed through all the windows, revealing from every angle just how dirty Kojima's sneakers were. No part of them looked white.

"I mean," I said, "we won't literally turn into flowers or desks, obviously . . . but we'll be acting just like things. So basically . . ."

"Basically?" she said.

"It's like we're . . ." I started saying, but Kojima cut me off.

"We're plenty like things already." She bit her lower lip and laughed. "You and I both know it isn't true, but that's what we are to them."

Kojima messed around with her hair and stared at the kitten on her bag again. I stared at it too.

"Everyone's like that," I said. "That's the thing."

"That's the thing," Kojima said.

"Can't do a thing about it," I said, and Kojima broke into a laugh, but quietly. I started laughing too.

As the train rounded a curve, the houses outside tilted back and pulled away.

"Trouble is," Kojima said and took a deep breath, "even if we're just things to them, they won't leave us alone, like actual things. We can never be like a clock on the wall." She gazed out the window. "That's the thing, right?"

She smiled at me.

"Hey, we're almost there."

Once we were through the turnstiles, we consulted a wooden signboard and followed the route it gave us, walking down the path, then turning left and heading straight. It took us to a big white building.

It was an art museum.

Inside, it was all white walls and white floors. The ceilings were really high, and there were tons of people, even though it was early in the day. They were all taking their time. Their whispers, rustling like fabric, sank into the whiteness of the walls. Paintings hung as far as I could see, each given its own warm halo of light. When we were standing in front of the first one, Kojima looked at me. Her face was alive with emotion. She stared at the painting, not saying anything, then hopped over to the next one.

I walked a little behind her, looking first at each painting and then at Kojima looking at the painting.

She would start from far away, to take the whole thing in, before edging her way closer, lips tight together. Once she had stared at it a while, she looked at me. When she looked at paintings, she got lines on her forehead. It didn't look like she was having fun at all. In fact, it looked like she was hurt. After she read the entire explanation on the placard by the frame, she jumped back, like something had occurred to her, and exhaled deeply, moving on to the next painting as if she were being pushed ahead.

The paintings here were mystifying.

In the reds and greens of the canvases, maidens danced with animals, a goat or something carried a violin in its mouth, and a man and a woman embraced under a gigantic blazing bouquet.

This swarm of unrelated images was like a glimpse into a dream. But not a good one. The joy I saw there was ferocious, and the sadness suffocatingly cold. Blues thrown onto the canvas warred with yellows approaching like tornadoes. People gathered round aghast to watch a circus spin to life. Above a city of snow, a man in white robes closed his eyes and prayed. Every painting was a moment of destruction coinciding with the birth of something wonderful. Each frame contained conflicting worlds. A crowd drawn into a sun spinning like a windmill. Fish washed ashore. A tentative horse with eyes more human than anyone alive. A pale maiden.

"You looking?"

I was spaced out in front of a painting when I heard Kojima's voice. When I realized what she asked me, I said yeah.

"See anything you like?"

"I don't know yet," I said. Kojima's face was even more relaxed than earlier. It was reassuring.

"So the museum is Heaven?" I asked.

"Nope," she said. "Heaven is a painting." She made a little snort and looked me in the eye. "The one I like the most."

"It's called Heaven?"

"No." She shook her head. "The artist is really good, but the titles are so boring it makes me want to cry. Here, look at this one."

She pointed at the placard by the painting. She was right. It was pretty bad up against the work itself.

"Sucks, right?"

"Kinda, yeah."

"So I gave it a better one."

"You did?"

"Yep." She laughed proudly. "Heaven is a painting of two lovers eating cake, in a room with a red carpet and a table. It's so beautiful. And what's really cool is they can stretch their necks however they want. So wherever they go, whatever they do, nothing ever comes between them. Isn't that the best?"

"Yeah."

"That's right." Kojima laughed a happy laugh.

"If you look at the room a second, it kind of looks like any other room. But it's not. It's actually Heaven."

"Heaven the place?"

"No, the one I told you about," said Kojima cautiously.

"Do you call it that because they're dead?"

"No." Kojima spoke to me in a low voice coming from the back of her throat. "Something really painful happened to them. Something really, really sad. But you know what? They made it through. That's why they can live in absolute harmony. After everything, after all the pain, they made it here. It looks like a normal room, but it's Heaven."

She let out a sigh and rubbed her eyes.

"Heaven . . ." she said. "I had a picture of it in a book."

"Yeah?"

"Funny how the more you look at pictures, not just of Heaven, but of anything, the more the real thing starts looking fake. Here, see?"

Kojima pointed.

"They're milking a horse on the horse's face. And the horse has a necklace."

"Look at these colors," I said. They were warm, but not necessarily comforting. A giant face and giant colors. We looked at the painting together.

"Look at these eyes," she whispered. "See the white line connecting the horse and the green guy?"

Eyes. The instant the word left her lips, I almost had a heart attack.

Kojima kept staring at the painting.

A little behind us, a boy who looked like he could barely walk let go of his mother's hand and ran off, bumping into Kojima's leg. He fell and started crying really loudly. Kojima was startled by the sound and tensed all over. The mother grabbed the child by the hand and pulled him up, bowing and apologizing to Kojima. She didn't seem to know how to respond and bowed back to the woman. She watched the mother lead her child out of the gallery. Once they were gone, she let out a breath and looked at me with the same startled eyes.

I wanted to say something that would make this sad and difficult expression go away, but before I had the chance she was back over by the paintings, and I joined her without saying anything.

After a while, I finally asked her.

"Where's Heaven? Is it far?"

When she turned to look at me, I felt like I could see my own face before my eyes.

"Yeah, it's all the way in the back." She was speaking so softly. "But I'm getting kind of tired. Let's take a little break."

We went outside. Kojima sat down on one of the benches and wouldn't move or speak.

When I said I was going to get us something to drink, she said she wasn't thirsty, so I walked over to the vending machines and came back with something for myself. The sun was at a high point in the sky. Just sitting there, I could feel the sweat forming in my armpits and around my neck. The skin under Kojima's nose was glistening with sweat. From where we sat, we could see onto a big open lawn slightly above us, where families and couples sat and ate their lunch on picnic sheets. Others were passing a ball around, and some had even taken off their shirts and lay on the ground sunbathing. There were big trees growing in the field, and people leaned against them, reading. This was the height of summer, I told myself. From the edge of the horizon, the sky was generously blue. Kojima gripped the kitten bag in her lap, completely still. I took a sip of my drink and realized I wasn't thirsty either.

"Is something wrong?" I asked, unsure of what to say. Kojima slowly shook her head a bunch of times, then shook her head again, as if she'd missed one. I nodded and looked at the people on the grass. Looks like a painting, I thought. All kinds of people walked past our bench. I wiped my forehead with the back of my wrist.

After some time had passed, I asked Kojima if she thought we should head home. She didn't answer, other than shaking her head again.

"Unhappamine?" I asked, trying to speak her language, but she didn't say anything. I wished I hadn't said it. Now all I could do was sit there.

Eventually I realized she was crying.

Not out loud. Kojima turned away from me and pawed her eyes. Tears dripped from her palms onto her cheeks. I squeezed the bottle of my drink, lukewarm by now, and stared down at the ground. I tried to think of something I could say to her, crying silently beside me, but came up empty, unable to act on my feelings.

"It's not one thing," she finally said, in a low voice. She rubbed her cheeks with her palms, and in a voice almost too soft to hear, she said she was sorry.

"We came all this way," she said, smiling at me awkwardly, trying to hide that she was crying, but she still looked like she was crying.

Her eyes were red, and the snot dripping from her nose was sucked in and dribbled out as she breathed. The pin holding back her springy bangs looked like it would pop out any second. I noticed Kojima had a bean-shaped spot on her right cheek where her skin had lost its color. I'd never been this close to her before. I couldn't believe how vulnerable she looked. She had no fight in her, like some tiny, helpless creature waiting to be snatched away. I know that I was helpless too, but beside me on that bench, Kojima looked smaller than any little kid I had ever seen. Much weaker than the way she looked at school. I felt incredibly sad. Unable to do more than sit and stare, I was just as helpless.

I couldn't figure out the real reason she was crying, so we just sat there quietly, together. Kojima stroked the kitten on her bag the same way she had when we were on the train. Maybe it was like a nervous tic. She looked up, as if the worst was over, and stared into the sky.

"When it's this nice out, something keeps me from moving."

The July sky was saturated with summer. Nothing moved over our heads.

"I feel trapped," she laughed.

"Like there's a lid on top of you," I said.

Kojima slipped a hand into her bag and pulled out a packet of tissues. She asked if she could blow her nose. I said sure. I was surprised by how loud she blew it.

"Good thing I had these," she said, wiping her nose. "It feels so good to really let it out, you know?"

"I'm glad."

"I don't usually carry tissues."

"Yeah."

"Glad I had them today."

"Yeah."

"Do you wanna blow your nose, too?" she asked.

"I'm fine for now," I said. I looked at my pockets. "I never carry anything. Just my wallet."

"What about your favorite pencil? Not even that?"

"I couldn't write anything down if I only had a pencil."

"But that's why everyone carries little notebooks, right?"

"My pockets aren't big enough for a notebook."

"Yeah," Kojima said, "I don't have that much on me either." She opened her bag so I could see. "Just my wallet, the tissues, and my scissors."

"You have your scissors on you?"

I must have looked surprised. Kojima nodded sheepishly.

"Wait, though," she said, "it's not like that. I don't cut things anymore."

"No, you can cut anything you want. I'm just surprised. I didn't think you'd bring scissors into a museum."

"It's not like I brought them because we were coming," she said, a little embarrassed.

"No," I said. "Sorry."

"I always have them, outside of school . . . not like I'm gonna use them. They're just good to have. It's not like they make me feel safe or anything. I just like having them." She closed her bag and rolled the top down a couple times, then set it on her lap again.

"I know," she said. "It's weird."

She covered her mouth with both her hands and smiled nervously. We could hear girls and guys cheering from the lawn. Several bicycles whooshed past us. A sharp light flashed into my eyes, making me squint, and when I looked I saw that someone on the far edge of the lawn was laying out a silver picnic sheet.

I thought for a second but then I said it.

"Kojima, get your scissors out."

"Why?"

"Cause."

"But why?" Little wrinkles formed between her eyebrows.

"Because," I laughed.

"Why are you laughing?" She looked puzzled. "Stop."

"Sorry," I giggled, "I'm not laughing at you."

"Then why are you laughing?" she asked sternly, with the same puzzled look.

"I'm not laughing."

"Yeah you are."

"Yeah, because you're not listening to me."

"You're not listening to *me* . . . what do you want them for?"

For a minute we were quiet, staring at our shoes. My feet were a lot bigger than hers. I started thinking about how weird feet are. Such a strange shape. As I was staring at her shoes like that, she toed the ankle of my shoe, so I did the same to her. We did that a bunch of times, but then she pressed hers right against mine, and said yours are huge. I laughed and said it's cause I'm a boy. She said I was right, and then we were quiet again.

"If you want to," I said to her, "you can cut my hair."

After a pause, I spoke again.

"You know what you said before? Like, if you start to feel the normal slipping away. If that happens, you can cut my hair."

Kojima dropped her jaw.

"Your hair? Why?"

"No reason. Just thought that you might want to."

"What do you mean by your hair, anyway? Like, where?"

"Anywhere. It doesn't matter. Just don't mess it up too bad. Or, well, if you need to make it messy to feel better, that's fine, too. It doesn't really matter."

Hearing this, Kojima stroked the back of her left hand with the fingers of her right. She looked like she was about to speak, but something was holding her back.

"When you feel like everything's falling apart, or things feel too good to be true," I said, "whenever things get like that, you can cut my hair. Instead of cutting up the junk mail or whatever, when nobody else is home. Just let me know, and you can cut it, whenever you want."

Kojima stared at me. Sweat seeped from every pore on her face. It made her skin look swollen. It was almost noon, and only getting hotter. The sky was free of clouds, and there wasn't any shade in sight. Occasionally a breeze blew through the park, grazing the edges of our bodies. Then Kojima looked at me and nodded as if letting go of something big.

Following the nod, she kept her head down and carefully opened the bag in her lap. Even more carefully, she slipped her right hand into the bag and pulled out her scissors. Her nest of hair was hiding her face, making it impossible to see what expression she was making. Now that she held the scissors, she turned her gaze to them. The handle was yellow plastic, and the tips were blunt, for crafts. The blades were flecked

with different colors of paint. They looked like they had seen some heavy use.

"I've had them since the first year," she said after a while, looking at the blades.

"Of middle school?"

"No, of elementary school."

"Whoa, eight years ago?"

"Are you sure it's okay?" Kojima asked me quietly. "You're really okay with me cutting your hair?"

"Yeah, a hundred percent sure."

She held the scissors with her right hand but clasped the silvery blades with her left palm, staring at her hands, like something else was on her mind.

"Chop-chop!" I said, trying to be funny. I sat up straight with my hands on my knees and turned my back to Kojima.

At first she didn't move, but then I felt her hands in my hair.

She slipped a finger behind my ear and made a little bunch, shaking it a few times to make it the right size. The hand holding the scissors hovered behind my head. I felt my hair slip between the blades. They sliced through the bunch of hair and made a grinding sound. I got goosebumps, and Kojima made a sound almost like a sigh.

I turned around to see her with her head down, holding a fistful of my hair in one hand and the scissors, slightly parted, in the other. She had cut close to the scalp, freeing a clump less than an inch wide and four inches long. The two of us sat just like that, completely still.

Kojima wouldn't look at me, but she kept pushing the fistful of hair in my face.

"Hey, enough with the hand already," I said and laughed.

She blushed and shot me a look back, like she was upset, or maybe she was happy, or maybe embarrassed, or on the verge

of tears. Honestly, I had no idea what kind of face this was, but she was laughing.

"It's like . . ." But she just looked at me, still red, then looked away, then back at me. She was still holding the hair up near my mouth, so I pretended to eat it. When Kojima saw this, she laughed out loud, and I laughed too.

"There's a lot left," I said, "you can keep going." I ran a hand through my hair and touched the spot where her scissors had been. Obviously I couldn't tell the difference from before, but she was holding a fistful of my hair.

Kojima stared at the little bunch of hair, then wrapped it in one of her tissues. When she was about to put it in her bag, I asked her what she did with all the other things she cut. She said she tossed them.

"Okay," I said, "then toss it. It has to be the same."

Kojima looked confused. "But it's not the same."

"Yes it is," I said. "It's nothing special."

But Kojima looked unsure. She stared at the bunch of hair.

"It's okay," I said. "When I say so, open your hand."

"I can't."

"Sure you can," I said. "Nothing's wrong. You can cut more whenever you want. There's plenty."

Kojima clenched her fist. Dead still.

"I can't do it."

"Yes you can."

She looked uneasy, but when I said her name she spread her fingers, almost out of reflex. The color returned to her hands and she gasped. Before she realized what was happening, the tissue opened and the cluster of hair fluffed apart and tumbled to the ground, where the clippings scattered and disappeared.

We didn't go back into the museum.

On the ride home, we played word games. Kojima started feeling a little better, and I managed to make her laugh a few times. We were starving, since we hadn't eaten anything all day, and could hear each other's stomachs grumble. It sounded like our belly grumbles harmonized. I made a joke about it and we laughed. But the closer we got to our stop, the less we spoke. We weren't even really looking out the windows. We sat in silence, only moving when the train moved us.

Outside the station, things were back to usual in the worst way possible. The sunset was spreading over us into the distance, growing longer with the shadows. The summer that had inundated us when we were in the park bore no relation to the summer we met here. Sweat chilled our skin in private, underneath our shirts. Our bodies were becoming tense. We didn't need to say it. She knew and so did I.

Kojima said goodbye and waved. I said goodbye. She looked back as she walked away, disappearing around the corner.

Standing there alone, I looked all around me. There I was, at the start of summer, standing right in the middle of it, in the same place I had met up with Kojima that morning. I knew it was the same place, but it didn't feel the same.

Postcard from New Mexico

DEBORAH LEVY

On Oct 31st I swam amongst the last leaves of the fall in my hotel pool in the railyard district of Santa Fe. When I surfaced from doing the jet-lagged lengths I saw a flip-flop lying near the edge of the pool, *ZEBRA* written across its red sole. The sun had been fierce that morning but at 5pm (when I was swimming) though my body was warm in the heated water, I was shivering as I spliced through the leaves. I realised it was snowing. For a while, I continued to swim as the snow came down and the sky darkened. Earlier that day (wearing a summer dress) I had passed a restaurant offering rabbit and rattlesnake stew on its menu. I knew I had the adventure in me to try at least one spoonful of snake. That's what I was thinking about while I swam in the snow in Santa Fe. And I was thinking about you.

Then later, when I was sipping mezcal (smoky, strange) by the log fire in the hotel, I saw a man talking to the staff at reception. He was holding up one flip-flop with *ZEBRA* written across its red sole. I waved to him and when he came over, I was pleased to tell him exactly where to find his missing flip-flop. He said, *thanks, I ran out of the pool in a hurry because the weather had changed so rapidly.*

I couldn't work out why he felt it was better to run in a solo flip-flop and that (again) made me think about you.

51

SEMEZDIN MEHMEDINOVIĆ was born in Tuzla, Bosnia, in 1960. He graduated with a degree in literature from the University of Sarajevo. He has published nine books. After the Bosnian war, in 1996, he moved to the United States. And after twenty-four years, he returned to Bosnia in 2019.

CELIA HAWKESWORTH taught Serbian and Croatian language and literature at the School of Slavonic and East European Studies, University of London, from 1971 to 2002. Since retiring she has devoted much of her time to translating fiction from the language now widely known as Bosnian-Croatian-Serbian and to date has published some forty volumes of translations in addition to other scholarly works.

Snowflake

SEMEZDIN MEHMEDINOVIĆ
TRANSLATED FROM THE BOSNIAN
BY CELIA HAWKESWORTH

'Love is a form of forgetting.'

—Richard Hell

When they carried her out of our flat into the rainy day, she was in pain and barefoot, so she turned and told me to bring her some shoes. I picked up the first ones I found. I drove behind the ambulance in which she was travelling towards the hospital, glancing from time to time at the white trainers on the passenger seat. Rain and the monotonous sound of the wipers. Canvas trainers are not for a rainy day. Sanja was in the red vehicle in front of me, her shoes were following her.

In the hospital, two doctors asked her synchronised questions and she answered. Questions about her allergies, about her medical history, she answered with wide-open eyes in the face of the authority of the two men in their white coats, as though she were taking an exam. And then one asked:

'Do you smoke?'

'Yes,' she said, 'but only two or three cigarettes a day.'

She's no good at lying; in situations like this she will sincerely confess everything. When I heard her answer the doctor's question, I thought that may well have been the case: at work she probably smoked two or three cigarettes, but she'd kept it from me, because she was anxious not to revive my desire for tobacco (in the past I had been pretty dependent). After my heart attack, five years ago, she too stopped smoking, out of solidarity, or at least she didn't light a cigarette in my presence. She had smoked 'two or three cigarettes a day' all her life, and it had never become a real addiction.

More than twenty-four hours had passed since that conversation with the doctors and now it had become clear why she had said she was a smoker: she had suffered a stroke and one of its consequences was forgetting. The stroke had damaged her so-called short-term memory, so that she'd forgotten the last three years when she no longer went out onto the balcony to smoke.

S he looks at her arm, which she can only move with difficulty, and asks: 'What's happened to me, Sem?'

'Yesterday,' I say, 'I was making coffee, you'd gone to the bathroom, everything was all right, it was raining. As I was pouring water into the machine I heard a cry from the bathroom. I thought you'd fallen, but that wasn't it, your arm was hurting, you said it was tingling and you couldn't feel your fingers. You didn't want us to call an ambulance, but you weren't getting any better, so I did call. They came, and after a quick examination, decided to take you to hospital. I drove behind the red ambulance and when I reached the hospital, you were already in bed, a nurse was giving you morphine, you were already having a transfusion, then they took you away, with your bed, to a different

room where they did a CT scan. It turned out that you were very anaemic so they sent you to the oncology department, as they thought you had cancer. The CT showed that you had a clot in an artery near your left shoulder, and they said it had caused a stroke, or rather a series of small, mini-strokes in the peripheral microvascular branches on the left side of your brain. And now, because you're anaemic, they don't know how to treat you. A stroke is treated with blood thinners, but the reason for your anaemia is potentially an internal bleed. So now, if they put you on thinners, it would exacerbate the bleed and that would be a serious problem . . .'

She looks at me anxiously, but she has already forgotten what she asked me, and has already forgotten my reply, and now she asks again: 'What has happened to me?'

The first night in the hospital, she slept and woke in short bursts, her sleep was shallow. She woke up, looked at me with an expression of disappointment on her face, and asked:

'Is Daddy angry with me?'

'Are you asking whether your father is angry?'

'Yes, he's angry with me and that's why he's not coming home . . .'

'Listen,' I said, 'your father died four or five years ago.'

She thought for a while, it seemed she had remembered, then she put her head on the pillow again and went back to sleep. What had actually happened? She'd woken up in her hospital bed as a little girl of five. That was a time capsule, a trauma of fifty years earlier, and now it was alive in her: her father wasn't coming home because he was angry with her. Oh, my little frightened girl!

Her father. I never met him, although we lived in the same town for sixteen long years. He never tried to contact his daughter, nor did he ever show any kind of interest in her. That was all

important to me, of course, but I didn't ask, I left it up to her to talk about it or not. And she rarely mentioned him. So I know nothing about him, apart from her incidental, sparse anecdotes. One was from her early childhood. They had a caravan somewhere near the coast. During the night he came with an unknown woman, woke his daughter and took her outside, so that she spent the night in the rain. A little girl at night, in the rain. Nothing connects me to him, apart from the fact that he marked my life indirectly, influenced it and altered my personality over time. Through his relationship with his daughter, he formed her hostility towards the whole male species. We have lived together for thirty years, and all that time she has been wary of me. I never saw him, but I bear that man as my personal burden. I'm tired of him. And I'm used to him. The other image I have of her father is connected with Libya. Her memory of Africa, where she lived on the sensitive cusp between childhood and youth, was bright and consoling. She would often say: 'I'd like to go back to Africa.' That was where she spent her last summer with both parents. Remembering Libya, she would always mention her father: 'He immediately felt at home there, he quickly learned Arabic, and began to make friends with the local people.' Then she'd talk indifferently, as though describing a stranger. Later, when he left, she didn't miss him. We're now on the cusp of old age, but that doesn't mean that at fifty-one one stops being a child. All these years, she hasn't missed him, that concrete man, but a father, one who ought by biological imperative to be on her side, when a daughter needs protection and security.

She woke up a little while ago as a five-year-old girl who had blamed herself fifty years earlier because her daddy hadn't come home for days.

<p style="text-align:center">✳ ✳ ✳</p>

I keep finding her white trainers in different places. Maybe the nurses move them? I haven't moved them. Or else they move around the ward on their own, impatient to get out of there as soon as possible. Yesterday, with her bag and white trainers, I came through the transparent hospital door that opens in a circle, asked directions to the emergency room, intending to wait for the medication that would cure the pain in her arm, and then help her to tie the laces on her white trainers, and hold her hand as we crossed the car park to our car. We'd drive home slowly, return to our everyday concerns, finish the tasks we'd begun in the kitchen: turn on the coffee machine into which I had already poured water, spooned the coffee . . . But that wouldn't happen, the doctors would meet us with bad news, she'd be settled in the oncology ward, and I'd stay beside her all night, like a loyal dog.

It all happened too fast. The doctors stated that, in all probability, she had cancer. I held her hand while she slept, and she clasped mine tightly, because she was dreaming about something. And I thought, she wasn't dying, because dying people no longer dream! A ridiculous thought, but I held onto her till the morning, because there was no one there who could console me. The warmth of her hand and her whole sleeping body was the only acceptable reality for me.

All my life I have borne the burden of my meaningless name. But I came to terms with that early on, convinced it was after all just a name, that it didn't matter what a boat was called, just that it could sail, and that we fill the being bearing our name with the glow of our being. It was a consoling thought. It's only today, in my fifty-sixth year, that I have completely accepted and identified with my name. This is why: The doctor asked her: What year is this? Which month? Where are we now? She looked at him and had no reply; she had forgotten the year and

the month and the place. Then the doctor pointed at me, sitting beside her bed, 'And who is this man?' For a moment she settled her gaze, she appeared to be looking right through me, and I felt a chill run through my whole body. I thought: she's forgotten me. But then her face experienced a total transformation, and she looked at me as though she had saved me from non-existence, or as though she had just given birth to me, and with an expression of the purest love she said: 'Semezdin, my Semezdin.' And that was the moment when my name filled with meaning. I was *her Semezdin.* That is my love story, and my whole life.

A ll of a sudden bodies in a hospital become distorted. The nurse who injects her with morphine looks pear-shaped. Her head is miniscule in comparison with the rest of her body. It's probably due to some inner optic problem of mine, which recurs whenever I find myself in a hospital. That is, I see human bodies as defective and incomplete. Perhaps because in hospital a body is transformed from a subject into an object. But as soon as I get outside, my gaze will become normal and I'll see people the way they presumably are. So a hospital becomes in my eyes like a crooked mirror, which distorts bodies. And then it seems to me that it's the presence of people that makes this world imperfect, when it's otherwise beautiful and amazing!

H . Gallasch, my friend from work, brought us food from an Italian restaurant, then she took me outside the hospital to breathe some fresh air. Through the big revolving door we went slowly out into the rain. Everything in the hospital is slowed down, adapted to the movements of the patient. Time slows down as well. From our ward, you had to pass through a labyrinth of corridors in order to come out into the rain. 'It's just as well you aren't a smoker,' said H. 'Otherwise you'd be popping in and out

for a smoke.' I didn't stay long outside, it was a cold April day, we said goodbye, and I went back inside through the door that revolved so slowly. I glanced at the paper sack of food in my hand and saw an image of Venice showing a palace and bridge with a gondola passing under it, and suddenly the revolving door became a time capsule.

Venice. The night before last I was reading an essay about Venice by Sergio Pitol, his first encounter with the town, which he saw through a fog because he had lost his glasses somewhere on the way. I read that two nights ago, and it seems that was all in the distant past, or in some other life. And while I was reading, I could smell cement, because a few hours earlier at work, my friend Santiago Chillari had been showing me photographs of the inside of an old building on one of the Venetian canals, which he and his family are restoring with the intention of turning it into a hotel; the photos were of workmen scraping the walls, stripping off the old paint, with building materials, sacks of cement around them on the floor . . . After reading this piece about Venice, I wrote one about Aleš Debeljak, my friend who died tragically two months ago. I thought about him and jotted down memories of our encounters. We used to meet often, speak on the phone, exchange emails. We got to know each other in the early nineteen-eighties, but it seems to me that our contact became pure friendship only last year: for a few days in October at a literary conference in Richmond, we shared a common balcony in our hotel and we chewed over our two pasts in lengthy conversations. I went through my email to find his last sentence to me. His last message ended with the announcement: 'This evening I'm taking our dog on our regular walk beside the Venice-Budapest train-line.' A poet! He managed to encompass a whole cultural space within the boundaries of a 'regular' evening stroll.

The door described a complete circle and I stepped back, into the hospital . . .

I n the morning as I was washing my face, I spotted in the mirror some white strands of hair on my forehead. Only two days have passed since we got here and I'm already going grey.

W hen the nurse comes into the ward to give her an injection, Sanja says: 'You smell nice,' to please her, to establish human contact with a small compliment before the pain.

I think there's something deeply problematic about the way treatment is managed in a hospital. Every ten minutes people come to check Sanja's name and date of birth, to scan the barcode on the plastic armband round her right wrist, to take her pulse, blood pressure, temperature, take blood samples, knock her knee with a rubber hammer . . . It's torture by sleep deprivation, and it could all be done less frequently, so that the patients have time to catch their breath, to fall asleep, to have some amount of rest, at least during the night. A hospital ward is a torture chamber. I think hospitals ought to sign the Geneva Convention and stick rigorously to the rules.

I put my own T-shirts on her, because they're bigger and more comfortable than hers. I've got one here that's the colour of the September sky in Sarajevo, on a sunny, cloudless day. That's the one she likes best.

I t's three in the morning now. Through the high hospital window I count the planes descending from the night sky to the airport, the lights from their windows merging with the lights from the windows of houses in Arlington. She opened her eyes briefly, glanced at me, then turned onto her other side and went

on hovering between sleep and waking. She glanced at me, but I'm not convinced she knew who I was.

It's three in the morning. I have always liked her early wakings. When I used to write at night, it sometimes happened that I woke her because I would forget to move the kettle off the heat before it whistled. So I might wake her at three in the morning and she would always be cheerful, ready to joke. There she is in the doorway, looking at me, shaking her head, and saying: 'You're fifty years old and still writing ditties!' And once, woken like that, still half-asleep, she said: 'The Chinese believe that dragons like the smell of copper.' Dawn is her time of day. That's why I remember many of her morning sentences. Showered, her hair wet, ready for work, she would spread out her arms and ask: 'Is someone going to tell me I'm beautiful?'

She has forgotten everything. She asks: 'How old am I?' Whatever number I tell her, she'll believe it. So I ask her date of birth, because she has to answer that question every five minutes for one of the hospital staff. 'September 17, 1960!' And I say: 'Now it's 2016. Can you work out how much time has passed between 1960 and 2016?' She closes her eyes and counts. Then she looks up and says: 'I can't be that old!'

Befuddled by painkillers, she easily drifts into sleep and even more easily wakes from it. She wakes briefly and says anxiously that she keeps sleeping and she ought to get up, because she'll be late for an exam at the university. And then I don't have the heart to tell her that our student youth is far behind us, in a past that would be best forgotten, in a country that no longer officially exists, in a world that is no more.

I went back to our flat to get some essential things we needed in the hospital, some clothes, toothpaste and a toothbrush,

some fruit, in case she gets hungry. On the way, I picked up the post from our mailbox, and opened a package in which there was a book. I leafed through it briefly and read a sentence from the first paragraph: 'All our problems are a consequence of our not being prepared to stay inside.' I walked along the corridor through which she had gone in the opposite direction the day before yesterday. Our lengthy corridor. From the lift to our door the distance is the length of two football stadiums. Once, weary, I stood at our flat door, having set off on an urgent errand in town, but when I looked along the lengthy corridor, I lost the will, couldn't face the long walk to the lift, turned round and closed the door behind me.

I t was less than two days since I'd been in the flat, but when I entered, memories sent me reeling, first of the previous morning, and then of all the days spent there, because every object in the flat reminded me of the motion of her hand putting it in that place. I took a shower and changed. On the computer I tried to find out what household tasks needed attending to. I know nothing about all that, she did it all. And my system soon collapsed in the face of all those passwords! I'd now need to reconstruct our reality from scratch; or would it be better to wait for Sanja to remember everything? I stood in the kitchen thinking about Saturday morning, before she complained about a pain in her arm. I had been about to make coffee for the two of us. I had poured the water into the machine, spooned finely ground coffee into the filter, all I had to do was press the button on the coffee machine. I did that now, and the sound of bubbling water drove the silence out of the room. I made coffee for two. I poured mine into a glass cup, but what to do with hers? And I don't know how to emerge from that Saturday morning. I want to freeze the time in my memory, to keep us

there in the room, to prolong for as long as possible the peace in which two people are getting ready to drink their morning coffee.

I'll try again to describe what filled me with anxiety. When I entered our flat, I glanced at the familiar objects around me, thinking at the same moment that all those objects were imprinted with the movement of Sanja's hand. She had put each object in its place and it was the movement of her hand that had maintained their sheen. That thought was dangerous because I was, unconsciously, seeing a world without her, just the movement of her hand. That's what brought on this anxiety, the swelling round my heart.

Her invisible veins, her punctured arm, so much blood taken for innumerable tests, so much pain from the needle . . .

In the nineteen-eighties, she had been allergic to everything: pollen, dust in books, and probably me. Twice-weekly injections kept her allergies under control. Her body was a living wound. My Frida Kahlo. It seemed as though she could only survive in a world without plants. It's true that in her late childhood, her pre-allergic period, she didn't get on with plants either: she refused to drink herbal tea . . . Every morning her parrot, Charlie, would repeat the only sentence he knew: 'Drink your tea, Sanja! Drink your tea, Sanja!'

When we moved to D.C., her allergies returned for a while—because of the swirling winds that spin dust and pollen around in the basin between the Atlantic and the Appalachian mountain chain—and she had allergy tests. The doctor scratched four long rows on her back with needle pricks (testing for all possible kinds of allergen) and for a while she bore those scars on her left shoulder blade, like Angelina Jolie's tattoos.

But where is the pain from her past now? And where is the pain that I caused?

The woman who takes her blood at five in the morning announces herself from the doorway loudly enough to wake us: 'Blood work!' She's called Dora Castro.

Today Sanja's right arm is numb, so that she no longer feels the needle prick. And I'm glad it doesn't hurt her, but I'd like it to hurt her. All my senses have gone haywire.

This evening we are doing Qigong in the ward with Asim, a doctor who believes in Chinese traditional medicine. A nurse came in and found us in the middle of exercises that resembled a sacred tribal ritual, and she left the room, walking slowly backwards so as not to disturb anything. Later, when she came back to take Sanja's pulse, she made my day by asking: 'Are you a Native American?'

Shared remembering, a precious part of our relationship, has pretty much vanished. How can I restore to her memory the days that should not be forgotten? Not the big, important events, but hundreds of tiny ones we have reminded each other of over the years. Once we were driving in New Mexico, and if you looked through the window on the left-hand side of the car you saw a lovely sunny day; but if you looked through the right-hand one there was rain pouring down the pane. A unique moment of pure beauty! What if she's forgotten it forever? But how good that she doesn't remember all the sad and difficult days. There would be justice in their remaining forever in oblivion.

'Are you related?' asks a nurse. But when I say 'She's my wife,' that is a simplification, she's more than that. For instance, in 1993, during the siege of Sarajevo, a murderer pointed the

barrel of a Kalashnikov at my chest. And she stepped between the gun and me.

'What happened to me?'
'Early in the morning of April second, it was raining. I decided to make coffee. You got up from the sofa and went to the bathroom. I spooned finely ground coffee into the filter, I poured water into the machine, and then I heard a cry from the bathroom, your voice. But ten seconds earlier you had been laughing! I went to the bathroom and found you doubled up, you said your arm was numb and you couldn't feel your hand or your fingers. Shall we call an ambulance? No! You came back to the sofa, but when you tried to lie down the pain got worse so you sat up again. I called an ambulance. They came quickly, but when I opened the door they complained about the incomprehensibly long corridor. "By the time you've walked down that corridor, the patient might have died," said a young man in a blue uniform. They took you to hospital, a scan showed that you'd suffered a stroke. And here we are now on the oncology ward. They thought you had cancer, but that's wrong . . .'

The fingers of my right hand are swollen. I can bear pain, I've learned. The cold in Sarajevo during the siege years brought on my arthritis, which has got quite a bit worse over the last two years. It attacks me in the shoulder and hip with horrible pain lasting from eight to ten hours. Or, as now, the inflammation makes my fingers stiff. In October last year I was at a literary gathering in Richmond. Wonderful weather, an Indian summer, and then on the first night I was woken by arthritis, my left shoulder was inflamed, unbearable pain; I stood by the window, rigid, in one position, looking out at the illuminated street. Young people were returning from nightclubs, laughing and tipsy, they

passed my window the whole night, loud and drunk, and how I envied them their youth and health. In the morning, when Sanja was already awake and getting ready for work, I phoned her to say I was in pain and could hardly wait for the pharmacy to open so I could go and buy some of those 'hot patches' that you stick on sore places to relieve pain, and she told me to open my bag, because she'd already packed them in case I needed them. That's how I lived all these years. I'd call her so she could tell me what I had in my bag.

Every day I reach for Sanja's documents, because I'm asked to fill in some new forms for which they need her personal details. That's how I've acquired the right to peer into her backpack and wallet. She always carries a backpack, she never got into the way of carrying a traditional woman's handbag, but always, as long as I've known her, she has carried a canvas bag or rucksack instead. All these American years she has worn her rucksack on her back to work and on journeys, but also on short outings to restaurant or cafés. It's a serious burden, there are hundreds of things in it and, as she puts it, a dozen little things that make her feel confident. For instance, she has to have reserve earrings, because earrings get lost and she feels unprotected if she finds herself in a public space without earrings. One of her acquaintances once confided in me that she had been known to pull a button off a blouse just so that she could ask Sanja to sew it on again. Of course she has a needle and threads of various colours in her rucksack. The young American who pulls her buttons off had in fact never before witnessed the process of sewing on buttons: she was used to throwing away any garment with a missing button and buying another. But that was not the only reason for her need to watch the drawing of thread through a needle. Whenever Sanja sews a button onto a shirt of mine I too watch

entranced, so that I understand her American acquaintance. In my case, sewing a button on is an image from my childhood that restores harmony to the world. Something in that act awakens primordial memories.

There's a photograph of me in her wallet. I didn't know she carried my image around with her. It's not a portrait, a photo for a passport or other ID such as often ends up in a wallet, but a cheerful snap of me holding a dog in my arms, and it isn't clear who looks happier or stupider in the photo, me or the dog. People put photographs of their nearest and dearest into their wallets out of inertia, but do they ever look at them? There are moments when we turn to those photographs, in a state of loneliness, travelling, when we are separated from those closest to us. I try to imagine her (in the past) opening her wallet and glancing at this snap. And what did my picture mean to her at that moment?

A message on her phone: 'Dear Sanja, the post offices are not open today, do you happen to know, please, what other shops sell stamps?' She's a little encyclopedia of practical solutions.

I'm keeping watch at her bedside. Three days have passed now. I have never loved her more. But, actually, that's not right. I've forgotten. It was the same during the war, the same whenever the presence of a catastrophe encroached on our relationship. That's only apparently a paradox; a tragic event increases our inner strength and our capacity for love. I keep watch at her bedside. I am an old, sentimental soldier.

I have no biography. A friend emailed me from Zagreb and asked: 'How is S.?' He doesn't know her. Or rather he knows her only as 'S.', the way I most frequently referred to her in my texts. He was enquiring not about the health of my wife, but the health of

my literary character. I had already described almost everything important that happened to me in my prose and poems, turning almost my entire life into fiction. It was now a collection of illusions, fairly unreliable, so that it would be hard to construct a factual account of my life. For years I've been transforming your body into words. That's my infidelity.

T he sound of scanning the barcode on her plastic wristband is accompanied by the question:
'Name and date of birth?' She says nothing.
'What year is this?' asks the doctor. She says nothing.
'What month is it?' She says nothing.
I ask her: 'Who wrote the line *April is the cruellest month* . . .'
And she says: 'T. S. Williams.'
It's interesting that she has merged T. S. Eliot and William Carlos Williams into one person. There must be a specific reason for that, but I'll think about it later, now I hurry to put her right: 'Not Williams, but El . . .'
And she says: 'Eliot! T. S. Eliot!'
In other words, she can't remember the calendar year, or the month in which we are now, but she does remember a line from a poem, and the name of the poet.
When we are left alone in the room, she becomes a child seeking attention, saying: 'I was in such pain this morning!' 'What was hurting?' I ask, anxiously. 'I can't remember now, but something must have hurt.'

E very ten minutes they come to take her blood, check her pulse, measure her blood pressure. At midnight they move her eight stories down to take a new image of her heart, then take her back to her room (the bed is her vehicle through the labyrinth of hospital corridors). They collect facts about her, but I'm not

convinced that all this information is scrutinised and taken into account, because every new person who appears in our room starts all over again with the same questions, informing him or herself about everything from the start. We repeat endlessly the same series of events that brought us to the hospital. And, since thrombosis was found in an artery on her left side, the cardiologist has insisted on restricting all activity with her left arm. This means that she can't have her blood pressure taken on that side, nor blood taken out of those veins. And a new person really does come every ten minutes to take blood, and a new nurse to measure her blood pressure, and each time they move towards her left arm, and each time I stop them and tell them about the embargo that they ought already to know about. In other words, if I didn't inform them about her diagnosis, they would forever be doing the wrong thing. A database is an American obsession. In order to collect new data, medical staff come into the room every five minutes, so that for four nights now Sanja hasn't had a wink of sleep. It's the third day since she hasn't had any water to drink or anything to eat. I smuggle ice cubes in for her to suck. I ask the doctor: 'Why can't she drink water, or eat?' 'Because she has had a stroke and the speech therapist has to confirm that she can swallow water and food correctly.' 'So why doesn't the speech therapist come to establish that?' 'He's scheduled for tomorrow.' In hospital, a body is exposed to systematic abuse. Every ten minutes new facts are collected in a database, which, as far as one can judge, no one consults and which is largely useless.

And why is a doctor's signature on prescriptions for medication always illegible?

I clasp her small trainers in my hand. I was looking for a label, the name of the company that produces them, but I didn't find one. It's not known who produced them, or where they

were made. There's no information about their origin. They are made of white canvas, the cheapest. Nameless. That's so like her! Because she buys things in spite of their branding: so if an iPhone, say, is the most popular of all mobiles, she will deliberately choose a different one, the one least shouted about. It's not always a satisfactory choice. That's why she now has a rather silly and unnecessarily complicated telephone, and, since she's begun to forget things, she's finding it ever more problematic to use it each day.

She woke up and asked: 'What are you doing with my shoes?' Good question. I must look pretty crazy peering at her trainers like this. They're just shoes to her. And that's how it is: all her shoes have the same name and there's no distinction between dress shoe and trainers, they're all shoes to her.

Come to think of it, at our very first meeting I was attracted by this absence of snobbism of hers. At that first meeting a group of people were discussing art. And then a girl (whose name I've since forgotten) who had just returned from Paris was talking enthusiastically about the work of her favourite painter, Toulouse-Lautrec. And Sanja, with the same enthusiasm for the painter and for one of his works in particular, went to the shelf and came back with *A History of World Art* open at that painting of Toulouse-Lautrec's. But her collocutor shook her head and said: 'Yes, yes, but . . . No, no, that's not it' (that was the snob in her speaking: she had seen the *actual* painting, while the one in the book was just a reproduction) and she had already lost interest in the conversation about art. Then Sanja pressed her finger onto the picture and to her collocutor's horror, said: 'Well, fuck that!' and went on talking about the painter. My kind of girl. My clever girl. My anti-snob!

* * *

When she went for her CT scan, because she was restless and kept moving her head, I stayed with her, wearing a lead apron to protect me from the radiation, holding her hand. And today, when we went for an MRI scan, in-depth imaging about which I had known nothing until now, I proposed to the girl who works there that I should again stay with the patient, to hold her hand and keep her calm. The girl laughed and said that wasn't possible and when I asked why not, she said it was forbidden because the room where the MRI scan took place was like a shooting gallery, and you could be killed in there, because, she said, for instance 'if there was so much as the tiniest earring in the patient's ear, the magnet would reject it with such force that it would lodge in the wall, like a bullet from a gun.' 'What kind of magnet?' I asked naively. 'This is an MRI machine,' she said. 'Do you know what the M in MRI stands for?' 'No.' 'It means: magnetic. MRI is Magnetic Resonance Imaging.' 'Well, OK,' I said, justifying my ignorance, 'but wouldn't it be a beautiful, unique death, to be killed by her earring.' The girl laughed, she found my ignorance entertaining.

A sunny morning. In the hospital car park a gardener is pushing William Carlos Williams's red wheelbarrow in front of him.

I've spent the whole day recalling Kafka's drawings and thinking of his *Diaries*. While Sanja sleeps, I keep vigil, I do nothing. I wait, although I'm not entirely sure what I'm waiting for. I supervise the nurses to make sure they don't accidentally give her the wrong medicine, or take blood from the wrong arm. Then I feel useful. I look through the window at the rainy sky. Life is slowly turning into Kafka's syntax where there is no future tense. Who was it who said Kafka was a continent, and when you read him,

71

you always come to places where you've never been before? I've never before longed like this for the outside world in which the two of us visited places where we've never been before. A longing for a time when everything was normal. From my perspective, that was ten days ago, but for her it was several years ago, before the time she has forgotten.

I want to believe that her memory will soon come back, because we don't have the strength to fight against forgetting.

Over the last twelve days, I've realised that people no longer call each other by telephone; they don't talk in real time, just send each other text messages. That's not so bad. The telephone rarely rings, and I talk to the rest of the world in silence, so that I don't wake her when she's sleeping. From the age of speech we have moved into the age of text. But I now need someone who would be prepared to listen to me for hours, a bottle of good Dalmatian wine, and maybe a cigarette.

She thinks she's still a smoker, so today she asked: 'Can I go outside and light up over a coffee?' She lit her last cigarette four years ago. The last four years don't exist in her memory. 'After the stroke, you became four years younger!' I say.

I try to draw her, but it doesn't work. The reason is simple: she has no awareness that I'm drawing her, or if she does, in five minutes she forgets. In a psychological and a moral sense it's an impossible demand constantly to regain her agreement to being drawn, and every five minutes to start from scratch.

In order to reawaken memory, repetition is key, and we have to renew everyday facts in the memory all over again, to recall the same events all over again. What year is this? Which month and day? She's well aware that she doesn't remember, and asks questions that are important to her, she turns to me out of her

forgetfulness with full emotional participation. One question she asks every day: 'How's your mother?' 'She died in December, four months ago,' I say. She starts to cry, 'I didn't know . . . I'm sorry.' And she repeats the question 'How's your mother?' every day. And every day she experiences with the same intensity the news she has forgotten, always hearing it for the first time.

It's after midnight already and I've been watching Pat O'Neill's *The Decay of Fiction*. It's an experimental video about the abandoned Ambassador Hotel in Los Angeles. Documentary shots of empty corridors, a deserted night bar, and abandoned rooms alternate with shots of important events that took place in those same locations. The film is edited so that space turns into time. And, as I watch, my anxiety grows, but nonetheless I can't stop staring at the screen, whose bluish light has woken Sanja. Her face is sweaty, she asks: 'Can you bathe me?'

I wash her secretly. She looks uncomfortable when the nurses help her, while for their part they oppose everything that I myself do. This is not a real bath; it's impossible to separate her from the bed and heart monitor, to which she is connected by transparent cables. I have supplies of damp handkerchiefs and use them to refresh her. From her face to her feet. And now that we are old, I recall the girl she was. I run the damp handkerchiefs over her face, neck, and shoulders, over her breasts, under her arms, carefully down her arms so as not to shift the needle in her vein, not to touch the wounds from the puncture holes in her hand, then over her stomach, between her legs, and down her thighs, calves, ankles, and feet. This could look like a mournful erotic game in which the only important rule is that my movements should not cause her pain. Her body is familiar territory for me; it has altered with time, and I remember it in various phases. I remember *all* her bodies.

In the course of the night, between Saturday and Sunday, we have become old people. But can I imagine any other woman who would have grown old like this beside me?

The world has gone on living without us. Nothing has changed because we have got stuck on the eighth floor of a hospital, our hands leaning on a glass wall through which, from a height, we look down on the garden of a family home. A man in the middle of a telephone conversation walks across the lawn over to an oak at the end of the garden, leans his left hand against its trunk, and continues his conversation. It is a vision of an ordinary life that suddenly seems remote and inaccessible. We are practising walking along the hospital corridor and have arrived at this glass wall, looking down at a family home in front of which a man is leaning his left palm against the trunk of an oak tree. Arlington is spread out below us, behind it is Falls Church, and beyond that Vienna and Tysons Corner. She draws a circle with a finger on the glass and says: 'We used to live there. I remember. That's where the Institute of Subtitling Hollywood Films was.' I stand beside her, my right hand leaning on the glass of the window, with the imprint of an oak's bark on my left palm . . .

It's almost dawn; we are looking at the hospital window pane. She's glad that she's awake to watch the transition from night to day. She says there's a great contrast between light and darkness, people ought to watch the sunrise ritually, so the body can accept the change naturally. Through the window of the hospital room, we watch to see whether the sun will again rise in the east. It's not yet dawn, so the light from the room turns the glass in front of us into a mirror in which we see ourselves.

'I've grown old.' 'You haven't grown old.' 'I have, I have.' 'No, you haven't.' 'I have!' 'You haven't!' 'I have if I say so!' And here is the sun.

'What happened to me?'
'It all happened early one morning, on the second of April. Saturday. It was raining. We had already had our morning coffee and I'd decided to make more. I asked you whether you wanted another, and you laughed and said you did. You got up from the sofa and went to the bathroom.' Whenever I describe our room, I say 'sofa', but it isn't a sofa, it's a daybed, and I don't know how we'd say that in our language; something to lie on that is higher and wider than a sofa, a 'day bed' (as distinct from an ordinary bed, which is primarily a 'night' bed), because it's for lying down on before it gets dark. Most of the important events in our life have taken place in our language, but the most important ones have happened in English. Those are the days from which I never emerged. There aren't many of them. Three or four. I would like them not to have happened, I would like not to remember them, but that isn't possible. So, to describe that day, April 2, 2016, I ought to use English. 'You got up from the daybed and went to the bathroom while I poured coffee into the filter. And while you were in the bathroom, your left arm went numb. You couldn't feel your fingers and there was unbearable pain in your shoulder. It happened in an instant. You were fine, cheerful and talkative, and then came that sudden pain. I called an ambulance, they came quickly and after a cursory examination decided to take you to hospital for a more detailed examination. And in the hospital, the CT and MRI scans showed that you have a clot in your left subclavian artery, which, in all probability, caused a stroke. Plus, it turned out that you are very anemic. All that is why we're here now.'

* * *

'Can I ask you something?' 'Go ahead.' 'When I die, please have me cremated. And then you absolutely must take me home,' she says.

Fear of death in a foreign world. There had also been fear of life in a foreign world, but such fear was not so threatening or devastating. We all live with our own fear of death, but the important addition ('in a foreign world') conveys a substantial, metaphysical unease, although there's an obvious paradox there: why do we feel uneasy about a space in which we will in fact no longer be, simply because we will no longer exist? We aren't capable of thinking outside our own life. Even in death it's important to be at home.

We watch the snow through the window. Big flakes are falling. She has never liked snow, she has a horror of the cold, and that feeling was magnified in the freezing war years, during the siege of Sarajevo.

She looks through the window and asks: 'What's this?' I say: 'Snowflakes.' 'I've never seen such big snowflakes,' she says. 'Nor have I,' I say. 'Up to now we've only known *snowflakes*,' she says, 'these are our first *snowplates*.'

A nurse comes into the room, bringing medication. She scans the barcode on Sanja's wristband and asks the accompanying routine questions: 'Your name?' 'Sanja Mehmedinović.' 'Date of birth?' 'September seventeenth . . .' And then, looking out the high window at the snow falling outside, I ask: 'And what month is this?' She gazes at the snow through the window until she remembers: 'April . . .' and begins to cry. 'April is the cruellest month, breeding lilacs out of the dead land . . . T. S. Eliot! I've remembered!'

The nurse looks at me, seeking an explanation, but I don't know what to say.

H er speech is unchanged, her supply of words is the same. If language is a mirror of the world, then nothing that she has remembered (and now forgotten) is lost. If her language has been preserved in its entirety, then the whole world that has settled in her language has remained complete. That means she has forgotten *nothing* and now we have just to grab that everything back from oblivion.

I vica came by this morning, he says he had a strange dream. 'In my dream I'm eight years old, and it's as if I'm looking at myself from outside: I've got a fringe cut at an angle, I'm in Sarajevo and I'm sitting on a low stone wall. Then my father comes up to me, he's young and handsome, and he says: "Come on, I'm taking you away from here." "Where to?" I ask. "To the Vatican." After that we're in the square at the Vatican and we come to a wall, which is in fact that same wall from Sarajevo. "Sit here," my father says, "and wait for me." And I sat and waited, but he didn't come back.'

Ivica . . . Since I've been in America he has been my older brother who walks behind me, correcting my mistakes.

H arun called from the plane, saying that he wasn't going to land at DCA (as he had first told me), but at Dulles. He hadn't looked carefully at the ticket he'd bought in a hurry. I emerged from the hospital garage into a sunny day.

Dulles is pronounced like Dallas and once, in the distant nineteen-eighties, a friend from Zagreb, on his first visit to Washington and America, became agitated when, some twenty minutes before landing, the captain informed his passengers over the

loudspeaker that they would soon be landing in *Dallas*. And my friend was convinced that he would be landing in Texas, that he was on the wrong plane, and that made him anxious. I'm thinking of his traveller's nerves as I drive to the airport, because that's how I'm feeling now: as though everything that's happening to me is the consequence of a misunderstanding of which I have just become aware, and that 'just' has been going on for days now, and profound anxiety has become my normal state.

On the way to the airport, I drove through Peach Tree, past the building where we lived in 1996 and 1997. I looked at the parking lot in front of the building and an image surfaced from oblivion. I've bought our first car, we're in the parking lot, it's snowing, Harun is chivvying me to let him drive, 'only over there to the library and back.' 'Go on,' I say. He's thirteen, he's driving a car for the first time, and, with an expression of pure joy on his child's face, he watches the regular motion of the windscreen wipers in front of him. And now, twenty years later, as I drove to the airport, I saw *that* smile of his. Instinctively I want to turn time back. I imagined a present for you, my son, in which you would constantly experience things for the first time.

I n the airport Starbucks, I buy a coffee, go to the luggage conveyor belt, and sit down on its metal edge. There are no tense travellers around me, just the occasional airport official passes with a walkie-talkie in which crackling human voices vanish. And then I remember that less than a year ago, before her flight to Sarajevo, Sanja and I sat in this same place, drinking coffee from cardboard cups. That means that I came instinctively to precisely this place, so great is my need to be close to her. At this moment, all the events of my life exist in unison in space. So all my presents exist constantly. I wait for Harun. At last he appears in a group of other people, with a red bandana on his head. He

stops for a moment to call someone. And then the telephone in my pocket rings, beside my heart.

Harun is sitting opposite her, at the end of the bed. She tells him he's thin and asks: 'What do you eat, what do you live off, sweetheart?' He tells her he has a lot of work and eats what he can along the way. There's something obvious in the relationship between mother and son, something irrevocable, but every time I try to describe it, I become confused and tongue-tied. I get up from the chair and in the mirror on the wall see myself, see the bed on which she is lying, and our son resting his hand on the edge of the bed. I see the three of us captured in the mirror so clearly, as though we are in the wasteland of the cosmos, warming each other with our hands. Three, we're plural, but at the same time, in the mirror we're the reflection of pure isolation. She looks at her son as though she hasn't seen him for years (literally, because her last memory of him is several years old) and says she loves him 'with a whole universe of mouse footsteps'.

In April of last year, Harun and I roamed through the American wilderness for a project he was working on, taking photographs of the starry sky. I remember one black night, we had stopped somewhere just before midnight. In the darkness I had the impression that I was at the very end of the world, and I recall our vigil till morning as an experience filled with isolation and sublime solitude. It was only in the morning that the view burst into life before my eyes, and what the cameras had been recording during the night were three red rocks in the valley and the sky above them. Monument Valley. A month later, in May, those shots were shown on a Jumbotron behind Mick Jagger and Keith Richards during the Rolling Stones' 'ZIP Code' tour, a visual illustration of the song 'Moonlight Mile'. What a giant step from solitude to non-solitude!

Something that came into being in maximum isolation from the world had become part of a public, global event.

My body remembers various kinds of solitude, but none has laid me waste like this as I sit awake through the night by her bedside, watching her tormented by pain and insomnia.

A new novel by Ian McEwan is due out in September. In the book, the narrator describes his unborn child hearing in his mother's womb a conversation in which someone is plotting a murder. Memory begins before our birth. But how could an unborn child remember words whose meaning he doesn't know when he hears them? Unless he has a photographic memory, so he recalls the words by their sound and only later is their meaning revealed.

Sanja used to have a photographic memory, the gift (or curse) of visually recalling whole pages of a book. But that disappeared with Harun's birth. In the later months of her pregnancy the doctor explained that 'the foetus was draining her', and she said: 'This child is stronger than me!'

She was always the one who took care of me, rather than the other way round. It's hard to change roles. She lies in her hospital bed, looks at me, and asks: 'Is there anything I can do for you?'

And when the doctor asks her something that she can't recall, she behaves as though she were at a school exam, and looks at me, raising her eyebrows for me to whisper the answer.

'What's your name?' 'Sanja.' 'Date of birth?' 'September seventeenth.' 'What day is it today?' 'I'm not sure . . .' 'What's the name of our president?' She tries in vain to remember his name, then describes: 'One of those two . . . from the same family . . .' (She's thinking of Bush.) 'Think,' I say, 'the current president is

the first African-American in the White House . . .' 'Wow! That's a real step forward!' And then she does remember: 'Obama!'

I sit by her bed, gradually becoming obsessed with forgetfulness. We discover something about time as we watch what it does to our body. Or watch a child growing beside us. But our body is not proof that time exists. And the problem is not that we forget, but that we remember. Quantitative physics does not recognise continuity. But our experience is precisely an experience of continuity. That's an insoluble problem. We remember what happened yesterday.

Renata came to visit this morning. She sat beside Sanja and did useful things the whole time; for instance, she massaged her face, evidently knowing how to behave in the company of a patient, while I looked on, endeavouring to remember all her actions, so as to be able to repeat them myself later. The massaging of Sanja's face looked like a ritual, and she described everything she was doing in a whisper, explaining why it was important to apply pressure above the brow bone, and then she pressed the area under Sanja's eye sockets. I'm very sensitive where eyes are concerned. On rainy days when I'm in the street and people come towards me with umbrellas, the pressure in my eyes increases. I'm wary of those metal spokes, one of which could damage my eye. It's an irrational fear, one of those formed in childhood. When Renata presses her left thumb into the soft flesh below Sanja's right eye, I instinctively close my eyes.

The question is: where does the time go? Forgetfulness is not only the disappearance of events from the past, but also the complete erasure of time. When I ask her what year it is, she doesn't know, and when I say it's 2016, she's surprised: 'Where did the time go?' 'It went.' 'It went to its own home,' she says.

In hospital the most important fact about us is the year of our birth. But in our lives that year is of no particular importance. I had to grow old to understand that. Everyone dies young.

The therapist is in the room now and they've been doing memory exercises for half an hour already. She's placing photographs on the mobile bed table in front of Sanja. Four photographs show a man shaving in a bathroom. Her task is to arrange the images in the right order. The first one shows the face with a week-old beard, the next shows shaving cream being applied, then the act of shaving, and the last in that succession is a photograph of a man wiping his shaved face with a small towel. A consequence of the stroke is the slow connection of actions in their continuity. Recovering from the stroke means speeding those connections up. But the problem with memory is precisely the loss of continuity. She hasn't forgotten, because, with a little prompting, I can bring her back to an event from the past; if she can't remember the name of Kendra's six-month-old baby, I say the Bosnian word for 'queen', and then she says: 'Quinn!' And then corrects me: 'Quinn is pronounced like queen, but Quinn is not a queen!' If she can't remember the name of the district of Sarajevo where we lived during the war, I begin: 'Seddd . . .' And she says: 'Sedrenik!' She hasn't forgotten, it just takes effort to remember. I watch her trying to arrange the photographs in the correct order. She isn't certain whether to place the last photo on the table in front of her at the beginning, the one of the man wiping his washed face with a green towel.

My morning shave is a riddle connected with remembering for me as well. This is the rule: after washing, I apply soap to my wet skin, and at the same moment as I begin to scrape it off with my razor, into my consciousness comes Z., a little girl

82

from primary school. She had an Afro hairstyle and an unnaturally short space between her top lip and her nose. Whenever I shave, her face appears so vividly in my consciousness, just as though she were standing behind me and her reflection could be seen in the mirror. Why does this happen? I don't know. There's no answer to the reasons for our memories. There's no answer even when it's a question of our earliest memories.

The doctor wears a brightly coloured tie with cheerful children's drawings on it, so that he conveys a positive, relaxed impression to his patients. That must be the case, as Sanja immediately compliments him on the colourfulness of his tie. She ends her praise by announcing that she has never seen anything like it. The doctor then asks: 'Are there no ties in your country?' Now that kind of question always strikes a nerve with her, that kind of offensive question foreigners here have to answer in the first years of their exile ('Do people drive cars in your country?'). 'Well now, doctor, the tie as a fashion item was invented in my country—the word *cravat* comes from the Croats, who wore them as part of their military uniform in the sixteenth century!' The doctor is surprised at her explanation, listens patiently to her lecture, then quietly takes the edge of his tie between his thumb and forefinger and pulls it out of his white coat so that it can be seen in all its colourfulness, on his chest.

Her sight has deteriorated. At the same time, her sight has improved. I don't know how else to say this. For instance: she no longer needs reading glasses, but when she looks at me she sees dark hollows on my face. Immediately after the stroke, she couldn't see anything on the right side of her field of vision; she kept touching the edge of her eye, as though there was something there preventing her from seeing and she was trying to remove it

with her hand. One evening her eye was irritating her so much that I bathed it in sterilised water. So, the dark patches that appear on the edge of her field of vision are particularly irritating. The experts say that the brain is a flexible and transformative machine. Sometimes she'll say: 'That's strange, on my right I'm now seeing geometric shapes and the faces of people who aren't in the room.' What's going on? Her mind is drawing images from her memory and building them into the dark patches of her vision so as to accustom her to seeing a whole, in fact convincingly deceiving her that there are no patches, no empty spaces; her gaze is filled with images from the past, or objects from her imagination. For a week now she has not complained of darkness on her right side and maintains that she can see.

I'm becoming irritable and the medical staff avoid me. Even my own hair is a burden. I had somehow to injure myself, so as not to injure anyone else. Last night, when Sanja had fallen asleep, I went to the bathroom and cut my hair with my razor. My first thought was to shave it all off, but my courage failed me when I looked in the mirror.

This morning Ivica came with a bouquet of flowers. Sanja's sleeping, so we whisper. There's no vase, just a tall glass. But for the flowers to fit into the glass, we have to cut off the firm green stems. Ivica shortens them with a knife. And suddenly, I have a sense image of human hair being cut with an axe.

The hospital bed squeaks every time one of us leans a hand on the protective rail. If one of us gets up and tries to extract ourself from it, the bed alarms the nurses on duty and they hurry into the room. I understand the purpose, but this is way over-the-top; every movement sets off a shrill alarm, which in the late-night hours freezes the blood in our veins, maddens us

both, makes me jumpy, and her too I presume. And then this evening it happened that the bed squeaked and no nurse came. They object if I do their job, but now I have every reason to be dissatisfied with their work. And why is that noise so irritating? The bed has its consciousness, but its cleverness creates more damage than benefit. Its basic concept is, of course, useful—an alarm that can protect the patient from potential self-harm. But in reality it is, on the whole, a machine for nocturnal torture.

We have moved too often, the last time two years ago, in February 2014. It's not OK to move in the winter, because rain or snow may fall on your household furniture, on the bed or books. We moved only a few miles to the north, over here, near the river, and on the way the young men who were transporting our things in a rented lorry lost our bed. In every move, something is lost, a box of books, a shirt. But, how can you lose a bed? It's not an umbrella. A bed is too big to disappear like that. 'Where's the bed?' I asked the young men taking our things out of the lorry, but they just shrugged their shoulders, perplexed.

The doctor (the one with the cheerful tie) presented me painstakingly with the problem that awaited us when we left the hospital: she would have to come every day for injections of Warfarin (an anti-coagulant), but it could all be made simpler if I agreed to give her the injections at home. 'Impossible, I'm terrified of injections,' I said. I could have succumbed to any addiction, but not heroin. 'A syringe? No, no, no way.' 'Would you not try?' 'Out of the question.'

That conversation disturbed me, because driving every day to the hospital would be exhausting for both of us. Besides, I can't ask at work for several hours off every day. I mean, I can ask, but who would approve it? That same evening, Sanja complained of

pain where they give her the injections, three fingers to the left or three fingers to the right of her navel. They do it mechanically and roughly. She was sleeping when the nurse appeared at midnight, and I asked: 'Can I give her the injection?' The nurse had been present at my conversation with the doctor, so she agreed readily. It calmed me that Sanja was asleep, so that at least I wouldn't see the pain on her face when I did it. The nurse explained the whole process slowly and patiently. It wasn't light enough in the room, and I didn't dare give an injection in the half darkness, so I turned on all the lights, which woke Sanja. Alarmed, she looked at me gripping the syringe with rigid fingers. I said: 'I'm going to give you your injection, so that it hurts less.' I said that more to encourage myself, but it soothed her. The needle was really barely visible; with a straight prick and without moving the syringe it couldn't hurt (much). It all happened quickly, because I wanted to get it over with as soon as possible. The nurse praised me, the way one compliments a child who has successfully carried out a task. And Sanja said: 'It didn't hurt at all!'

'Listen,' I say. 'I went to all your scans, CT, MRI, with you. I was beside you, wearing a lead apron in the midst of the radiation. I held your hand as long as it lasted! Now, is that love or isn't it, you tell me?'

'Give over,' she says. 'Stop dicking around!' (That's a phrase she uses as a translation of an expressive Bosnian colloquialism with the same meaning.)

Thinner, in a new outfit, a blue-grey silk blouse and grey knee-length skirt, with sunglasses and a new hairdo, she went out into the sun and looked around bewildered, as though she were seeing the world for the first time.

'Look at you,' I say, 'like a Hollywood diva on her way home from rehab!'

She laughs and says: 'Melanie Griffith!'

We're on our way home from the hospital, and as we come onto George Mason Drive, she gazes at the houses along the road: 'I've never been here before! It's all unfamiliar.' Then we turn onto Columbia Pike, the street on which we lived a little more than two years ago and along which we drove to and from work. I watch her reactions, waiting for her to recognise something, anything . . . We pass a place called Rappahannock Coffee and she says: 'I came here once with Kendra!' She begins to remember. I want to believe that once she gets back to her own world, to the intimacy of her flat—and when she comes again into contact with her neighbourhood, with places where she has often been—she will remember everything. I really believe this and I'm impatient for it to happen, for her focus to return and for her finally to relax back into her own world. And the fact that she recognises a café in which she may have been only once, that she remembers she was with her friend, that she had drunk coffee (which was good!), that she had eaten a croissant, just strengthens my conviction that her memory will be quickly restored. We drive towards the Pentagon, with the panorama of Washington behind it. It's the middle of April, but the sky is as blue as summer and I'm happy to be going home on such a lovely day. For me this is an omen, and as we drive I keep saying: 'Everything's going to be all right.' I ask her: 'What can you see now?' 'The Pentagon,' she says. And the closer we get to the building where we live, her memory seems to me to be increasingly vivid. But when I stop in the car park in front of the building, she asks: 'How long have we lived here?' 'Two years.' 'I don't remember it at all! This is the first time I've seen this building!'

We have come back. I open the front door, and our flat smells of coffee.

I t's almost midnight. Harun peers into the fridge looking for something sweet. He's after a particular taste from his mother's repertoire, but what is it? He can't remember. He tries to recall what that taste reminds him of. Then he does after all remember the Mexican dessert *tres leches*. Dough that draws sweetness into itself like a sponge; something like the *patišpanja* of his childhood. *Patišpanja* is a dessert that came to Bosnia from Spain—as its name suggests—brought by the Sephardim. The taste of *tres leches* is like *patišpanja*. Midnight and *patišpanja*. All these years she has done the cooking, now it's my turn. Am I capable? It's time to give her the last medication of the day, Lipitor. I wake her, she props herself up and, half-asleep, takes her medicine, then turns onto her other side. I cover her up, saying, like a prayer: 'Darling Sanja, make us *patišpanja* . . .'

H aircut, colour; she insists on that, because she doesn't like the grey hairs that have begun to show at the edges, while I have long wanted her to let her natural hair grow. Renata came with scissors and is skilled with them; she cut Sanja's hair so that the right side is a little longer and falls naturally over her ear, while the shorter, left side is tucked behind her ear. It is even shorter at the nape, but that whole asymmetry turns out well, making her still lovelier. She had to have her hair cut shorter to make the days of recuperation easier, and we opted for a style that in normal circumstances she would never have agreed to. I'm not certain that she'll like her new haircut, but I like it. When she bathed, I used to run my fingers through her hair. I've been repeating that action for thirty-five years now: running my fingers through her hair. She resists a little, because she has a cat's

nature, while I must have a dog's because I like being touched. For thirty-five years she has fallen asleep gripping a lock of my hair in her hand. That's why I've let my hair grow long all this time, so that she can hold it while she sleeps.

It calms her to hold my hair . . . We kept moving house, the walls of our rooms kept changing, but there was always the same black-and-white photograph over the desk, taken by Mladen Pikulić way back in 1980. The photo is of Sanja with V., her friend from her youth. They're standing side by side, shoulders touching, looking at the camera. She's wearing a white summer dress. A snowflake. In a white dress that reaches almost to her ankles, Sanja is standing on the tips of her left toes, while her right foot is invisible, leaning against the wall behind her. Her right arm is raised above her head, and she's holding a lock of hair in her clenched fist. But the hair is alive, and at the moment when the photograph was taken half the lock had escaped from her hand. That is the only movement in the picture, probably only visible and crucial to me. Her need to hold onto hair is a consequence of her insecurity.

The first time I saw this photograph was in a small Sarajevo gallery, in a group exhibition, at the opening of which the then unknown punk band, Zabranjeno pušenje, provided the entertainment.

Today on the Internet I came across some scenes from a film by the young Colombian director Ciro Guerra. In one scene a Western scientist shows a photograph to the shaman of an almost completely extinct tribe; the picturesque inhabitant of the Amazon is evidently seeing a photograph for the first time in his life, and he looks at himself in the picture with interest, sees his necklace, then looks at the same object on his chest and

89

compares them. When the scientist tries to take the photograph out of his hands, the man is surprised and says: 'What are you doing?' 'I'll keep this, it's mine,' says the scientist. 'But this is me,' says the confused shaman. And then the scientist corrects him: 'This isn't you. It's a picture of you.' Two opposed concepts of possession.

I sent the link to her email address, for her to see when she gets better. The two of us weren't made for this world, because there's nothing in it we want to possess. But now I realise that we're being punished: if I'd acquired property we would have enough money for me to take her to a warmer place to sit on a bench or sunny balcony and watch the gleaming water.

A photograph gives shape to memory. When I look at my past, the way it exists in photos, it seems to me that I'm not just one, but several, perhaps even a dozen different people.

My friend Milomir Kovačević once emailed me a photograph and asked: 'Do you remember when this was?' In the picture I'm very young, I'm sitting at a table, perhaps at a literary evening, or some such event. I had never seen that photograph before, and I don't remember the year it was taken. Maybe 1984, or 1986, or 1988? In those years I used to wear a black sweater. Clothes lasted a long time, and I remember that sweater more clearly than myself in those days. I remember that Sanja bought the same sweater in white as well, as she couldn't decide on the colour. I remember their smell. And so, over time, the sweater had become less of a stranger to me than the young man in the picture.

Tonight we went with Harun to Gravelly Point, a park beside the airport, because he wanted to take photographs of planes landing at night. It was still light when we got there. He walked in front of us, looking for a suitable place for his camera, while

over his head flew a flock of butterflies, as though accompanying him. A dozen big monarchs! There should have been a photograph of them!

The monarch butterfly migrates from Mexico to Canada and then returns, but that migration takes four generations. The first generation migrates from Mexico to Texas, the third is born in Canada. The grandfather and grandchild butterflies live out their brief lives in different countries. Like those of us who are born in the Balkans.

Two weeks ago Harun arrived at one airport (Dulles), and he is leaving from another (DCA). I'm uneasy about his departure. In our lives this is an event that is constantly repeated: driving one another to the airport. There have already been too many partings. I stopped the car, we both got out for him to take his bag from the boot and for us to say goodbye. A quick embrace ('Take care of yourself!' 'You too!') and he had already vanished through the automatic door that closed behind him so that I saw my reflection in it.

And then, frozen there, gazing at the glass airport door, I was greeted by an acquaintance. He was glad to see me. I was still sad, affected by our parting, but this man was genuinely glad we had met. I recognised him, but I couldn't remember his name. We used to meet outside the Voice of America building when we both worked there. Many years had passed since then. He was a passionate reader of poetry, and at those smoking breaks we talked on the whole about poetry. Once he brought me *Recollections of Gran Apacheria* by Edward Dorn, to show me the sketches in the book and the photograph on the last page, so as to convince me that Dorn and I were so alike we could have been twins. What was his name? I endeavoured not to let him see my embarrassment. He reproached me for not getting in touch since

I left Voice of America. In the end, he grew sad and told me he had cancer. I didn't know what to say. I never know what to say when I hear tragic news. Where was he going? San Diego. I have forgotten his name, but I remember that he used to underline important passages in his books with a graphite pencil.

She forgot to give Harun a ducat; she remembered after he left. 'So, you remember that gold coin?' 'Of course I do!' I'm glad every time she remembers something recent. It means that her forgetting is not amnesia, she has lost focus, and when she is reminded of an event, an image is then awakened in her and so plucked from oblivion. She bought that ducat this year, in January I think, or February, but she had forgotten where she put it; she searched all the places where the little box with the gold coin inside might have been but didn't find it. And she said: 'Come to think of it, the ducat is something that otherwise doesn't exist. A ducat as a non-existent unit of measure. In our language a clever person would be praised with the words "all his ducats have value". The closest we got to a ducat was when a factory started producing chocolate in the shape of a coin. Did you go digging in your garden, looking for non-existent treasure? We all dug and searched for gold coins in our childhood. The ducat was a measure of value from the past, the nineteenth century presumably. And we all referred to gold ducats, without ever having actually seen one. That's why I bought that gold coin with the face of Mark Twain on it as a gift for Harun, so that a ducat would be a non-existent measure of value for him, a metaphor, as it had been for us. I put it somewhere in the house, but where? I don't know, I've been searching all morning but I can't find it. He often quotes Mark Twain on his Facebook page, the two of them were born on the same day . . .'

* * *

Varnishing her nails. I paint her nails. I'm slow and I don't move calmly from the root of the nail to the tip, I'm not exactly a skilful painter. But she doesn't object. She has small, child's hands; when her nails are painted black, they look like watermelon seeds. Today's colour is: yellow.

She exists in a child's memory. 'Once Zara, a little girl of five, saw a woman with yellow nail polish and a yellow scarf. Zara is now a grown woman and she often remembers that unusual woman with yellow nails waiting for a bus at the Huntington Terrace stop. The little girl grew up with that image . . .'

'And who's the woman with yellow nails?'

'You.'

Drawing a clock. This morning I managed to persuade her to draw a clockface: to write in the numbers and draw the hands so that she can tell what time it is. Yesterday she put the 12 and 6 in the right places, only she swapped all the numbers from the left with the ones from the right. But this morning they are all in the right places, except that she has written 9 where she should have put 3, and 3 where 9 should have been. She is still mixing up the left and right sides.

Ina, my boss from the German television station, sent flowers, a lovely bunch of tulips.

(This year in Arlington, deer have been going into gardens and eating the flowers. Not just any flowers, they are selective, and they are particularly fond of tulips. They haven't done this before, or at least, the owners of Arlington gardens don't remember it.)

Ina once wrote a text for me on a sheet of paper so that her writing could only be read in a mirror. As a child in her first year at school she wrote with her left hand; later she was taught to use her right, but she could never be dissuaded from mirror writing. The left and right sides of her brain are in perfect harmony.

93

I look at the clock Sanja has drawn on a sheet of white paper and think: if these notes about her should ever be published in a book, then the text should be printed so that the words can be read in a mirror placed next to the open pages.

How long will our process of recovery last? A telephone call from D. in Vermont. Among all the other health advice, D. says that Sanja ought to eat walnuts. 'They are good for the brain,' D says. 'It's no coincidence that the kernel of a walnut looks so like a brain!'

I brush her hair and dress her. At first I chose my own T-shirts and shirts, because they're roomier than her tops, which made it easier for me, and I confess that I liked seeing her in my clothes. But I soon discovered she has quite a rich collection of light summer dresses. I choose a new one for going out in every day. I brush her hair the way I think it should be arranged, and she doesn't object, but accepts my choice of dress for the day; she is slowly being transformed into a little girl and I into her older brother. An inversion of our ages. When we met, we were serious and old beyond our years, but then we began to grow backwards and now we are two weary, frightened children.

After an absence of three weeks, I went back to work: she stayed alone in the flat and that worried me. She began writing a diary, in which she noted small domestic events, so as not to forget them in the course of the day. And I want to believe that this is one of the ways that her new memory can begin to be formed. She's alone at home, and I'm anxious and keep going out to get coffee. Over the entrance to the building where I work, they've installed a closed-circuit camera. Inside, in the corridor, is a small flat monitor whose screen shows the pavement outside

the entrance from a bird's-eye perspective. As I come back from the café I open the door and take a few steps towards the screen and always see myself in front of the building, opening the door and coming in. That's because the image onscreen is delayed by a full eight seconds. We don't know why. But always when I come back in, I hurry to the screen so as to observe my entrance into the building more carefully. And I see it with a child's interest, because it's pleasing to see oneself in a past that's only eight seconds old and hasn't yet become a memory.

At midnight, my left arm goes numb, it must be a new heart attack. So now what? I get out of bed carefully so as not to wake Sanja. It's really not good. It's not the right time for an infarction. The arm's quite numb. I search in my bag for the nitroglycerine tablet I carry in case my heart seizes up like this; it should help for a while. I put the little bottle with the tablet in front of me on the desk. Then I open the unfinished texts on my computer, intending to email them to Harun, to protect them from the chaos of multiple versions, so that in the future no one will mistakenly print texts I wasn't yet happy with. These small tasks soothe me, although my arm is increasingly stiff. I open the piece I've been working on for months now, correct one or two typos, alter the occasional sentence, and then add a whole new fragment. When I've finished, I read through what I have written and I am satisfied and that stimulates my desire to write. I stay awake until morning, making notes. And at daybreak I fill the kettle with water for our first coffee. Outside it's drizzling.

They say that troubles never come singly; other, smaller or greater problems graft themselves onto them. And that is indeed the case. Of all the additional troubles that have occurred over recent days, the one that most disturbs me is the car alarm,

because it has suddenly begun to go on and off of its own accord, bothering people around us. It happens unexpectedly, sometimes after midnight, or early in the morning. There's no logic to the activation of the alarm. Our car is a Ford Taurus, made in 2002, and on the Internet I found that the unusual behaviour of the alarm was a factory fault. That happens with American cars; in a culture founded on a quick profit, cars are built with cheap components, so as to save on their production and produce the maximum profit. In any case, the alarm goes off uncontrollably and this causes me a significant problem. I wake easily and dash down to turn it off, and then come slowly back up the stairs. Sometimes it happens that on my way back I hear it again, so I go back down. Horrible! I have begun to be afraid of our Taurus. Today I fell asleep from tiredness, and now her voice summons me from sleep: 'Wake up, Sem, the car's whistling again!'

Sanja's stroke occurred in the English language. In these notes I translate the whole event into an isolated, fairly remote language (spoken by a relatively small number of people, so that I can imagine its future disappearance). Some details are not translatable. Our isolation is seen most clearly in the empty space between the two languages. But that empty space is the same as forgetting.

At work, at lunch break, I go up to the roof with my salad, I sit in the shade of a large satellite disk, and at the level of my gaze there's a placard proclaiming BLUES ALLEY. It's a jazz bar where I used to go in 1996 and 1997, twenty years ago. I was working at Voice of America then. And I used always to go there after midnight, when my night shift finished. The music would have stopped, the guests were dispersing, the musicians packing up their instruments. I used to go there because of a delusion:

under the blue light of the bar, at the end of the day, I could be one of them, musicians, free night birds, and not a bewildered immigrant. I haven't been there for nearly twenty years. But now almost every day, if it isn't too cold or wet, I sit on the roof just after midday, opposite the bar. It's a narrow alley and if I were to stretch, I could reach the white board inscribed blues alley. All my past is here, just across the road and within reach. If I were to launch myself properly, I would be able to jump into it from this roof.

After two months of not setting foot in a bookshop, we went to Barnes & Noble. Two months without the aroma of books. She walked behind me explaining: 'There's nothing in this shop. They only have books that sell well here.' She was right, but I needed to breathe in the smell of paper, for it to restore my balance, and I wanted to buy Don DeLillo's new novel (*Zero K*, that went on sale yesterday). I easily found the book on the shelf, but the design and layout of the text put me off. I'd find it tiring to read. That happens to me with certain books; they are made ineptly so that they become unattractive objects. I'd like to read the new novel, but my eyes resist it. We went out as warm rain began to fall. It moistened the body agreeably. It was too hot in the car, the windows misted up from inside. As we were leaving the car park a motorbike materialised right in front of us, with a woman hugging the driver round the waist. Two old people, in fact. When the rider appeared in front of us he was so close that I first saw his frightened face and heard him scream. It was only thanks to that scream that I instinctively trod on the brake, they passed in front of us, and I paused for a few seconds before we went on. I watched them in front of us; he seemed confused and kept changing lanes uncontrollably, so I skirted carefully round him and continued. Sanja kept saying, the whole time: 'Drive

carefully! Please, drive carefully!' She thinks there's something wrong with my concentration. And she's probably right. When the bike had disappeared from my rearview mirror, she said: 'The woman on the motorbike wasn't wearing a helmet.' (That's against the law in the States.) She's become very perceptive.

This morning I'm driving to work, the roads are empty, but at the turning for the Pentagon I'm joined by a group of bikers. I drive with them escorting me. I'm alone on the road with the bikers, each one with the American flag sewn onto the back of his jackets or jeans. In Rosslyn, they turn onto Route 66, towards the airport, while I carry on over Key Bridge, my Taurus the only car on the bridge, its electronics faulty, the green digital numbers on the dashboard saying it's 9:45 in the morning, while my phone says 7:25. I enter Georgetown, go down into the garage, where there are a few cars, and I emerge from underground back into a cloudy morning. The board under the inscription BLUES ALLEY is not displaying the name of a musician, which means there's no concert tonight. I go into our building: darkness, there's no one around. I switch on the computers and check our monthly timetable because I believe I'll find the answer there. And here it is: today's Memorial Day. I should have remembered that as I drove with the bikers. I would have known if I'd taken any notice of the news over the weekend. But I've been routinely repeating actions in which my consciousness participates only superficially. My reality is her paralysed arm. Time is measured by the short intervals between her medications. I'm so close to her that forgetfulness settles on me like a narcotic.

I have tamed the alarm by no longer locking the car. I've discovered that for some reason unlocking the door confuses it. The car doesn't recognise my key, so it thinks I'm a thief and the

alarm goes off. We got the Taurus as a gift from Kendra a year ago. When she offered us her old car, I was hesitant, because I didn't like the look of it. I remembered that at the turn of the century, the American auto industry was dominated by a fairly unappealing design; all vehicles were a bit egg-shaped, while the Ford Taurus, with its rounded and curved body, stood out particularly for its ugliness. Had anyone then offered me a new one, I would certainly not have taken it. I wouldn't now either, in all probability, but we've needed a car since we moved to a building some distance from an underground station, and getting to work without a car would mean changing my means of transport three times. I accepted the gift. I always give my cars names, and when Sanja asked me: 'What's it called?' I said, with a smile: 'Corto Maltese!' But I think that I only really accepted the car after she became ill, because everything would have been much harder without transport. This morning we went to buy fruit. On our way back we went down to the shop's garage in the lift, with our bags of blackcurrants and strawberries. When the door opened, among a dozen nondescript cars of various colours I caught sight of our Taurus. And it looked good! Among all the others, it looked to me convincingly better-looking.

I've been interested in memory loss for quite a long time, and last year, my cardiologist explained that forgetfulness is one of the side effects of the medication I've been taking for years now. Soon after seeing him, I went to Arizona to revisit, twenty years on, our first American address in Phoenix. And I wrote a diary during that journey in which I tried to discover the extent of my forgetting. Fear of forgetting became an obsession with me some time ago, so this loss of Sanja's was more than pure coincidence. The question I kept asking myself in the solitude of the hospital room was: Does our obsessive preoccupation with certain subjects

mean that we influence events ourselves, or do we unconsciously recall our near future, so that the memory expresses a deeper interest in problems we have yet to encounter? Did I influence what happened to Sanja, or have I been remembering it for some time already as an event that had yet to come?

Here's another brief memory in connection with our first address, as a contribution to the theme of forgetting. Some time ago Harun wrote the screenplay for a film that opens with a violent war scene in which a girl is injured and her man killed. The consequence of her injury is amnesia. She does not remember anything. The Red Cross discovers that her husband is in fact still alive, because they find his name and a new address on their lists. She goes there, although she has already forgotten everything connected with him, she can't even remember what he looks like. The man she is going to meet turns out to be the man who killed her husband and then used his personal documents to leave the country under a false identity. And the place of their meeting is Phoenix, that first American address of ours.

When Harun and I turned up last year in front of our old flat in Phoenix, nothing happened, not a single sign that the place recognised us. Not only people, but places too can experience amnesia.

I had decided to take Sanja to Blues Alley on Friday, to hear Arturo Sandoval. I thought it was time for us to begin participating in events, so that she'd have things to remember. But it was too ambitious a plan. This morning (it's Friday) she woke tired and out of sorts, with a pain in her right arm, and she didn't want to leave the house. After work, I went out of the back door into Blues Alley. It was raining on and off, and in front of the bar Arturo Sandoval was standing, alone and lost in thought, in a blue

linen jacket, holding a Cohiba between his fingers, occasionally glancing at the sky and puffing out thick smoke. I wanted to talk to him, but I couldn't think what to say so I walked past him, continued along Wisconsin Avenue, and went into the underground garage. I had two tickets for the concert in my pocket. I checked that I hadn't lost them along the way, still hoping that the pain in her arm had eased.

Since her stroke, her perception has sharpened: she sees the patterns and anomalies around her more clearly, the logic and illogicality of phenomena. I bring her cherries.

'Americans don't make a distinction between sweet and sour cherries, they're all "cherries" to them. Whereas we have "*višnja*" (morello cherry) and "*trešnja*" (sweet cherry). Did you have any little girls in your school called Višnja? We had several in my school. But not a single Trešnja. We had an expression: "If the *višnja* was like the *trešnja*", implying that the latter was better and nicer than the former, and yet little girls were named after the sour cherry, not the sweet. That must be because of the energy of the words, because, as far as I'm concerned a watermelon, "*lubenica*", is tastier than either kind of cherry, but it seems unnatural to call a girl Lubenica. I don't like my own name, Sanja, I never accepted it, it's not me. I'd prefer to be called Višnja. Or Dunja (melon). Of all the fruits, the nicest girl's name is Dunja. You come across Malina (raspberry), but you'd never find a girl called Kupina (blackberry). And, now, think about it, in our language not a single fruit or plant is masculine. Apart from *jasen* (ash tree), if the name Jasenko comes from *jasen*. No, I tell a lie! There's also Jasmin, after the flower. And maybe there is some other name that comes from a plant, which I've forgotten, since the stroke . . . There's the girl's name Jelka (fir tree), but there isn't a single man called Bor (pine), although that would be a good name.'

We buy cherries every other day. Even in our childhood they weren't this tasty. This is the year of the cherry.

'Actually,' said Sanja, 'where did you get your name?' 'From my cousin, Semezdin. In April 1992, my uncle Rizo, Semezdin's father, phoned me in Sarajevo from Tuzla and said: "You write for the papers . . . You should know that everything you write will one day be used against you." He was asking me to be careful what I said, because in a war people can die because of the wrong word. "Be careful!" he repeated several times. That was an unusual conversation at the beginning of the war. And at the end I asked him about the origin of my name. It's after a Circassian, he said. A Circassian who lived in Bijeljina, in northeast Bosnia. He was a musician and a convivial man, whose forebears had been exiled by the Russians from the eastern shore of the Black Sea, from a place called Semez. So, the name came from the Circassian's nostalgia for the place of his birth. I like this little theory about the name and I'd like to believe it, but I haven't been able to find any reference in books to a place of that name on the shore of the Black Sea, so I have to take my uncle's explanation with a pinch of salt.'

She watches the same film every day. Her taste for repetition is nothing new, that's how she's been since the late nineteen-eighties, when she began reading just one book, Thomas Mann's *The Magic Mountain*. Over the last decade, she has watched *Pride and Prejudice* in all its film versions. She explains frankly: she is drawn to a world that exists only in costume drama. 'I'm only interested in a world where there are no telegraph poles.'

'What are you going to do today?' 'I'll watch my film . . . Don't laugh. I think that's a virtue. People easily lose interest in things,

they treat each other like novelties and quickly get bored with them. I'm devoted to my film. I'm true to my choices.'

The film she watches obsessively is about a pair of ice-skaters; the images of snow and ice appeal to her, because as a result of the stroke, the right side of her body, especially her right arm, is prone to waves of heat. And whenever she watches it, the film functions as air-conditioning.

'It's as though I'm dreaming everything I see . . .' That's always her first sentence when we go outside. 'I'm not sure whether what I'm seeing is really real. Or am I imagining it? I keep thinking this is a dream, that I'll wake up and everything will be as it was before.'

She doesn't remember. She knows that she's had a stroke, because she keeps being told, and she knows because of the aftereffects (pressure in the right side of her body). Nevertheless, she has trouble believing it really happened to her, because she doesn't remember the event itself. She keeps experiencing that state when we wake in the morning and try in vain to recall a dream of the night before. Or the other way round, as though everything is a dream from which she will wake at any moment. As though she's imprisoned in someone else's dream.

Last Saturday at the swimming pool, I was sitting at a table under a sunshade. Sanja was in the water; I heard her voice and thought she was calling me. I sat up straight, came out of the shade, and saw her arguing with a swimmer who was saying: 'This is a swimming pool!' 'Yes, it is, but it's not just yours!' And I went over to the edge of the pool: 'What's going on?' 'Nothing,' she said. 'This man splashes too much when he's swimming.' I lowered myself carefully into the water, although I didn't really

feel like swimming. The man straightened up, pushed his swimming goggles onto the top of his head, and looked at me, and I was close enough to see on his shoulder the tattoo of a hand with a raised middle finger. A rebellious message to the world. The tattoo explained his arrogant attitude to Sanja as well. He was showing the whole world, including me as I swam towards him, a tattooed middle finger. An old-fashioned tattoo the colour of pale indigo, a threatening sign drawn on the skin with a needle. I hadn't quite reached him when he turned and waddled off to the edge of the pool, leapt energetically out, sprinkling water all around him, and went back to his recliner. 'Look at him! Running away with his tail between his legs,' she said. But I had gone simply to calm her and to protect her with my body from the water others splashed about. She watched him victoriously as he left, and that flattered my male pride.

And this evening, as we crossed the car park, a couple passed us. Tanned, they were smoking as they left the pool. He was the young man with the tattoo, giving the world the finger. The slight aroma of tobacco hung in the air as they went. Sanja stopped, turned, and watched them walk away. She closed her eyes, trying to remember, or simply to smell the smoke in the air. Then she came to and followed me.

She's a real little girl! We're at the swimming pool, and she's lying on her front on a recliner, watching a column of ants moving along the crack between two cement blocks. She has blocked their passage with a finger and waits to see whether they'll start climbing up her hand. But the ants make a detour in an arc round her finger. And I say: 'You know, Jules Renard has a very short story about ants, shall I tell you it?' 'Go on.' 'He says that every ant looks like the figure 3. And how many there are! 3 3 3 3 3 3 3 3 3 3 3 3 3 3 3 3 3 3 3 . . . to infinity . . .' She

says nothing. And I don't know whether she likes my version of Renard's story. She's usually talkative, but sometimes (and ever more frequently) she closes herself up completely and then there's no way I can get her to speak.

After my heart attack (November 2010), the doctor said I had 'survived this time', but if I had to come to him again, I wouldn't leave the hospital. He explained that there were five things I must give up, counting them all out on the fingers of his left hand: 1. cigarettes, 2. cigarettes, 3. cigarettes, 4. cigarettes, 5. cigarettes. Sanja took his explanation literally, and I had no choice, I had to stop smoking. Four years later, at Ivica Puljić's flat, I lit a cigarette on the balcony and puffed a bit; it was a delightful, cheerful gathering, with a lot of dear and interesting people, but then Sanja caught sight of me in a cloud of smoke and went berserk, shouting at me and bursting into tears. It was midnight and she rushed outside and I followed her and our friends were left in shock. In the morning they called to apologise, as though they were to blame for my lighting up.

Last month, Obama was in Cuba, and my colleagues went there to report on the historic visit of the American president. When they were preparing for the journey, H. asked what they should bring me and I said, a Cohiba. I said that without thinking, mainly to give her an impossible task, because Cuban cigars still could not be brought across the American border. But, at some risk, travelling in the group of journalists accompanying Obama, H. brought out a wooden box of twenty-five Cohibas. I don't know whose pleasure was greater, mine when I was given them or hers because she had been able to smuggle them for me. When I came home with the box, Sanja dug in her heels: what's this, was I going to start smoking again? Of course not, these are cigars, you just puff on them, you don't inhale and they aren't

dangerous. Out of the question! And I said: OK, the box is just for decoration, I'll give the cigars to friends, until they're all gone. Nevertheless, she kept a close eye on the box, secretly opening it and counting the cigars, while I would take one in the morning in a little ziplock bag, justifying myself by saying it was a gift for Ivica or Asim or Santiago; at the end of the day, she would sniff me to check whether I smelled of tobacco.

Every time I use the word 'puff', I think of Mirko Kovać. He never smoked, he told me, he simply didn't like the smell of tobacco smoke. But once, in a Moscow hotel, his friend, a film director, opened a box of cigars in front of him that were specially made in Cuba for the Yugoslav president. There was a gold ring round each cigar, with TITO inscribed on it. 'I had to try one, to see what a cigar called Tito tasted like! But I didn't know that cigars should be puffed, that their smoke should not be inhaled. I took three drags and passed out.'

Ever since we came home from the hospital, she has been glancing suspiciously at the wooden box, unable to remember how the Cuban cigars came to be on my desk. Nor does she remember her fears. She opened the box and established that the remaining cigars were drying in the air of the room and said: 'Maybe we should put a couple of cabbage leaves in the box . . .' (In our country dry tobacco used to be 'refreshed' with a green cabbage leaf.)

I am reminded of September 4, 2012, when I was in Zagreb and met up with Kovać, who was unwell and was supposed to go for some hospital tests the next day. Over dinner in a restaurant, he tried out a new subject for his writing on his companions. He spoke about his experience of being ill and of hospitals, because his 'new reality' had produced quite unique images that he would like to describe. 'In hospital,' he said, 'in the oncology department,

I watched two amorous patients, a man and a woman, kissing passionately, while their metal oxygen bottles knocked into each other, clanging . . .'

She's always sad when she remembers her youth. Today, we were on our way to a restaurant and the radio was playing a song from the eighties ('Every Breath You Take') and she burst into tears. When she calmed down, she said: 'Were gramophone records at home called *sound carriers*?' She remembers language.

We live a lonely life; we have few friends here, they can be counted on the fingers of one hand. They sometimes come to see us. Today Sanja's American friend Kendra came out of the lift at the same moment as I opened the door of our flat to wait for her, but the distance between us was great (it's a long way from the lift to our door, the corridor is straight and infinite), and I waved to her, but I was too far away and she gave no sign that she'd seen me. That's our corridor. She walked for a long time from the lift to our door, and when she was quite close I saw that she was carrying flowers in a small pot, very elegant white calla lilies.

Sanja doesn't like being given flowers that aren't in pots. She calls flowers that have had their stems cut before being put into a vase 'ripped'. Dead flowers. When she gives flowers, they're always in a pot, with their roots in soil and instructions for watering them. That's how it's always been, as long as I've known her. 'It's impolite to give dead flowers to sick people. Imagine expressing care, or love, or friendship by giving one another dead birds!'

In the building opposite us there are three young Arabs on the balcony. This is the third night they've been carousing until morning. They have two hookahs on the table in front of them

and talk loudly, laughing and singing. They must have just arrived in this country and don't know nighttime rules—there's no loud singing on balconies here. I hadn't been listening to them but to Sanja's breathing; if they woke her, I was thinking of calling the police. Although I hoped someone else would do that for me, because when the police came and took their names, they would no doubt arrest them as terrorists. And then I heard a police car under their balcony and now they've settled down. I've just been watching them through the window: bare to the waist, they smoke and converse quite quietly, maybe they sing in a whisper, while their gestures suggest that they're rappers . . .

There's always an excess of bread in the house. Sanja makes it into croutons for my salad, but there's still more than we need. That's because of our wartime hunger. There has to be enough food in the house, just in case. When I take the leftover bread towards the rubbish bin, she objects: 'You mustn't throw bread away!' She never throws it away: she crumbles it for the birds. And now I'm tossing them crumbs instead of her. This evening, I say, I didn't see any birds gathering to eat them, just squirrels and dogs being walked by their owners. And she says: 'That's fine, all animals are birds when they eat crumbs.'

She sleeps, and when she wakes, she gets up and goes to the fridge. This hunger dates from her hospital days. And it already shows on her body: she's put on weight. I made a short video lasting ten seconds on my phone, and showed it to her cautiously. She waved me away: 'Cameras add eight kilos.' When was the last time I heard that! People used to say it in the nineteen-sixties and seventies, when the only cameras were for television. Through their lenses the human body weighed eight kilos more than in reality, I don't know according to what scales.

If I suggest she's eating something she shouldn't, it distresses her and she says: 'You're torturing me with hunger.' And then I haven't the heart . . .

'Do you remember when you fed the birds at the pond in the garden of the building where you worked?' I ask her. 'Yes, but I didn't know they were migratory birds. They got fat and they couldn't fly south.'

S he refuses to go out and constantly looks for an excuse to go back to bed.

'It's time to sleep. I've always been interested in that state of hibernation when you are neither alive nor dead. Then the brain switches off and rests. The brain is a creature that lives in us. I know that's not biologically correct, but I find it interesting to think like that. And sleep is always agreeable. Sometimes it isn't, because of nightmares, but far more often it is, because if that weren't the case we'd probably have great resistance to abandoning ourselves to a state in which our consciousness is switched off, and we're closest to death. If dying was the same as falling asleep, perhaps people would be nicer to each other and there would be fewer problems in our lives. Because life could be good and simple if people didn't complicate it for each other. And the number of heart attacks and strokes would diminish . . .'

W e spend a lot of time remembering the past; that's how we check how much of everything we've forgotten. We keep making lists, remembering important books, songs, or films. 'I remember that before New Year's we went to a little cinema to see *Pride and Prejudice*. It was sunny when we went in, and when we came out it was snowing!' she said. I remember that snow as well.

Some ten years have passed since then.

We have plenty of time, so that every day we revive our memories of the same events. And there always comes a moment when she asks me to tell her which of our acquaintances has died. I don't like that question, because I know how upsetting my answers will be; many of those closest to us have died in recent years. Every day I alter my replies, so as to make them less stressful, but that doesn't help much. Over and over again, with the same intensity, she hears the news of the same deaths. I'm afraid that this multiplication of events, like the reflections of the human body in two mirrors placed opposite each other, will be completely devastating for her. Every day, as though for the first time, she learns the news of the death of other people. I've thought of stopping mentioning the dead. But if I start concealing the past, she won't forgive me when she does eventually remember everything. And I believe that she will emerge from her forgetfulness, as one emerges from a dark cinema into the light of a lively city street.

'We've both had *attacks*,' she says. 'Harun is a child with *attacked* parents.'

On Saturday, we were at the swimming pool, lying on recliners and blinking in the shade of a small tree. When the wind bent the branches, they came close to our faces. We looked up into the canopy with its small green leaves, the sun at times flashing through them. We lay there. The leaves rustled, the water murmured. And then she said: 'I've always liked looking at the sun through branches like this. When I was at nursery, there were acacia trees in the garden. Now it's as though I was in fact looking through the leaves of those acacias. What's this tree called?' 'I don't know.' 'When we were children we used to eat the blossom.'

I took a short video on my phone of the living leaves above us, lasting about twenty seconds, and then slowly moved the phone towards her, filming her face briefly, three or four seconds, and stopping. Then I showed her the video. As far as we could see on the screen in the reflected daylight, the little film seemed nice. When we got home and I looked at it carefully, I saw that I had stopped recording at the moment when she turned her face towards me. Oh, that look haunts me now. Such an expression of bliss, reconciliation, and absence of vanity, such a lack of interest in posing, and such a withdrawal from everything . . . Melancholy, but beautiful! We stayed at the pool for two hours and she was glad we were there, even though the water was cold; she had gone to the edge of the pool with great enthusiasm, but after dipping her toe in, she gave up on the idea of swimming. Earlier too, when we were on the way to the pool, she was quite happy: 'I feel more natural in the water. Water is my closest element. Maybe some forebear of mine was a mermaid!' I thought she was happy. But then the cold lens of the telephone camera revealed the look in her eyes . . . How to console a person with such a look?

Sometimes, when she's cheerful like today, she says that her forgetfulness is not a problem, or is a lesser problem than the pressure she feels in her right arm.

'I don't think there have been such important events in my life that I should remember them. Besides, we don't even remember our birth, and that ought to be one of the most crucial events. If only my arm would stop hurting. Forgetting doesn't hurt . . .'

Questions we repeat every morning. 'What day is it today?' 'Which year?' 'What month is this?' Outside the wind says Juuuuuuuune.

* * *

111

She opens up pages on the Internet randomly, researching what she's forgotten and what she still remembers. She tires quickly because of problems with her sight; sometimes what she reads disturbs her, and sometimes she's pleased with what she finds. In an online dictionary she finds the word '*labrnja*', laughing at the sound of the word and its meaning. *Labrnja*: the space for the teeth. 'In Bosnia men used to tell women to "shut their *labrnja*!" Imagine that: shut the space for your teeth!'

Otherwise, recently she has tended to divide the world into men's and women's, and she defends her gender. She was looking at some photographs from the end of the nineteenth or early twentieth century and said: 'This isn't female one-upmanship, but look for yourself at male history! Just look at the models of beards and moustaches. How much time has passed since the moustache of Franz Joseph was in fashion? An emperor, with something like this on his face [she tapped the screen of her iPad], sideburns and moustache joined together in an unsuccessful bird's nest! It would be a mercy to shave it off. [She used the expression '*štucovati*', a word from the German *stutzen*, meaning 'cut very short', that had reached us with the Emperor Franz Joseph.] We should go through time, since the beginning of the world, cutting all beards and moustaches very short.'

There's a squirrel in the tree above our recliners at the swimming pool. We watch it, and it seems to me that it's looking at us too. And Sanja says: 'It's possible that the molecules of water in that squirrel were once in the body of Leonardo da Vinci!'

She said she fancied pomegranate seeds, so I went to the shopping mall and bought six large pomegranates. When I brought them home, she said: 'That's too many. Who could eat all those? And they're already overripe . . .' She didn't go near

them for two days, but today she cut one open. How easily the rind broke! And the bright sun in our room illuminated the perfectly red seeds in the freshly opened fruit. 'Oh, God was pretty inspired when he created the pomegranate. He had a good day!' She scooped out the seeds and went on: 'It's completely illogical for God to be male, since males don't give birth. Religion is proof that there's a lie at the heart of the male imagination. The pomegranate could only have been invented by an architect of the female gender. An architectress.'

She talked and talked. I broke in during the brief pauses between her sentences, repeating: 'I know, I know.' And she said: 'I know you know, but I have to say something.'

Today she's teaching me to cook. We bump into each other by the cooker, fight over the space that used to be exclusively hers, and is now a little bit mine. She says: 'It's only in *sogan dolma* that onion is treated with some dignity. Mostly it is chopped into a dish and so becomes an important ingredient. It's *only in* sogan dolma that the whole architecture of the dish is based on it, on its form . . .' I follow her instructions obediently. She looks at the picturesque glass containers she has filled with herbs and spices, whose aromas she is now re-discovering. She holds a dry, grey-green leaf on her open palm and as though she were remembering everything, says: 'I always liked dishes that included a bay leaf . . .'

She starts cooking. She's making butter biscuits. She's got flour even on her socks.

I take food she has prepared for me to work, mostly salads, but she never cuts the vegetables completely (so they won't lose their freshness), I have to do that later, and so along with the container of food, she adds a knife to the bag, metal, but

coloured orange, so that at first glance it appears to be plastic. It's very sharp. Last year on my way to Boston I passed through the body scanner at the airport, turned round to wait for my luggage, and saw on the screen in front of the security officer the inside of my carry-on and in it my knife! Several officers in blue shirts came running up to me, and I said: 'That's for salad!' They explained agreeably that I couldn't get onto the plane with it and had two options: throw the knife into the rubbish bin, or post it to my home address. They gave me a FedEx envelope, I filled in everything I had to, put the knife in, sealed it, and handed it to the official. From the plane I phoned Sanja to tell her what had happened and she said: 'It's a good thing you didn't end up in jail!' And she said we shouldn't open the envelope when it arrived. We should keep it as an art object or a time capsule.

The day before I brought her back from the hospital, I called in at the flat to prepare for her arrival: I washed, dusted, and vacuumed. Behind the sofa I saw a miniature spider, a spiderling, so small it wouldn't have been able to survive my touch. I left it to weave its slender threads. Two weeks have passed since then, Sanja has just woken up on the sofa, and there's the red trace of a spider bite on her forehead! She's still allergic to them. And that's the rule in our relationship. In the end everything that occurs is my fault.

No one visits us anymore. I hadn't thought about that before, but it's clear to me now: people are afraid of a sick person.

One of her most frequent questions: 'How did Harun take all of this?' I tell her he was here for ten days in April. I'm used to her question, and have a prepared answer, which always surprises her because she has forgotten everything. And then she repeats

the same question: 'And did he hug me when he came?' She asks this with such seriousness and waits for my answer with such concentration, as though a hug were a precise test of a son's love.

Our son and his photographs. When we moved into this flat, she chose four of his photos and had them framed. I had my own suggestions, but she immediately rejected them, because their subjects didn't bring 'healthy energy' into the room. For instance, my favourite photograph of Harun's is of a girl in red beside a large fire. Sanja hesitated, but then confessed that she didn't want to 'hang a fire' on the wall of our room. Opposite our bed is a photograph of a girl sitting on the edge of a tall building: her bare feet hang in the air, and below her is Route 66 and a green traffic sign displaying the turnings for Pentagon City, Crystal City, and Alexandria. The river intersects with the road, and you can see all the bridges apart from Key Bridge, and in the distance, the tower of the airport (DCA). For the last twenty years, this is the way I have driven to work. How often have I turned at this very crossroads towards Alexandria! How often have I crossed each of these bridges, at all hours of the day and in all seasons. No space in the world is so imprinted in my body as this panorama, which I see, spread out, from my bed. Before, when I looked at the photograph, I used to pay attention to the depth of the image and the familiar roads, but now I'm disturbed by the girl sitting on the edge of the high building in Rosslyn. Her face is covered with her hair. She's wearing a dress (a wedding dress?) that is probably white, but because of the morning (or evening?) light, it has a violet tinge. I hadn't thought of this till now, but that girl could have been Sanja in her late twenties or early thirties. It's quite possible that she identified with her, and that's why she chose this photograph and put it in a prominent place, so that she sees it every day before she drifts off to sleep.

She didn't want the picture of the girl beside the fire (for fear of its dubious 'energy' in the room), but she chose a girl sitting on the rim of an abyss. What was it she had relinquished?

'I don't feel like going back to my job. I studied philosophy, but it didn't get me anywhere. I did tedious, bureaucratic work. Now I'd like to change my profession.'

'What would you like to do now?

'I'd like to look after dragons. I know dragons don't exist, but one can be a keeper of creatures from stories. They too need protection.'

After a visit to the doctor, we stopped by Starbucks at Bailey's Crossroads. We used to go there sometimes, in the days when we lived near the café, which is frequented mostly by immigrants from Africa. I watched Sanja stop in front of the door of the women's toilet, which was, it turned out, locked, so she waited patiently. She always does this: first she goes to wash her hands, as though it were a religious ritual. After a minute or two, the door opened and I saw a girl coming out, she could have been nineteen or twenty; immediately after her a young man emerged as well. It's not exactly a frequent phenomenon here, in puritan America, to see a man coming out of a space intended only for women. Sanja turned to me, spread her hands, and smiled. There was a smile on the girl's face as well, but it expressed her embarrassment, in fact shame, because she'd been caught in an act that wasn't publicly approved, and as though she felt a need to hide, she went over to the newspaper stand and stared at the photograph on the front page of the *New York Times*; the young man followed her and they quickly slipped out of the café. The lovers were young Arabs (the girl's face was framed in a grey silk scarf).

After that, we drank our coffee, laughing, and didn't mention the event that had caused this gaiety. 'It's all going to be all right,' I said. Everything will be good. And from time to time I turned towards the newspaper stand and looked at the photograph on the front page of the *New York Times*.

It was a photo of a rickety bridge made of old rough boards, in a gentle arc over a stream, the tributary of a river or sea, with tropical marsh plants growing beside it. In the foreground sat a three-year-old girl in a light-grey sleeveless top and trousers of the same colour, her feet apart, her knees touching, so that her whole little child's body formed the shape of an X. Her little fingers were fiddling with a small orange flower, which she was looking at as though she was hiding and was clearly uncomfortable about being photographed. The bridge led to a house without a door, and a white cat with black ears and black tail (its back turned to the camera lens) had stopped in the middle of the bridge and turned to look at the child. There was something inconsolable in the pose of the little girl and in the cat's turning. (The caption under the photo read, 'Resettling the First American "Climate Refugees".')

She has begun to read, she says she must inform herself about world events, but problems with her sight slow her down, she can't stay long at the computer screen and she's irritable. She reads the news on the Internet, then says: 'It says *in the paper . . .*'

Until this evening I didn't know that she really was keeping up with the daily news. We had just watched a film (*The Magic of Ordinary Days*, a Hallmark love story from the Second World War), in which there were images of an internment camp with Japanese prisoners who were in fact born here, so they were Americans, most of whom had never seen Japan, and whose only 'sin' was their ethnic origin. And, as we watched those scenes,

117

she said: 'If Trump wins the election, they'll set up camps for Muslims here!'

We are accompanied by what is perhaps an unfounded fear. In the autumn and winter of 2001, Muslims here were suspected, followed, and arrested. Once, we were coming back from shopping and saw several police cars, their doors open, in front of the entrance to our building, and we heard the crackling noise of their walkie-talkies, and Sanja said: 'They've come for us!' We stood on the opposite side of the road, with plastic bags in our hands as dusk fell, watching the red revolving lights floating above the police cars, and she said again: 'They've come for us!'

She says she slept badly last night, because a 'talkative family of cicadas' had moved in under our window. ('Are cicadas also illegal immigrants in this country?')

The hospital invoices are arriving. At the end of the day, I went down to our post box on the ground floor. On my way back, I returned along the lengthy corridor and heard footsteps behind me. I turned round, but there was no one there. I went on walking and listening to the sound of my own footsteps, convinced that a moment before I had perhaps heard myself, my own trudging, and mistakenly believed that someone was following me. But then the footsteps started again, along with muffled panting, as though I was being followed by someone accompanied by a dog; I turned round, but there was no one, just the empty corridor as far as the eye could see. In our building there are more dogs than people. As far as noise goes, this building is a real zoo. I had just unlocked the door and entered our flat when the footsteps stopped. I'd like to believe I was imagining the sounds because of my physical and mental exhaustion. ('Who is the third who walks always beside you?' T. S. Eliot)

* * *

'I can't take it anymore, I'm tired, I just want to go and be with my grandmas and grandpas, with Mensur and Muzafa, with Ibrahim and Fikreta!' (Those are the names of our dead . . .) This isn't the ordinary loneliness of one who has been left with no one to talk to or without the closeness of another person, another body; it isn't the isolation of Robinson Crusoe. It is, I fear, the isolation in which the dead are more real than the living.

I am gradually discovering that her forgetting is deeper than I had realized and her memory is fairly selective. It seems to me that she has forgotten everything apart from her fears.

When we left the hospital, I had hoped that as soon as she was surrounded by familiar objects, she'd start to remember. In addition, I was absolutely sure that she'd now begin to recall new events, and that this would begin to build her new memory. When she was surrounded by familiar faces, I thought, we'll conquer her forgetfulness. But that didn't happen. Familiar faces no longer calm her. 'They remember me while I was in hospital, but I don't remember that. Everyone else now knows more about my life than I do. I'm a stranger to myself. I'm Camus' *Outsider*.'

It's clear that the state of her right arm has worsened, the sensitivity of her hand has been reduced so that she often burns herself on the gas flame when she's cooking, or she cuts herself, which is a serious problem, because she's taking blood thinners, which make the healing process more difficult. Today I told her: 'It's hard to stop our bleeding.' I talk about her in the plural, instead of saying *she* I say *we*. I have identified myself with her state. Yesterday I bought two boxes of plasters of various sizes. The pressure in her arm is sometimes so powerful that she gives up on everything. My care, even my presence in the same room

now bothers her. I go to my desk, but she follows me almost immediately, because she thinks I'm angry, and asks: 'Would you like me to make you some tea?' And that shatters me.

Earlier ('before the stroke') she defended her right to solitude, and would go to the bedroom after dinner and watch her films on her own. When I chided her for that, she'd say she had a 'cat's nature', solitary . . . But now she's sociable; if I go away, if I'm at my desk, writing, she invents little diversions to encourage me to talk. She's forgotten many events from the past, and now she's discovering the world all over again and showing a child's curiosity about it. 'May I ask you something?' 'Of course.' 'What do you think about Jesus?' That's the kind of unexpected question she starts a conversation with. She asks: 'What do you think about butterflies? I think they're beautiful, but they frighten me when I see them up close . . .' She's become highly entertaining company.

A hot day, extremely humid. We set off to buy coffee filters. It's getting dark, the heat isn't easing. And before we parted company in the car park, because I'm irritable in this heat, she said: 'You go and sniff books, do something for your soul!' She went to get the filters, while I went into a bookshop and bought a book: Jean-Dominique Bauby's *The Diving Bell and the Butterfly*, made into a fine film I saw about ten years ago, and the time has come now for me to read it. It's about a man who's paralysed, after experiencing 'a massive stroke'.

There was no sign of Sanja, so I went to help her with the shopping. I caught sight of her in the fruit section. I keep reliving the moment of our *meeting*. I remember, it was thirty years ago now, I was looking out the window of my student room at number 2 Franjo Rački Street, and—there she was!—she was

turning out of Wilson Walk towards my window, her hair was wet from bathing . . . It must be that serotonin or some other neurotransmitter in my brain was activated the instant I saw her, because then my whole state changed for the better. I watched her secretly for a few minutes choosing fruit. The year I had my heart attack, the grapes were very good; this year it's cherries that are particularly delicious. Every year is different. I watch her smelling the peaches. But the fruit we buy today has no aroma.

Since she had her stroke, the people who run the company where Sanja worked for eighteen years for the protection of refugees have not called once to ask how she is. Every time I call them, the person who answers the phone says that a certain Donna Pellegrini is working on Sanja's 'case', and she will contact us. Three weeks have passed and Donna Pellegrini has not called. And so, in our world, Donna Pellegrini is the most important and therefore the most frequently mentioned person, although it is perfectly possible that she is an invented, non-existent figure.

A quiet afternoon at work. With the volume low, I'm recording the speech of the Republican candidate Donald Trump when I feel something warm on the back of my neck. I turn round and behind me is an ash-coloured pit bull breathing heavily, one of those dogs with tiny eyes and small pupils, looking threateningly at me and growling (or I may have imagined the growling in my alarm). Fortunately, a woman soon appeared in the doorway, calling to the dog as though she were addressing a two-year-old. She apologised for taking it away from me. Exactly that: she apologised for depriving me of its company, convinced I was enjoying it. People here really like dogs. In the relationship between the dog, its owner, and me, I was actually the one at fault. The pit bull was not to blame for alarming me. My resistance to dogs is an

absence of empathy. While dog owners cannot see beyond their emotional system, they expect the rest of the world to relate to their pets with the same fondness they do, because in the world of a person who loves, the only criterion is love.

Refugees have two worlds: the one they have left, and the one where they are now. The antagonism of the two worlds is the essence of exile. That duality is carried over into language: the first language is the mother tongue, the other the language of the new surroundings. After a stroke, a person may forget their language, or they may begin speaking a quite different language, with which they had not previously been in contact. Sanja's languages are all present and correct and she has no difficulty in moving from one to the other; in that sense nothing has changed. But the atlas of her world is confused. She sometimes wakes convinced she is in Sarajevo. She says: 'I must go to work.' 'OK, if you go out the door now, how will you get there?' 'I go down in the lift, come out of the building, cross the road, then the big parking lot, I go to the underground, take one train first, then change to go round to Ćengić Vila . . .' 'This is Washington, there's no Ćengić Vila here . . .' She's confused because of her own nightmare, but then she redeems herself, charmingly: 'How shameful! What kind of town is this with no Ćengić Vila?'

The medication that is meant to reduce her pain and depression is called Lyrica. *This is the way the world ends*. By a word changing its meaning.

We were told the windows would be cleaned at the end of last week. A workman came Tuesday and removed the protective mesh that stops tiny creatures coming in when the windows are open. But the cleaners have postponed their work for

a week. Today it's Saturday and because all the windows are open, a sparrow came in through one of them, flew about frantically, and then did manage to find a way out through a different window. It all happened quickly. The air that the little bird swirled about in the room turned the page of the book I was just reading.

I make notes in haste, along the way, in the car, in the lift, in bed, just woken from sleep, because if I don't record things straightaway, I will certainly forget them. But if it weren't for this note-taking, if there were no moments when I turned into myself, I feel I would exist less, or I would forget myself.

Each of these moments exists in a perpetual present. But, nevertheless, every word of this diary will be forgotten. This book will no longer exist, nor will there be anyone who remembers her.

There are *nows*, says physicist Julian Barbour, there are various 'nows' and all of them exist simultaneously, as different possibilities. And that's all. No one and nothing travels from one 'now' into the next 'now'. We pass, but time does not.

Life is the flight of a sparrow that flutters in through one window, and flies out of another.

Fifteen years ago, it was raining. A taxi driver was taking us to the Fish Market, because you wanted to see the restaurant that features in one scene of the film *Sleepless in Seattle*. But when we reached it, you were disappointed. In the film it was a more attractive and better-lit place, while we entered a small, dusty bistro. The difference between the fictional and non-fictional is not the same as the difference between the real and the illusory. In the case of this concrete restaurant, it's a real place, used in the past for the needs of a fictitious film story. 'Everything looks better in a film!' you said, with a note of regret in your voice. When we're young, we want our love story to be

123

unique. It would have been better if you hadn't met me, for our relationship contained no material for romantic comedy. It's always better in a film; there's no smell of fish slowly thawing on the stalls of the great market. Life stinks.

'Sem Mehmedinovik! The man who has a rubbish bin in his car!' That's how my friend Santiago, the cheery Spaniard, introduced me today.

That's because of Sanja's need to put everything around her in order. There mustn't be any rubbish on the floor. That's why we have a rubbish bin in our old Ford Taurus.

She listens to music so as to remember her youth, on the whole songs from the late nineteen-sixties and seventies (mostly Crosby, Stills, Nash & Young). And she says: 'Woodstock, how magical that sounded in the Balkans! But Woodstock is a place for storing wood! How provincial we were! Why even those who knew what the word Woodstock meant would not be moved. It does sound mighty in English! It could not be an ordinary wood stack. And if it was to do with trees, they would have been special, American trees, and not our beech or common oak . . .'

Today we went for a doctor's examination. The doctor (a neurologist), said several times that it was a serious question whether our medical insurance could cover the cost of the memory test (this was, allegedly, an expensive examination to determine the extent of forgetfulness). She repeated that it was 'a serious question' three times, and then Sanja lost patience and said that it couldn't possibly be a serious question. 'Why does Something exist, and not Nothing? That's a serious question!' she said.

Time has stood still, it seems to me. It has been two months since Renata cut her hair, but her hair doesn't seem to be growing.

* * *

The only items of value in our flat are books. And this book-shelf, handmade, the work of an American sculptor. It's made of light wood and it's easily moved from one place to another. Today, as I was vacuuming, I shifted the shelf with my shoulder and a lot of books fell onto the floor. Sanja came to help me put them back. And I remembered something: when he came to see us the first day after we returned from the hospital, Asim used precisely that image to describe her state after the stroke. 'It's as though an earthquake had knocked books off a shelf onto the parquet,' he said. 'And now each one has to be put back in its proper place.'

It's been three months since her stroke, and her bosses haven't even telephoned to say hello and find out how she is, whether she's recovering. That's probably how it is everywhere in the world. So I arranged a meeting. In my telephone conversations and email exchanges, R. (an official in Human Resources) kept giving me contradictory answers, so that I had no confidence in her explanations about Sanja's rights and obligations. And if I hadn't called her yesterday, I wouldn't have known that Sanja's employment comes to an end on August 6. How come, since she hasn't yet used her vacation days? R. maintained that she hadn't yet received approval for that from her boss, who's on leave.

That's why I've asked for this meeting, to try to get some concrete answers. R. keeps me waiting in the lobby, after a young man in uniform at the entrance to the United States Conference of Catholic Bishops instructs me fairly authoritatively to sit to one side and wait. After a while, R. appears, leads me into a conference room, shows me where I am to sit, but herself remains standing, near the door. She puts down a sheet of paper with explanations. I suggest that she sit, as though I am at home here

and she the visitor. But she says, no, no, she'll stand. This is an unusual situation: I'm sitting, reading, while she stands, rigid, at a distance. It's presumably not that she's afraid of my reaction, and stays on her feet so she can run away in the event that I charge angrily in her direction. I insist that she sit down, because she's making me nervous. She does so reluctantly, her shirt done up to the highest button, but she pulls the pendant on the chain round her neck onto her collar: a gold German Iron Cross. 'Are you German?' I ask. Out of a need to mollify her, I tell her that I work for German television. She looks at me fairly coldly and, instead of replying, points at the paper in front of me.

The moment I got home, I had to take a hot shower. 'I've never experienced such coldness! I'm frozen right through!' I tell Sanja. And she laughs and says: 'What do you expect? It's the Vatican! A corporation that officially uses a dead language!'

Her isolation. When I get home from work I run up the stairs, and she opens the door as I reach it. Smiling. I thought she watched from the window for the Ford Taurus to appear in the car park, and then went to the door to open it before I rang the bell. But it isn't like that. She says she doesn't look out of the window, but waits by the door, watching through the spyhole.

When I get home from work, we have a coffee and remember the past. Every day. And I always hope she will have woken up that morning and recalled everything. In our conversations, we often go through the list of addresses where we've lived. She remembers some of them, but not others. We lived in Zagreb for a few months, for instance, and she remembers that. She left Sarajevo with Harun in September 1995. The town was still besieged, and a driver from the Soros Open Society Foundation drove them over the airport runway to Konjic, where they got

into a truck that took them to Split. Two days passed before I could speak to them. By then they were already staying with my Zagreb acquaintances Nenad and Marija, whom Sanja had met then for the first time. In our short telephone conversation, she told me that she and Harun were fine, that the journey had been exhausting, and that they were resting. She said that Marija and Nenad were good people. I asked her: 'How do you know?' And she replied: 'Because in their house a cat and a dog live together.'

She's finding her isolation increasingly hard. We decided to start learning Spanish in the hope that this would help fill her day. As long as I've known her she has praised the music of the Spanish language. 'Just don't hurry me, you have your rhythm, and I have mine. I'll learn slowly. *Poco a poco!*' she says. In fact she doubts that the two of us can study together. Once, thirty years ago, the differences between us were so great that it's a real miracle we're still together. Her recollection of the previous century is more intensive than her memory of the twenty-first. She says: 'We're a dog and a cat who've been living together for thirty years now.' What's important for her is the accord that's rarely established between natural enemies. The rule is that cats and dogs don't like each other, and when it happens that they can after all put up with each other, that harmony makes this world a better place. Over time, we've reached an accord. Or it might be more accurate to say that the differences between us are increasingly slight. We differ the way a Spanish 'r' differs from a French one.

At 7 a.m., before I set off for work, I make her coffee, and she prepares my lunch, goes back to bed and sleeps for another hour. She drinks her coffee when it's cold. For the rest of the day until I come home, she invents jobs for herself as a refuge from

loneliness. Because of her forgetfulness, it's very important that everything is always left in the same place, so that she can find things more easily. But, in order to fill the time she spends alone, she moves objects around the flat and re-arranges the furniture. Today she sent me an email. Subject: Call me. And underneath, an explanation: *I don't know where I've left my phone.* I called her, she set off towards the source of the sound and so found her phone. Last year something similar happened, only the roles were reversed. She was in Sarajevo, I couldn't find my phone, so I sent her an email asking her to call me. And she did, and the sound came from the washing machine where I'd put my jeans, onto which I had earlier spilled coffee. She called in time, so that the phone wasn't drowned in water and detergent. That's so wonderfully simple: she phoned me from a different continent to save me from my forgetfulness. It's a shame there isn't a machine that discovers forgotten events and returns them to the memory.

On my way to work, a text message from her: 'Do you remember when we were children, little girls wore crocheted collars on their school smocks . . .' It was early in the morning, and she was in the depths of her childhood.

Two hours later she called to say: 'I've ironed all your T-shirts, and I kissed every one.'

And here I am, I can't stop thinking about those kisses, as though a hundred cats were tickling my soul with their soft paws.

We had put on our best clothes. I was driving south along Route 66 when we began to slow down. I pressed the accelerator, but the Taurus had trouble gaining speed. Then we slowed to a standstill, stopping on the hard shoulder. We got out of the car and saw grey smoke curling up from it. I had the feeling that at any minute the smoke would turn into fire and the car into

an inferno. I tried to investigate, but the more I touched under the hood the dirtier I became. Irritated, I made an effort not to convey my irritation to Sanja. She had tamed the wind in her hair by pushing her sunglasses onto the top of her head; her gold necklace gleamed in the sun. She was young again! I touched her face with my filthy hand and she wiped the soot from my brow, straightening my eyebrows. The smell of spit and memories of childhood. We were already late for where we were headed and my irritation completely disappeared. We laughed, hugging, without knowing where our happiness had come from. And then a pigeon landed right beside our car. Not exactly a place where you expect such a bird to appear. You won't find any seeds to peck here, my dear! It waddled about fearlessly, wound itself round our shoes . . . An unusual pigeon, its legs covered in feathers right down to its claws. A feather-shanked pigeon. *Golub gačan,* I say. That's what it was called in our childhood.

Holding hands, we step into the revolving glass door through which I have often passed over the last months. Our moving shadows break up in the glass. The melancholy of late summer. We go up in the lift to the fourth floor. We're in the hospital for a routine medical examination. We sit and wait. In the silence, we look at a painting in front of us by an anonymous artist. And then Sanja asks: 'Isn't it a pitiful destiny for an artist for their work to end up on the wall of a doctor's waiting room . . .?'

Towards midnight, in the flat above us, someone is moving furniture and the feet of tables scrape over the floor. I don't know why this is repeated every night. Once, when the noise was insupportable, I went upstairs and banged on the door, which no one opened. I don't know who lives in the flat above ours. I don't know why they drag their furniture over the floor on top of our

heads just before midnight. But I'd like to know. Their restlessness doesn't last long, not more than two or three minutes, and after that I always become aware of the silence that surrounds us.

Today, in a book, I found the following description: it's 1913, and the setting is the Grand Hôtel de Cabourg: Marcel Proust has rented five rooms, and stays in one of them; the other four are so that it's silent.

S he says: 'It's the twenty-first century now, but I had a friend who was born in the nineteenth.'

We often mention the passing years. We've become quite childish in many ways. I feel quite tranquil. It's enough for her to straighten the collar of my shirt and that touch calms everything in the universe. Misfortune has reduced us to our essence. And nothing is left of us, apart from love.

T oday we went to Tony's Auto in Alexandria, where we used to live and where we've had all our cars fixed over the last twenty years. Repairs to the Taurus would cost nearly three thousand dollars, and that's more than the vehicle is worth. So we gave up the old Ford, and the one-eyed mechanic said they could take it to the car cemetery. I took my belongings from the glove box, mostly documents, pens, and loose change, and we bade the Taurus farewell. I didn't feel particularly sad.

When we turned from there onto Fayette Street, we stopped to let a car go past with a camera on its roof and GOOGLE on its door, filming the street for that Street View on Google Maps. Just here, in the building behind us, was where we had lived until five years ago, before we moved, fleeing from painful memories. After today's chance filming, I thought about our being imprisoned for a long time at our old address. On the film we would

have blurred faces, so that no one would be able to recognise us and our privacy would be protected. For a moment I was pleased about that, but then, once I had become aware of it, my pleasure turned into apprehension.

We left our green umbrella in the boot of the Taurus, but we didn't feel like going back.

LOUISE ERDRICH is the author of seventeen novels, as well as volumes of short stories and poetry, children's books, and a memoir of early motherhood. Her fiction has won the National Book Award and the National Book Critics Circle Award (twice), and she has been a finalist for the Pulitzer Prize. A member of the Turtle Mountain band of Chippewa, Erdrich lives in Minnesota with her daughters and is the owner of Birchbark Books, a small independent store.

Stone Love

LOUISE ERDRICH

I spent a star age in flames
Bolted to the black heavens
Waiting for you.

Light crept over the sill of the earth
A thousand upon ten thousand
Upon a hundred thousand years
But no light touched me
Deep in depthless time
Waiting for you.

Fate flung me out,
Hauled me here
To love as a stone loves
Waiting for you.

Touch me, butterfly.
Like you, I have no hands.
Kiss me, rain.
Like you, I have no mouth.
Snow sit heavily upon me.
Like you, I can only wait.

Come to me, dear
Unenduring little
Human animal.

I have no voice
But your voice.
Sing to me. Speak.
Let the clouds fly over us.
I have spent a star age in flames
Just to hold you.

DAISY JOHNSON is the author of a short story collection, *Fen*, and two novels. Her first, *Everything Under*, was short-listed for the Booker Prize (making her the youngest author ever to be short-listed for the prize); her second is *Sisters*, published in 2020 by Jonathan Cape in the United Kingdom and Riverhead in the United States. Johnson lives in Oxford, England.

The Snowman

DAISY JOHNSON

The room my sister dies in smells of hot water bottles and the salt we secretly scatter into the corners and in front of the door. We wait, that winter, for the snow. My sister is in the room she dies in for nearly two years. She likes to make jokes about how her body is starting to look like the sheets she lies under. A joke that isn't really a joke. Our mum's hands take on a metallic sheen, a mechanised twitch: she changes the IV and pops the packets of pills and bends to see to the catheter. Every day on the news that final winter the weatherperson says snow is coming and every day we sit waiting for it in that big, illness-overflowing bed. I am fourteen years old. My sister is eighteen. Before she was sick we had hated one another. Broken one another's things, bruised and scratched and did damage to each other's bodies. That winter we sit in the bed side by side and watch animated films on the laptop and listen to the sound of our mum moving in the rooms downstairs. My sister's attention span is short as a struck match and her legs burn if she stays in one position too long. I make her soup from the cartons in the fridge and carry it up the stairs spattering and boiling my bare arms and we watch *The Lion King* and *The Incredibles* and *Moana*. The light through the window often makes it seem like the snow has come while we

were distracted; cold, hard light on our thin-skinned faces and my sister's tiny arms. We watch *The Snowman*. We watch *The Snowman* five or six times a day. I try to suggest other things, but my sister gets angry and anguished and snaps the way she used to and we watch *The Snowman*. Do you know the story? It is nearly Christmas and there is snow like the snow we dream will come. A boy builds a snowman and in the night it comes alive. The introduction goes: *I remember that winter because it had brought the heaviest snow I had ever seen.* My sister loves it. I dream that I build something in the garden for her and in the night it comes alive. We wait for snow. My mum goes out and comes back with a Christmas tree so tall it can barely get through the door. Together we yell and hustle and bash it up the stairs and into my sister's room. She watches us suspiciously. We load the branches down with ornaments and homemade reindeer made out of years-hardened cookies and strange paper shapes from when we were young and that look like nothing and curl at the edges.

My sister says, it isn't Christmas.

But it is Christmas. It will be Christmas in two days and we will sit around her bed and eat turkey from a packet and tiny spring rolls. My mum drags over a chair and stands teetering to put the star on the top. My sister looks at me. I can see her pulse beating in ten or fifteen places on her body. When she first got sick we believed in everything there was to believe in. I left piles of salt around the room and we crushed our hands together and made wish after wish. I left a bulb of garlic in a milky bowl beneath the bed until the smell got too much, and wrote messages on screwed-up bits of paper that I hid around the room and sometimes we stayed awake all night seeing if that would shake the sickness right out of her bones.

<p style="text-align:center">✳ ✳ ✳</p>

Later I will be drawn to relationships with people who do not need me, will not meet my friends, will ignore my phone calls, won't notice when I am so low, so dog-dark, that I cannot see the leaves for the trees.

I leave our mum doing the tree and my sister watching her and I go out into the garden. It has been days, perhaps weeks, since I have been outside. I can feel my insides humming to the tune of the air. The ground is sodden and so muddy my shoes are overcome and I have to stomp back for boots. It is cold. It is colder even than it looks and I put on gloves and my mum's hat and another pair of socks from the radiator. I walk down to the bottom of the garden and out onto the lane beyond. There is the staticky hum of traffic not far away and the buzz of someone's television. After my sister dies we will move to a smaller house in a city and I will go to a school where no one knows I even had a sister who believed what I made her could stop her from dying. Do you see how time bends and won't stay still, how uselessly it holds us?

I climb the stile of the first field I come to and walk along the bare furrows. It feels like years since I have walked here and perhaps it is. We used to have a dog when we were younger, a terrier who bit but who loved to run and never managed to catch a rabbit. We would walk the dog here. I imagine him ahead of me, the flash of white, ears flattened with speed. I walk from one end of the field to the other and then back again. Everything is marshy and dead. I walk from one end of the field to the other and then back again and as I go I start picking up things from the ground. I find a blueish stone the shape of an arrow and a bundle of twigs meshed together with hair and a mud-filled pen. Soon I start picking without even really looking at what I'm doing. Occasionally I think I feel something on my bent face and look up

at the white-sheet sky that smells of snow but there is never any there. I pick up dirty stones by the handful and clods of mud and thin weeds and put them in my pockets. At the pine tree I take off my gloves and scrape at the rough trunk with my fingernails and tear at some of the lower branches. In the garden I dig for a while with my bare hands until I find some of the bulbs mum had planted in the summer, some of the old shrivelled potatoes we hadn't managed to find. I look up to the window of her bedroom thinking I might see my sister there, watching me. But the window is empty, the curtains drawn.

I squat down. I squash the clods of earth together and add handfuls of the soft dirt, pressing and mashing with my hands until I have something roundish. I press the stones—the blue stone at the centre—into the mud and stick in the twigs, the balls of hair, the sticky bits of weed, the scrapings from the trunk of the pine and the green needles. My fingers are bleeding a little from grappling with the pine trunk and the blood goes in too. I stand back to see what I have done. It is an odd, squat, nearly formless, unevenly balanced little creature. Not quite right.

In the house I go quietly. I can feel the mud hardening on my hands and face, even in my hair. The pockets of my coat are slick with dirt and my boots are caked. Thinking of the snowman I look for something belonging to my sister on the coatrack, a scarf or hat, but there is nothing. I can hear my mum moving around in the kitchen, emptying the dishwasher, the radio on low. The house feels like it is waiting for something. I am waiting too. I am waiting waiting waiting. In the sitting room I sift through the piles of books, hunt beneath the sofa, look in the drawers of the dresser. If it wakes now it will not be ready. Surely she has touched everything at some point. Surely everything in the house belongs to her, too. I take a pillow from the sofa and then put it back down. I can hear my mum; she will come in soon to make

up the fire or watch something on the television. I go quickly towards the back door and out into the cold. My sister used to love stories of apocalyptic winters, a freeze hard enough to stop a body in its tracks. Here it is. A cold vast enough to cut us loose. I stand on one foot and pull off my boot, tug at the muddy sock. It is mine. It will have to do. I push it into the side of the shape until it is hidden. I look up at the window. I want her to come see me, standing there.

Inside mum says, what have you done? Why are you so dirty? The sides of the bath become slicked with black, the water leaves a tideline as it drains, the plughole blocks and blocks again.

In the night I make the herbal tea she likes and go to see her. She is not asleep. The light from the laptop takes her face and makes it strange. I watch the end of *The Little Mermaid* with her. I watch her mouthing the words. I hold the tea up to her face when it is cool enough to drink. When she is done I tell her what I have made for her. I watch her eyes on my mouth. I point to the window.

I do not help her because she would not want me to. We are still partly enemies even though everything is different than it was before. There are stains on her thick pyjamas and she is so thin it looks like she might easily flash and be gone. I do not think she would leave any trace of herself behind. She walks slowly, as if just learning how to do so. She has her hands out in front of her. If she fell I would not be close enough to catch her but I do not move any nearer. The moon is thick and clotted, hearty enough she will be able to see down onto the garden. She clutches the sill and leans forward so that her nose nearly touches the glass.

It's moving, she says.

My throat and mouth feel full of cotton. I press my hands down against my belly until it hurts and bite my tongue hard. It's moving, I can see it, she says. Can you see it? She asks, but I do not go closer to look. I do not go closer to look and she does not come away from the window. I do not know how long we stand there. On Christmas day we eat turkey from a packet and tiny spring rolls off plates on our laps. We watch *The Night Before Christmas* and our mum laughs so hard she spills her wine onto my sister's white duvet. I think of the end of *The Snowman* when the boy goes out into the garden and finds the snowman he made has melted away. I do not look out of the window. I do not look out of the window or go to the front door and open it and look down the slope of the garden. We eat Christmas cake and leave the tree lights on all day. When I am older my mum and I go out for Christmas every year, eat in restaurants or cafes, even—a few times—find the only cinemas that are open and have nachos and popcorn for dinner. Sometimes, in the city, I think that I see the creature I made for my sister. Down alleys or on the opposite platform just as a train comes in, or in the windows of other people's houses. In the windows of other people's houses.

VALZHYNA MORT was born in Minsk, Belarus, and writes in Belarusian and English. Her newest book is *Music for the Dead and Resurrected*, published in 2020 by Farrar, Straus and Giroux. Mort is the author of *Factory of Tears* and *Collected Body* (both from Copper Canyon Press) and a recipient of the Lannan Foundation Fellowship, the Amy Clampitt Residency, the Bess Hokin Prize from *Poetry*, the Gulf Coast Prize in Translation, and most recently, a National Endowment for the Arts grant for translation. She teaches at Cornell University.

Poet's Biography

VALZHYNA MORT

I picked your book from Sandeep's shelf,
the poet's biography read: "lives and teaches."
Though the book was fairly recent, it was no longer true.

I almost met you once – an almost-meeting I remember clearly
because of my embarrassment:
I was having loud sex in a hotel room
while you stood knocking at the door wanting to give me your book.

Now the trains stand frozen in a winter storm,
and I pity the trains
as if they were shivering butterflies,
a whole herd of them, the last of its kind,
stuck in the snow England has never seen.

Sandeep is cooking dinner, you are dead, the lover's gone,
your book in my frostbitten hands.

GUNNHILD ØYEHAUG was born in Norway in 1975 and is an author, as well as a teacher at the Academy of Creative Writing in Vestland, Norway. She has an MA in comparative literature from the University of Bergen, and has written poetry, novels, short stories, and essays. She has also scripted a feature film and a short film. Her novel *Wait, Blink* was long listed for the National Book Award in 2018. Her most recent publication is the novel *Presens Maskin* (Kolon, 2018; "Present Tense Machine").

KARI DICKSON is a literary translator from the Norwegian. Her work includes crime fiction, literary fiction, children's books, drama, and nonfiction. She is also an occasional tutor in Norwegian language, literature, and translation at the University of Edinburgh, and has worked with the British Centre for Literary Translation and the National Centre for Writing.

Apples

GUNNHILD ØYEHAUG
TRANSLATED FROM THE NORWEGIAN
BY KARI DICKSON

1.

The dog came pelting towards me. Mouth half-closed around a stick, coat rippling. *Freeze time*, I thought, so we stay like this forever, me here in the field, open and white, and him with the snow glittering and swirling around him in midflight.

It was afternoon by the time we turned home. The dog ran in front of me, behind me, beside me. Completely untroubled. When we got to the cabin, dusk was falling. I brushed the snow from us, gave the dog some food, water, lit the fire.

Later in the evening there was a knock at the door. It was Sonja, who owned the dog. The dog leapt to its feet, ran to its owner, and jumped up, Sonja laughed and said doggy things to the dog, Sonja looked at me with a questioning and slightly dumbfounded smile, as though she was saying to me, without saying, you could just have rung and told me. *Freeze time*, I thought, as I stood watching the dog jumping up at Sonja and Sonja looking at me with her gently quizzical smile, as though she wondered who I was, who could just take the dog like that and not say anything, again. You like the dog, Sonja said, and I nodded. You can come

and visit, you know, Sonja said. I nodded again, would you like something to eat, I asked, I've just baked some rolls. Sonja looked at me, as though taken aback, either because I'd baked the rolls or because she wasn't sure what to do, OK, she said.

I put the rolls and a pot of tea on the table. Sonja looked around the cabin; the dog was lying on a blanket on the sofa, asleep. I hoped that I wasn't dreaming, that I wouldn't wake up and it would all be a romantic dream, that a person and a dog had come to visit me, that I'd made them food, that I'd put cheese on the table, that I saw a person standing there looking at my family pictures hanging on the wall, as though she was genuinely interested, and the dog lay sleeping on the sofa, and felt cared for and safe. And I liked the way I had written this, intimate and honest, and I liked the fact that Sonja was named after a variety of apple.

2.

The class clapped. The author showed a page from a fruit ency-clopaedia on the digital blackboard, with an illustration of a round, red apple, and the text underneath said that Sonja was an autumn apple, resistant to apple scab, sweet in flavour, with a rich red colour and good keeping quality. Well, the author said, that was something I wrote yesterday to show you a way to turn everything upside down at the last moment, first: a realistic story without any meta levels, where "I" has a dog and is happy and looking for moments to freeze, and then at the very end destroys everything by saying "I liked the way I had written this," so everyone falls out of the story, and knows that what they have just read is fiction. Obviously, it's not a style I would use for anything I was going to publish, said the author who was the lecturer that day. The creative writing class at the creative studies

college looked at the author. They didn't actually chorus "oh", but might well have done by the look on their faces. The author was tall, had dark hair and a long, pointed nose that gave him a distinctive profile, his slim hands holding a pen as he spoke. He looked at the class. His name was Aksel, after his farmer father's favourite potato. Aksel caught young Signe's look of scepticism— or was she irritated or annoyed? She had a slightly protruding upper lip, and a very sweet mouth, and when she didn't believe something, the pout became even more pronounced. Her eyes were big and serious, and it was clear she was thinking something. Her hair was light brown and cut in a bob that framed her face. Aksel waited, he waited for a critical comment, or at least a question, from Signe. Does anyone have any strong objections to the text? Aksel said. A hand went up, we don't know very much about his background, the student said, we aren't told much about why it's so important to him that someone comes to visit, what it is that he finds difficult with other people. Aksel nodded. True, he said. Perhaps there could be something in the room that gives a clue, he could have an aquarium or something like that, the aquarium could represent the confined, introverted space, keeping all the fish at a distance from him, another student said, which made Aksel smile, good idea, he said. An aquarium in a cabin? a third student said, that's not very realistic. No, that's true, the second student said. And what would the aquarium symbolise, would the aquarium symbolise him, that he was an aquarium with fish in it, with a glass wall to keep the world out, or would the fish represent the world he couldn't connect with because he was outside the aquarium? a fourth student wondered. Let's forget the aquarium! the second student said. Everyone laughed, and the corners of Signe's mouth turned up, but barely. Why does he want to freeze time? another student asked. Signe turned to the student, but that's obvious, Signe said, who

149

usually corrected everyone, he wants to freeze time because it's much easier to live in a happy moment than with all the difficult stuff before and after, and in any case, it's a device to illustrate writing, writing is an attempt to stop the constant flow of all that is difficult, to hold it still, to observe it. Signe glanced at Aksel, just long enough for him to realise that she wondered if he was impressed by what she'd said, before she looked at the floor. Her objection didn't come until the day was over and he was out on the street that ran like a long sentence past the creative studies college, which lay more or less in the heart of Oslo, not far from the fjord. Signe came out with her bag through the glass doors, and stepped onto the pavement where Aksel was standing lighting a cigarette. She looked at him with the same sceptical expression, pout, and eyes. Let's continue in the present tense. It's easier, when it comes to dramatic experience: I know, Aksel says, I know I shouldn't. By this, he means smoking. There was something, Signe says, something I thought about that text you read out today. I could tell, Aksel says. Signe looks surprised. Oh, she says, because she doesn't really like the author's overconfidence. What I thought was this: I liked the story without the meta sentence at the end, which just ruined the whole thing. I liked it when he was out in the snow with the dog, and he was happy, and that then he went back to the cabin and baked rolls and had a visitor. End of. What you're saying is that you like a realistic narrative, Aksel says. What I'm saying is that I like stories that are genuine, Signe says. That are not clever and pretending to be something they're not. But it was only an example, the author says. I don't believe you, Signe says. I think you liked it when you were writing it. I think you were into it. I think you were in the landscape in your head, I think you pictured the snow, and the dog, and I think you liked that there was something about the dog that the protagonist longed for, and I think you thought that if you named a person

after an apple, the meta device you used to leave your own story would somehow feel less obvious because of the symbolism of the person growing out of the soil, which we all do really, in a way. AND: I don't for a second believe that you actually wanted to deconstruct it at the end, I think it's exactly what you're looking for, but you're trying to camouflage it. Aksel: I don't mean that all stories should finish with "I liked the way I had written this." Signe: And I don't mean that that's what you meant. I think you have a longing, and that's alright. Aksel: I've never said that it's not alright to long for something. Signe: But that's precisely what you do when you undermine your own story about it. Aksel: I don't agree. Signe: What's your argument? Aksel: I'll have to think first before I can answer that. Signe: Have you read Inger Christensen's poem about dreams? Aksel looks at her. Every time she opens her mouth she makes him a little more like a snowy field inside—empty, he has nothing to say. It's something about her eyes, they're so incredibly big and see right through him, he can't hide anywhere, he feels nervous, or is it anxious? I can't remember, he says. It's in *Alphabet*, Signe says, and it, or rather she, compares an apricot tree in bloom with someone who's dreaming, when the tree is flowering, it's full of dreams, apricot blossoms are the dreams, you understand? And then she says she finally understood that "A dreamer / must dream like trees / be a dreamer / of fruit to the last." That's utterly wonderful, Aksel says. And it is wonderfully true. But you know, he says and looks at Signe, in the same collection of poems there's another apricot tree in a dream that someone dreams, and did you notice what that apricot tree does? Signe's eyes flicker. The apricot tree scrutinises the dreamer, the "I" that is, before turning around and leaving suddenly. What do you think about that? Aksel says and takes a drag on his cigarette before dropping it to the ground and stepping on it with the toe of his shoe. Signe looks at the

stubbed-out cigarette. The stubbed-out cigarette grows into a symbol. She looks at him with a stubbed-out cigarette in her eyes. I think I need to think about it again, Signe says, because she's actually never thought about it, the fact that this collection of poems that she loves for its tangible content (apricot trees exist, etc.) and strong morals (take care of the planet), also uses meta devices. She, who normally catches everything, has failed to catch something so fundamental. What we are witnessing is an intellectual turning point for Signe. And Signe would no doubt wish that this entire conversation had a different outcome from the one it did, that she had not become the apricot that she naturally became for him, in fact, it took her several years to get over it, that she had gone home with him, this and that happened, in short, that in the course of a few months they went through the whole tiresome young woman/older man relationship that inevitably follows its necessary dramaturgy based on the young woman's need to be seen and her essentially mature mind that finds no resonance in her male peers, and the older man's attraction to youth and constant longing to be seen, a longing that for some men is voracious and never satisfied, so constantly seeks out new, fantastic girls, but time and again these girls' lack of life experience seems to ruin the relationship for the older man, whereas the man's lack of listening ears appears to ruin the relationship for the young woman, not least, that he almost exactingly uncovers great flaws in her not yet fully developed sense of self (which is exactly what provokes the need in him to carry on searching for the perfect woman who does *not* have this flaw), but the most frustrating thing of all, says Signe, and surveys her students at the University of Bergen, who are sitting listening to her story, which she has slipped into so unexpectedly, was that it ended just as I had wanted his story about the cabin and the dog to end, with fruit, that's to say, my bare arse, to put it

humorously, and normally that would have been the kind of irony that I appreciate, but now I'm so old, and this is my last day as professor at this institute, and this story is what started it all for me, the reason I became a literary scholar in the first place, and I feel, actually . . . nothing. Nothing at all. The students clap uncertainly. Signe smiles at them, she is sixty-eight years old and a rather large lady, and she has to bend over slowly to pick up her bag from the floor. She takes her coat from the chair and leaves Auditorium A at the university for the last time.

3.

Outside, the sky is blue, it's late May, and Signe walks to the bus that will take her home. She passes a flower shop, which is blooming with bouquets of tulips and roses and anemones, and bushes she does not know the name of, which are temptingly green in their own way standing there in their pots, but at the back, right against the flower shop window, on a small table, is a little tree that catches her eye, and she stops. And this is what the scene looks like from the outside: a stout, older woman stands looking at a tree. She holds her bag with both hands in front of her girth, resting the bag on her stomach, as older women with bags often do. And what is happening inside her is this, she is asking the question: What kind of tree is that? She leans over to look at the label where the name of the tree is written. And it says: Sonja.

Next scene: Signe takes the apple tree to the counter, she pays, the apple tree is given to her in a plastic bag, but that doesn't work, Signe has to carry the apple tree in her hands. Thankfully the tree is small and thin, and it's not far to the bus.

For the entire bus journey home, Signe is in a strange mood. Another line from Inger Christensen's book pops into her mind, perhaps because she is carrying an apple tree: right at the end

153

of the collection, there's a poem about some children sitting by a road after a war, and they have lost everything. And then the poem says: *there is no one to carry them anymore.* She sits with the apple tree on her lap and looks out at the sky. It's blue, with wispy white clouds. When she eventually gets home, she lets herself into the small, red house in a garden that is so well-suited to an older woman of girth, and puts down the apple tree in the hall. Sonja? Signe calls. The story crackles with surprise. Sonja answers from one of the rooms, but Signe can't make out if it's the kitchen or the living room. Mum! Sonja shouts. Sonja comes hopping out into the hall—Sonja is Signe's forty-five-year-old daughter. She has Down syndrome and works in a sheltered workplace, where, in her own words, she makes "everything" and always finishes for the day half an hour before Signe comes home from university. Sonja is the result of the months when Signe and Aksel went through the relationship dramaturgy of young woman/older man, and Signe has been alone in her responsibility for Sonja, from the time even before she discovered she was pregnant, as Aksel disappeared in a way that no one can really hold against him: he drowned in the Mediterranean, he dove in too deep, down to a coral reef, and he should perhaps have remembered the discussion in class about the aquarium as a possible symbol, he might perhaps have seen that it was in fact a foreshadowing, but he didn't, he dove down and there he drowned, in all that blue, with fish of all colours swimming cheerfully around him. Signe hugs Sonja. Let's make dinner now, Signe says. Signe feels a lump in her throat a number of times through dinner, it must be because it was her last day as a professional, now she's a pensioner, all that's missing is the big farewell party, and so she embarks on the final stage of her life. How will Sonja get on without her is a question that has cropped up more than once, even though she's not ill, she's just old, there's no doubt about

that. She tries to keep the chitchat going, asks in a thick voice: So how was it at work today? Just like normal, Sonja says. I love you, Signe wants to say. And was Andrea nice today? Signe asks. Andrea Liliane *Hamar*, Sonja corrects her. Signe smiles. Was Andrea Liliane *Hamar* nice today? Signe asks, it's easier now, she will be able to eat without crying. She is always nice, Sonja says. Oh, Signe says, I had the impression that Andrea could be a little naughty at times. Yes, Sonja says. But not today. She's learnt to behave herself. That's good, Signe says.

Sonja and Signe do the washing up. Signe washes and Sonja dries. Signe looks at her, looks at her daughter who is standing there drying the plates with such care, the tears well up in her eyes, *freeze time*, Signe thinks, freeze time as I stand here looking at her! But time does not freeze, Signe hands her an already dried plate. There! Sonja says. Now we'll have coffee! Yes, Signe says, and swallows. But first, I've got a surprise for you, Signe says, wait a moment. Signe goes out into the hall, and comes back into the kitchen with the small apple tree. Oh! Sonja cries. A tree! It's an apple tree, Signe says, and it's called the same as you. Sonja Olsen? Sonja says. Just Sonja, Signe says. I thought we could plant it in the garden. Let's plant it now, Sonja says. OK, Signe says.

4.

Signe and Sonja kneel in the garden and pat down the soil around the trunk of the small tree. They are both wearing gardening gloves. The story is unsure as to where it should end. If it should end here, or if it should end with Signe's young fingers that once leafed through a book and found a poem by Inger Christensen where it said that "A dreamer / must dream like trees / of fruit to the last," and she felt that this was so true that it couldn't be truer,

that it was a truth that was radiant and luminous—or if it should stop with an open, white landscape where Aksel is throwing a stick to a dog that's not his, that he has borrowed, or if it should stop when the dog picks up the stick and comes running back in a way that is ridiculously happy, as though the dog is smiling (but it's actually because it has a stick in its mouth) and its long black-and-white fur ripples around the dog's body as it jumps through the circus director's hula-hoop-like hoop, stretched with thin greaseproof paper. Sonja, the small tree, has no answer, just a thin trunk and a few branches, and some budding leaves. And in this moment, she stands there in the garden, a tree in waiting, something that will grow, blossom, bear fruit, lose fruit, lose her leaves, be covered in snow, etc. with an astonishing patience and the peace that is particular to apple trees.

SANDRA CISNEROS is a poet, short story writer, novelist, essayist, and visual artist whose work explores the lives of Mexicans and Mexican-Americans. Her numerous awards include a MacArthur Fellowship, the National Medal of Arts, a Ford Foundation Art of Change Fellowship, and the PEN/Nabokov Award for Achievement in International Literature. Her novel *The House on Mango Street* has sold over six million copies, has been translated into over twenty-five languages, and is required reading in schools and universities across the nation.

Exploding Cigar of Love

SANDRA CISNEROS

(to the tune of el Hokey Pokey)

You toss your *corazón* in.
I toss my *corazón* in.
We toss our *corazones* together,
And we shake them all about.
We light the love cigar,
And we get a little high.
And that's what it's all about.

I write a poem for you.
You write a love poem—*for me?*
We send a hundred and three emails,
And we shake them all about.
We light the love cigar,
And we get a little high.
And that's what it's all about.

You advance *un paso*.
I retreat *pa'trás*.
I *tacuachito* toward you,
And you take a two-step back.
The more I pull, the more you tug.
The more you push, the more I scram.
What are we?
Pepé Le Pew and the cat?

You toss in sub self-esteem.
I toss in emotional hemophilia.
Insecurities, addictions,
And we mix them all about.
We light the love cigar,
And we get a little high.
And that's what it's all about.

You text: You're too much for me, baby.
I text: Well, maybe you're not enough!
You text: I need to be free.
And I'm shakin' all about.
We've been tripping on the love cigar.
Now sobriety sets in. Bang!
And that's what it's all about.

HARUKI MURAKAMI was born in Kyoto in 1949 and now lives near Tokyo. His work has been translated into more than fifty languages, and the most recent of his many international honors is the Hans Christian Andersen Literature Award, whose previous recipients include J. K. Rowling, Isabel Allende, and Salman Rushdie.

PHILIP GABRIEL is Professor of Japanese literature at the University of Arizona. He has translated many novels and short stories by the writer Haruki Murakami, including *Kafka on the Shore*, *1Q84* (co-translation), *Colorless Tsukuru Tazaki and His Years of Pilgrimage*, and most recently *Killing Commendatore* (co-translation). He was the recipient of the 2006 PEN/Book-of-the-Month Club Translation Prize for his translation of *Kafka on the Shore*.

On a Stone Pillow

HARUKI MURAKAMI
TRANSLATED FROM THE JAPANESE
BY PHILIP GABRIEL

I'd like to tell a story about a woman. The thing is, I know next to nothing about her. I can't even remember her name, or her face. And I'm willing to bet she doesn't remember my name or face either.

When I met her I was a sophomore in college, not yet twenty, and I'm guessing she was in her mid-twenties. We both had part-time jobs at the same place, at the same time. It was totally unplanned, but we ended up spending a night together. And never saw each other again.

At nineteen I knew nothing about the inner workings of my own heart, let alone the hearts of others. Still, I thought I had a pretty good grasp of how happiness and sadness worked. What I couldn't yet grasp were all the myriad phenomena that lay in the space between happiness and sadness, how they related to each other. And that fact often led me to feel anxious, and helpless.

That said, I still want to talk about her.

What I do know is that she wrote tanka and had published a book of poetry. I say published, but the book was made up of printed pages bound with string, a simple cover attached, more a pamphlet, really, that barely rose to the level of a self-published

book. But several of the poems in her collection were strangely unforgettable. Most of them were about love between men and women, or about death. Almost as if to show that love and death were concepts that adamantly refused to be separated or divided.

> *You and I / are we really so far apart?*
> *Should I, maybe / have changed trains at Jupiter?*

> *When I press my ear / against the stone pillow*
> *The sound of blood flowing / is absent, absent*

"I might yell out another man's name when I come. Are you okay with that?" she asked me. We were naked, under the covers.

"I'm okay with that, I guess," I said. I wasn't totally sure, but I thought something like that probably wouldn't bother me. I mean, it's just a name. Nothing's going to change because of a name.

"I might yell pretty loud."

"Well, that could be a problem," I hurriedly said. The ancient wooden apartment I lived in had walls as thin and flimsy as one of those wafers I used to eat as a kid. It was pretty late at night, and if she really screamed, the people next door would hear it all.

"I'll bite down on a towel, then," she said.

I picked out the cleanest, thickest towel in the bathroom, brought it back, and laid it next to the pillow.

"Is this one okay?"

She bit down on the towel, like a horse testing a new bit. She nodded. The towel passed muster, apparently.

It was a totally chance hookup. I wasn't particularly hoping we'd get together, and she wasn't either (I think). We'd worked at the same place for a couple of weeks, but since the work we did was different, we hardly ever had any chance for a decent conversation. I was working that winter washing dishes and helping out in the kitchen of a down-market Italian restaurant

near Yotsuya station, and she worked there as a waitress. All the part-timers were college students, except her. Maybe that's why she seemed a bit aloof.

She decided to quit the job in the middle of December, and one day after work some of the employees went to a nearby izakaya to have some drinks. I was invited to join them. It wasn't exactly a full-blown farewell party, just us drinking draft beer, having some snacks, chatting about various things. I learned that before she waitressed she'd worked at a small real estate agency, and at a bookstore. In all the places she worked, she explained, she never got along with the managers or owners. At the restaurant, she didn't have any blowups with anyone, she explained, but the pay was too low for her to get by for long, so she had to go out and look for another job. Not that she wanted to.

Someone asked what kind of job she wanted to get.

"I don't care," she said, rubbing the side of her nose. (Beside her nose there were two small moles, lined up like a constellation.) "I mean, whatever I wind up with isn't going to be all that great anyway."

I lived in Asagaya at the time, and her place was in Koganei. So we rode the high-speed train together on the Chuo line out of Yotsuya. We sat down side by side in the train. It was past eleven, a bitter night, with a cold, biting wind. Before I'd known it we were in the season where you needed gloves and a muffler. As the train approached Asagaya I stood up, ready to get off, and she looked up at me and said, in a low voice, "If it's okay, would you let me stay at your place tonight?"

"Okay—but how come?"

"It's too far to go all the way back to Koganei."

"I have to warn you, it's a tiny apartment, and a real mess," I said.

"That doesn't bother me in the least," she said, and took the arm of my coat.

So she came to my cramped, crummy place, and we had some cans of beer. We took our time with the beer, and afterwards, like it was a natural next step, she shed her clothes right in front of me. Just like that, she was naked, and snuggled into my futon. Following her lead I took off my clothes and joined her in bed. I switched off the light, but the glow from the gas stove kept the room fairly bright. In bed we awkwardly warmed each other up. For a while neither of us said a word. So quickly naked with each other, it was hard to know what to talk about. But our bodies gradually warmed, and we literally felt the awkwardness loosen in our skin. It was an oddly intimate sensation.

That's when she asked, "I might yell out another man's name when I come. Are you okay with that?"

"Do you love him?" I asked her after I'd gotten the towel ready.

"I do. A lot," she said. "I love him so, so much. I'm always thinking of him, every minute. But he doesn't love me that much. What I mean is, he has a full-time girlfriend."

"But you're seeing him?"

"Um. He calls me whenever he wants my body," she said. "Like ordering takeout over the phone."

I had no clue how to respond, so kept quiet. She traced a figure on my back with her fingertips. Or maybe she was writing something in cursive.

"He told me my face is plain-looking but my body is the best."

I didn't think her face was particularly plain-looking, though calling her beautiful was going too far. Looking back on it now, I can't recall what kind of face she had, exactly, or describe it in any detail.

"But if he calls you, you go?"

"I love him, so what else can I do?" she said, like nothing could be more natural. "No matter what he says to me, there are just times when I'm dying to have a man make love to me."

I considered this. But back then it was beyond me to imagine what feelings this entailed—for a woman to want a man to make love to her (and even now, come to think of it, I don't entirely understand it).

"Loving someone is like having a mental illness that's not covered by health insurance," she said, in a flat tone, like she was reciting something written on the wall.

"I see," I said, affected by her words.

"So it's okay if you think of some other woman instead of me," she said. "Don't you have anybody you like?"

"Yeah, I do."

"So I don't mind if you yell out that person's name when you come. It won't bother me at all."

There *was* a girl I liked at the time, but circumstances kept us from getting more deeply involved, and when the moment arrived I didn't call out her name. The thought crossed my mind, but in the middle of sex it seemed kind of stupid, and I ejaculated into the woman without a word. She was about to yell out a man's name, like she said she would, and I had to hurriedly stuff the towel between her teeth. She had really strong, healthy-looking teeth. Any dentist would be properly impressed. I don't even remember what the name was she yelled out. All I recall is some nothing, run-of-the-mill name, and being impressed that such a bland name was, for her, precious and important. A simple name can, at the right time, really jolt a person's heart.

I had an early class the next morning where I had to submit a major report in lieu of a midterm, but as you can imagine I blew both of these off. (Which led to some huge problems later, but that's another story.) We finally woke up in the late morning, and boiled water for instant coffee, and ate some toast. There were eggs in the fridge and I boiled those up and we had them.

167

The sky was clear and cloudless, the morning sunlight dazzling, and I was feeling pretty lazy.

As she munched on buttered toast she asked me what I was majoring in at college.

"I'm in the literature department," I said.

"Do you want to be a novelist?" she asked.

"I'm not really planning on it," I answered honestly. I had no plans whatsoever at the time of becoming a novelist. I'd never even considered it (though there were plenty of people in my class who'd announced they were planning to become novelists). With this, she seemed to lose interest in me. Not that she had much interest to begin with. But still.

In the light of day her clear teeth marks embedded in the towel struck me as a little bizarre. She must have bitten down pretty hard. In the light of day, she seemed out of place. It was hard to believe this girl before me, small, bony, with a not-so-great complexion, was the same girl who had screamed out passionately in my arms in the winter moonlight the night before.

"I write tanka," she said, out of the blue.

"Tanka?"

"You know tanka, right?"

"Sure," I said. Even someone as naïve as me knew that much. "But this is the first time I've met someone who actually writes them."

She gave a happy laugh. "But there are people like that in the world, you know."

"Are you in a poetry club or something?"

"Not, it's not like that," she said. She gave a slight shrug. "Tanka are something you write by yourself. Right? It's not like playing basketball."

"What kind of tanka?"

"Do you want to hear some?"

I nodded.

"Really? You're not just saying that?"

"Really," I said.

And that was the truth. I seriously was curious. I mean, what kind of poems would she write, this girl who, a few hours before had moaned in my arms and yelled out another man's name?

She hesitated. "I don't think I can recite any here. It's embarrassing. And it's still just morning. But I did publish a kind of collection, so if you really want to read them I'll send it to you. Could you tell me your name and address?"

I jotted them on a piece of memo paper and handed it to her. She glanced at it, folding it in four, then stuffed it in the pocket of her overcoat. A light green coat that had seen better days. On the rounded collar was a silver broach shaped like a lily of the valley. I remember how it glistened in the sunlight streaming in the south-facing window. I know next to nothing about flowers, but for some reason I've always liked lilies of the valley.

"Thanks for letting me stay over. I truly didn't want to ride back to Koganei on my own," she said as she was leaving my place. "That happens with girls sometimes."

We were both well aware of it then. That we would probably never see each other again. That night she simply didn't want to ride the train all the way back to Koganei—that's all there was to it.

A week later her poetry collection arrived in the mail. Honestly, I really didn't expect her to follow up and send it. I figured she'd totally forgotten about me by the time she got back to her place in Koganei (perhaps trying to forget me as soon as she could), and never imagined she'd go to all the trouble of putting

a copy of the book in an envelope, writing my name and address, sticking on a stamp, and depositing it in a letterbox—maybe even going all the way to the post office for all I knew. Which is why, one morning when I spied that package in my mail slot, it took me by surprise.

The title of the poetry collection was *On a Stone Pillow*, the author simply listed as "Chiho." It wasn't clear if this was her real name, or a pen name. At the restaurant I must have heard her name many times, but I just couldn't recall it. No one called her Chiho, that much I knew. The book was in a plain brown business envelope, with no sender's name or address, and no card or letter included. Just one copy of a thin collection of poems, bound together with white string, silently resting inside. It wasn't some cheap mimeograph, but nicely printed on thick, high-quality paper. I'm guessing the author arranged the pages in order, attached the cardboard cover, and carefully hand-bound each copy using a needle and the string. To save on bookbinding costs. I tried imagining her doing that sort of piecework, but couldn't picture it. The number 28 was stamped on the first page. Must have been the twenty-eighth in a limited edition. How many were there altogether? There was no price indicated anywhere. Maybe there never was a price.

I didn't open the book right away. I left it on top of my desk, casting the occasional glance at the cover. It wasn't that I wasn't interested, it's just I felt that reading a poetry collection someone put together—especially a person who, a week before, had been naked in my arms—required a bit of mental preparation. A sort of respect towards it, I suppose. So I finally opened the book that weekend, in the evening. I leaned back against the wall next to the window and read it in the winter twilight. There were forty-two poems contained in the collection. One tanka per page. Not a particularly large number. There was no foreword, no

afterword, not even a date of publication. Just printed tanka in straightforward black type on white pages with generous margins. I certainly wasn't expecting some monumental literary work or anything. Like I said, I was just sort of personally curious. What kind of poems would a woman write who yelled out some guy's name in my ear as she chomped down on a towel. But what I found as I read through the collection was that several of the poems really got to me.

Tanka were basically a mystery to me (and still are, even now). So I'm certainly not able to venture an objective opinion about what tanka are considered great, and which not so much. But apart from any judgments of literary value, several of the tanka she wrote—eight of them, specifically—struck a chord deep within me.

This one, for instance:

> *The present moment / if it is the present moment /*
> *can only be taken / as the inescapable present*

> *In the mountain wind / a head cut off / without a word /*
> *June water at the roots of a hydrangea*

Strangely enough, as I opened the pages of the collection, following the large, black printed words with my eyes, and as I read the poems aloud, the girl's body I saw that night came back to my mind. Not the less-than-impressive figure I saw in the morning light, but the way she was as I held her body, enveloped by smooth skin, on that moonlit night. Her shapely round breasts, the small hard nipples, the sparse pubic hair, her dripping-wet vagina. As she reached orgasm she shut her eyes, alternately biting down hard on the towel and calling out, heartrendingly, another man's name in my ear. The name of a man somewhere, a humdrum name I can't recall anymore.

171

As I consider that / we'll never meet again / I also
consider how / there's no reason that we cannot

Will we meet / or will it simply end like this / drawn
by the light / trampled by shadows

I have no idea, of course, whether she's still writing tanka or not. As I said, I don't even know her name, and hardly remember her face. What I do remember is the name Chiho on the cover of the collection, her defenseless, soft, slick flesh in the pale winter moonlight shining in the window, and the mini-constellation of two small moles beside her nose.

Perhaps she's not even alive anymore. Sometimes I think that. I can't help but feel that maybe at some point she took her own life. I say this because most of her tanka—or at least most of the ones in that collection—were, beyond all doubt, images of death. And for some reason these involved a head being severed with a blade. For her that style might have been the best way to die.

Lost in this incessant / afternoon downpour / a nameless
ax /decapitates the twilight

But in a corner of my heart I'm still wishing she's alive somewhere in this world. Sometimes I'll catch myself, all of sudden, hoping that she's survived, and is still composing poetry. Why? Why do I take the trouble to think about something like that? There's not one thing in this world linking my life and hers. Even if, say, we passed each other on a street, or were seated at adjoining tables in a restaurant, I seriously doubt that we would even recognize each other. Like two straight lines overlapping, we momentarily crossed at a certain point, then went our separate ways.

Many years have passed since then. Strangely enough (or perhaps not so strangely) people age in the blink of an eye. Each and every moment our bodies are on a one-way journey to collapse and deterioration, unable to turn back the clock. I close my eyes, then open them again, only to realize that in the interim so many things have vanished. Buffeted by the intense midnight winds these things—some with names, some without—are blown away, without a trace. All that's left is a faint memory. Even memory, though, can hardly be relied on. Can anyone say for certain what *really* happened to us back then?

But even so, if we're blessed, a few words might remain by our side. They climb to the top of the hill during the night, crawl into small holes dug to fit the shape of their bodies, stay quite still, and let the stormy winds of time blow past. The dawn finally breaks, the wild wind subsides, and the surviving words quietly peek out from their hideouts. For the most part they have small voices, are shy, and only have ambiguous ways of expressing themselves. Even so, they are ready to serve as witnesses. As honest, fair witnesses. But in order to produce those enduring, long-suffering words, or else to find them and leave them behind, we must sacrifice, unconditionally, our own bodies, our very own hearts. We have to lay our own necks down on a cold stone pillow illuminated by the winter moon. Maybe, other than me, there's not another soul in this world who remembers that girl's poems, let alone can recite some of them. That slim little self-published book, bound together with string, is now forgotten, with the exception of number 28, all the other copies dispersed, sucked up somewhere into the benighted darkness between Jupiter and Saturn, vanished forever. Perhaps she herself (assuming she's still alive) can't recall a thing about those poems she wrote back when she was young. Maybe the only reason I recall some of her poetry even now is because it's linked to memories of her teeth

marks on that towel. Maybe that's all it is. I don't know how much meaning or value there is in still remembering all that, in sometimes pulling out that faded copy of the book from my drawer and reading it again. To tell the truth, I really don't know.

At any rate, her words remained. While other words and memories turned to dust and vanished.

> *Whether you cut it off / or someone else cuts it off / if you put your neck on the stone pillow / Believe it—you will turn to dust*

NIELS FREDRIK DAHL is a Norwegian writer, born in 1957, whose work has been translated into several languages. He is the author of five novels and seven poetry collections. A book of selected poetry, *Dette er et stille sted* ("This is a quiet place"), was published in 2017.

BECKY L. CROOK is a literary translator who has translated the children's poems of Norwegian writer Inger Hagerup. She is the founder of *Sand*, a literary journal in Berlin. She recently finished writing her first novel. When not dealing in words, she can otherwise be found in the woods, in her garden, in a book, or in conversation (with food!) with those she loves. She lives on an island near Seattle with her husband, daughter, and cat Momo.

THILO REINHARD is a translator and musician. In 1985, following studies at the University of California, Berkeley, he moved to Oslo, Norway, where he still makes his home. Reinhard translates from Norwegian, Swedish, Danish, and German into English.

How to Manage

NIELS FREDRIK DAHL
TRANSLATED FROM THE NORWEGIAN
BY BECKY L. CROOK WITH THILO REINHARD

For Linn

How to manage, how to lie down next to the dog, to its breath,
 its warm heart, until something you thought would never
let go lets go, your arms, your tongue, everything has been
 recorded somewhere though we don't know where, every
second of these years, these seven thousand days and nights,
 every caress, every cry and every sigh, every kiss and
every sadness, every touch, every speck of sun against the forest
 floor and it should be possible to read and understand

what it means to be you, be me, be with you, with me, follow you
 closely, your mouth, can you open your beautiful mouth,
we lie on the wave-scoured rock at the water's edge, you are
 writing your book, the fjord lapping the stone is dark
turquoise, grey geese above us, the ocean is warm enough now
 for the quiet lives of seahorses, a stingray's smile, and
for the jellyfish, who live on light, this is also a home, I know that
 you know that, but how to live, how to take in the

ears and flashing eyes of the roebuck in the wheat field which
 weathers from pale green to golden, the dog whimpers, and

I too would like to be a little closer, always a little closer to you,
 like a weary principle, maybe,

a stubbornness I'm not entitled to, but no quiet like that which
 is at the heart of your disquiet, without

gestures, closest to the skin, how to stand upright with one's arms
 outstretched, how

to hold the fingers together, the palms facing downward, how to
 spin around on one's own axis, how

to swirl like a dancing dervish while streams of sunlight are taken
 by the wind and a veil of fading green

is drawn across the grey silhouette of pine trees on the opposite
 side of the fjord, and when winter falls upon us,

you there in the snow, like it's all new, like something you've
 never seen before, and then you've seen it, and then you

haven't, once again anew, winter, winter, winter, every speck,
 every flake, every sliver, every

crystal, will it be white, yes it will, will it be peaceful, yes it will,
 if we're playing, pretending that the flecks of

sunlight against the forest floor are linked together like some
 brilliant necklace lost in the cellar, if we pretend

that you are listening directly with your heart to every sound,
 the dog talking in its sleep every single night, the girl

calling out to you from the depth of a dream, you're holding her
 warm body, you're pulling away the dreams

from her forehead, you wake up some mornings to a withered
 world that needs saving,

breathe life into it, how to breathe, until far inland, across the
 quarry that's lit up

all through the night, a white circle behind the eyelid when the
 day has shut, a sunspot turned inside out on the horizon,

the rain like jellyfish tendrils below the clouds, can it come here,
 do you think, can it drum us into

sleep and be there when we wake, the cool, dark sound outside,
 everything that happens to us is a riotous now and will

not let itself be remembered, now, now, now, now, like a breath
 of fire, outside, perhaps, it's springtime again, all the

birds, unquiet and then happiness, under the blossoming tree,
 with open eyes, with open mouth, we are without age and

without fear, and the forest, the night, the grass is stored in our
 faces, in the light of our fingers

RICHARD RUSSO is the author of nine novels, two story collections, one book of essays, and the memoir, *Elsewhere*. In 2002, he received the Pulitzer Prize for *Empire Falls*, which, like *Nobody's Fool*, was adapted into a film, in a multiple-award-winning HBO miniseries; his latest book is the novel *Chances Are...* In 2016 he was given the Indie Champion Award by the American Booksellers Association, and in 2017 he received France's Grand Prix de Littérature Américaine. He lives in Portland, Maine.

Good People

RICHARD RUSSO

E ven in the dim light of the crowded tavern, Tana's flaming
red hair was a beacon. Making my way toward it, I won-
dered—and not for the first time—what would happen in the
not too distant future when it began to gray. Red like that didn't
come in a bottle. Would she grow dull by degrees or wink out all
at once, like a lighthouse flame?

Sliding in next to her, I said, "How'd you manage to snag the
best booth in the joint?" It was the last week of classes and the
place was heaving.

"Good things," she said, studying my gruesome injury without
visible sympathy, "happen to good people." And bad things: well,
no need to say it. "*That*," she continued, "is one big-ass ugly eye."

I ignored her and poured myself a beer from the sweating
pitcher in the middle of the table. "Where's what's-his-name?"

"Guess."

"Already?" I said. "You've been here, what? Fifteen minutes?"

"He has the bladder control of a sixty-year-old woman with
ten kids."

Right on cue the men's room door swung open and Bobby,
dressed in jeans and a threadbare tweed jacket over his favorite
T-shirt—the one that read, *I Shaved My Balls for This?*—emerged,

drying his hands on his jeans. Evidently the Sweet Spot's men's room was out of paper towels again. Until recently there'd been a hand drier in there, but it had fritzed and when it went unrepaired somebody'd yanked it out of the wall. The hole it left was one of many, though the others were all smaller and fist-shaped. The Spot was the sort of dive bar that was popular with both grad students and bikers, two groups that in southern Florida were not as mutually exclusive as they were most other places. Punching the men's room wall wasn't even particularly discouraged here, though when you did you were supposed to sign your name beneath the hole. Perhaps because a Sharpie had been thoughtfully provided for this purpose—it dangled from a string that had been tied to the handle of a wall urinal—a surprising number of people did. Come August, in preparation for the new academic year, the wall would be re-Sheetrocked and plastered over, and the process of its destruction would commence all over again.

"You want to sit next to your wife?" I said when Bobby arrived.

"Not particularly," he said, cocking his head for a better look at my eye.

"Don't start," I warned him. "I'm in no fucking mood."

"Jesus, Guy," he said. "You should definitely see somebody."

"It'll heal."

"Yeah, but the thing is?" he said. "It's your whole head that needs examining, not just your eye. A bar fight? At your age?" I couldn't help grinning at him. There were really only two kinds of people in the world: those who believe what you tell them and those who don't. Bobby belonged to the first category.

Turning to his wife, who was definitely in the second, I said, "I could've sworn I warned him not to start."

She shrugged, as if to say, *Welcome to my world*.

"Did you win, at least?" Bobby wanted to know.

"Winning isn't everything," I told him. "The important thing is to compete."

"In other words you got your ass kicked."

"Yeah, but it wasn't a fair fight."

"How so?"

"She outweighed me by a hundred pounds, easy." This did elicit a grudging smile.

"Poor baby," Tana said, causing me to rotate and face her again. "How did it start? Was she wearing a MAGA hat?"

"Can we change the subject?"

"Sure," she said, fixing me now. "Where's Cloe?"

"Visiting her mother."

"Wait," Bobby said, shaking his head vigorously, as if it contained a rattle. "Isn't her mother . . ."

"Dead?" I said, turning back to him. Because yeah, she was. "Why do you have to find fault with every single thing I say? Can't we just sit here quietly and drink beer? Celebrate the weekend?"

"It's only Thursday."

"We're academics. No one signs up for Friday classes."

"When I was an undergraduate," he recalled nostalgically, "there were *Saturday* classes. Remember those?"

"No, really," Tana said. "Where's Cloe?"

"Are you sure you don't want to sit next to her?" I said to her husband. The trouble with half-moon booths was that whoever occupies the middle seat gets ganged up on. "I feel like my head's on a swivel."

He ignored this. "So, what'd you do? Go someplace else after we left here?" Clearly his feelings were hurt.

"What? I'm not allowed to drink except with you?"

"Okay, but you *told* us you were heading home. You *said*—"

"Maybe I enjoy lying to you," I suggested. "Did you ever think of that? I mean, what do I *do* for a living?"

Tana nudged me in the ribs. "*Now* I remember what I wanted to ask."

"What's that?"

"Where's Cloe?"

"How should I know? Text her."

"I did. She isn't responding."

I feigned surprise at this. "She turned in her grades this morning. She could be on a flight to Madrid, for all I know."

"Really?" Bobby said. "She's all done?"

"What can I tell you? Tennis coaches don't have a lot of exams to grade."

Clearly dispirited, he shook his head. "I've still got two batches of portfolios."

I snorted. "Poetry."

"Don't sneer. I hate it when you sneer."

"Okay, but describe a typical portfolio," I said. "What would it contain? Like, three sonnets? A hundred words total?"

Bobby, pointing his index finger at me, appealed to his wife. "And he wonders why people punch him."

"Poor baby," Tana said again, this time massaging my shoulders. "So many, *many* words he has to read! How *big* and *thick* his portfolios are compared to our puny ones! It's not fair! He should earn much, *much* more money than we do!"

"I *do* earn more money than you do."

She abruptly left off the massage. "Only because those Hollywood idiots keep renewing that movie option," My first novel, published decades earlier, had gotten some attention at the time. A producer had offered an option on it, then promptly lost interest. He dutifully continued to renew it every year, though, a small annuity I had gotten used to.

"Plus he owns *this* place," Bobby reminded her.

I didn't of course, but every fall he and Tana told a fresh crop of grad students that I did, and because my name is Guy Sweet and this was our go-to watering hole, most of them believed it, never mind my repeated denials.

"Actually," said Bobby, pointing, "aren't those your students over there?"

"Hard to tell with just the one good eye," I said, but sure enough, there on the other side of the tavern sat most of my Wednesday evening seminar.

"Oh, *look*!" Tana said, doing her best Sally Field. "They're *waving*, Guy! They *like* you! They really *like* you!"

"Next year," I said, raising my glass in their direction, "we're going to have to find a new place to drink."

"God," Tana groaned, Sally Field vanishing as quickly as she'd appeared. "Another year here. I don't want to think about it."

"Oh, come on," her husband said. "It's not so bad."

She ignored this as if he hadn't spoken. "Here's a thought! Maybe global warming is worse than we imagined. Maybe by next fall the whole university will be underwater."

Bobby was shaking his head. "Remember how happy we were when we landed these jobs?"

"Why would I want to be reminded of that?"

"We came here as newlyweds. All our poet friends were jealous because we had tenure-track jobs. They said we had life by the balls."

"Whereas the opposite proved true."

"Yeah, but when was the last time a poet ever had life by the balls?" I pointed out.

"Let me think," Tana said, pretending to take the question seriously. "Rod McKuen?"

Her husband sighed. "Happiness is a choice, is what I'm saying."

Tana put her index finger in her mouth and made a gagging sound.

"Also a pursuit," I added, "along with life and liberty. Not to mention a constitutional right. Some would even say a responsibility."

"Well," Bobby said, more to his wife than to me, "*I* choose to be happy."

"Fine," she told him. "Do that."

It occurred to me that they might actually be having a serious discussion.

"Professor Sweet?" said a nearby voice, startling me. Laura from my seminar. Turns out one-eyed men are easy to sneak up on. "Could I have a word?"

I consulted my watch. One of my few rules: twenty-four hours must elapse between when a student's work is critiqued in class and when they can meet with me to discuss it. Back when I instituted that regulation I was still young and green enough to believe that nobody could stay pissed off for more than a day. By my calculation only twenty-two hours had elapsed, which meant I'd be within my rights to put her off until tomorrow. On the other hand, it was the end of the semester and she didn't appear angry. She did look like she might cry, though, which would be just as bad.

Bobby must've come to the same conclusion, because he rose gallantly. "Slide in," he offered. "I have to visit the gents anyway."

Tana looked at the ceiling. "You've got to be joking."

Bobby ignored this, nodding significantly at Laura and me. "Don't you have to . . ."

"Pee? No," she told him, herself sliding out of the booth now. "I might vomit, though."

At this Bobby sighed even more mightily. "Tana . . ."

"I'm not saying I *will*, just that I *might*," she told him. "Think of it as a choice. Like happiness."

When they were gone, Laura, the most earnest and anxious of my students, said, "Do you think she was serious?"

"I've never known her to be."

She looked relieved, but then, really taking me in, she immediately became anxious again. "That looks really painful."

"Eh," I shrugged, though in fact the eye was throbbing to the beat of my respiration.

"Is it true?" Laura was saying. "That you were in a bar fight?"

"Nah, that's just what I'm telling people."

She blinked, confused. "Why would you do that?"

"Excellent question. Your next assignment is to write a story about a man who tells a lie that makes him look bad. Why would he do such a thing?"

"Ummm. Last night was our last class?"

"You can hand it in next fall."

"That's kind of what I wanted to talk to you about. I've pretty much decided not to come back."

"Because of your workshop?" Her final story had taken a pretty good pummeling. If I hadn't been preoccupied, I'd have stepped in sooner. Instead, I'd let it continue.

"That," she admitted, "but other things too."

"Like what?"

"I guess I thought writing would make me happy," she said. "It used to, actually. Not anymore."

I doubted this remark was intended as a criticism, but it was hard to take it any other way. Good workshops offer rigorous analysis that proceeds from goodwill, the desire to be helpful. Bad ones descend into something closer to a blood sport, and that's what had happened to ours over the last month. According to

Bobby and Tana the same thing was happening in their classes, evidence, they believed, that our program was on the rise, that the students we were admitting now were more talented and serious than the ones who were applying a decade ago when the program was still new. Competition was good. I had my doubts. "I'm not sure writing is supposed to make us happy," I offered.

"Okay, but didn't you tell us also that if you could be happy without writing then you probably shouldn't write?"

Yep. I had said this. Yet another truism I'd once subscribed to and now doubted.

"I mean, what's the point?" she continued. "Nobody reads anymore. Everybody's watching Netflix. Isn't reading kind of over?"

"Those Netflix shows are all written," I pointed out.

"I guess," she said. "I just keep thinking that to write stories you have to believe you're special."

"And you don't?"

"I think I'm pretty ordinary."

I grunted.

"What?"

"I only ever hear that from women writers," I told her, which was true. Their male counterparts by and large proceeded from an entirely different set of personal assumptions. "Mind if I ask how old are you?"

"Twenty-eight."

"And you think by now you should be extraordinary?"

"Steve Jobs was. Mark Zuckerberg."

"They weren't trying to be writers."

"Taylor Swift?"

"Musical careers typically start earlier. End earlier, too. Look. I can't tell you if you should quit or not. But you should probably

stop comparing yourself to celebrities. That never made anybody feel better about themselves."

"Okay, but how?"

"How what?"

"How do you just stop doing something you know isn't good for you?"

"If I knew the answer to *that*," I told her, "I wouldn't have this shiner. What are your plans for the summer?"

She shrugged. "Get a job?"

"Doing?"

"I don't know. Waiting tables?"

"Nothing wrong with that."

"Everybody else is talking about how they're going to write their asses off. I'm looking forward to *not* writing. Also I keep thinking I should let somebody else have my teaching assistantship. Somebody who really wants to be here."

"Don't be an idiot. TAs are cheap labor. It's the university that benefits. Take the summer. No writing. Just read. And only women writers, at least a decade older than you. Come the middle of August if you feel the same way, let us know. We'll find somebody else to abuse."

"Really?"

"Trust me."

"I do, actually," she said. "Trust you?"

"Dear God," Tana said, sliding back into one end of the booth as Laura slid out the other.

"What?"

Breathless Sally Field was back again. "Oh, I *trust* you, Professor Sweet. I really, *really* trust you!"

We stared at each other for a long beat, until I said, "So did you?"

"Did I what?"

"Vomit?"

Before she could answer, her husband returned, again drying his hands on his jeans. "So," he said. "What're we talking about?"

"I love you," Tana told him, and to look at her you'd have sworn she meant it.

His face brightened. "Yeah? How come?"

"Because you choose to be happy. *That* takes fucking balls."

Making the turn onto our street, I wasn't entirely surprised to see Cloe's car in the drive, its hatchback open. Even from a distance I could see that the vehicle was packed to the gills. The front door to the house stood wide open. In my rearview I saw Bobby and Tana—we'd all left the Sweet Spot together—register the situation as well. Bobby started to slow down, but I saw Tana shake her head urgently, and when I pulled into the drive they kept going. They lived on an adjacent cul-de-sac, their house situated almost directly behind ours. Cloe and I had helped them find it when they moved here—what—a decade earlier?

I was standing in the drive, staring at the crammed vehicle—even the passenger seat was stacked high with boxes—when Cloe emerged dragging two large suitcases. I could tell at a glance that there wouldn't be room for them, but I knew better than to say so. Actually, I was kind of proud of her. She'd thought ahead, leaving the suitcases for last so they'd be accessible when she stopped for the night somewhere between here and Arkansas, where both our families lived. Her usual MO was to just do things and deal with the unforeseen consequences when they arose. It was one of the sadder through-lines of our marriage—her telling me what she wanted to do and why, and me telling her what was wrong with how she was going about it. Now even her goodbye

190

to all that wasn't going to work out like she'd hoped, yet another bitter pill she had little choice but to swallow.

"Do you mind stepping out of the way?" she said.

I did as instructed. "Cloe," I said.

"Don't," she warned. "There's room. They'll fit."

"Yes," I agreed. "But not in this vehicle. Take the SUV."

"I don't want the SUV."

"Want doesn't come into it. It's what you need."

"Wait a second," she said. "Let me write that down. Want doesn't come into it."

She hoisted the first suitcase in, and yeah, there *was* room for that one. The vehicle's roof sloped, though, which meant the hatchback wouldn't close over the second. But of course she had to try, and give her credit, when she saw I was right she just set the suitcase down on the pavement and shifted into consequence-mode. Which of the boxes she'd loaded earlier could she do without to make room for the remaining suitcase? Could something be secured to the roof with bungee cords? Some other even dumber idea born of frustration?

"Be sensible," I said. "Take the good vehicle. I'll repack it. You really shouldn't be lugging heavy boxes with an injured shoulder." Though if last night was any indication, the physical therapy she'd been doing for her torn rotator cuff was paying major dividends.

"You hate my car," she pointed out.

"It'll be okay for the summer. Maybe in the fall I'll trade it in for something better."

Her eyes narrowed. "Let me guess. One of those little crotch rocket roadsters. Bright red."

Which pissed me off, of course, though I had it coming. "Please? Let me help?"

She paused, considering, not wanting to admit I was right, not wanting to accept my generosity, if that's what it was. "I *do* deserve the better vehicle," she said.

"No argument."

"You know, it's kind of amazing?"

"What is?"

"You're not even going to ask me to stay, are you."

"You seem pretty determined."

"Yeah, except that's not what's holding you back. You said last night that you wished I wouldn't go, but we both know that's bullshit. With me gone you won't have to sneak around anymore." When I said nothing to that, she said, "Fine. Knock yourself out. I'll be inside."

I'd loaded only a couple boxes when Bobby pulled up to the curb and got out. Staring at the house, he said, "Tana was right, then? Cloe's leaving?"

I nodded.

He sighed, genuinely saddened. "You want a hand?"

"Why not?"

It took all of fifteen minutes, but by the time we finished, I was winded. Until this year I'd been good about trying to stay in shape, getting up early to run most mornings, playing Saturday morning basketball with our grad students. I knew I needed to start doing all that again, but lately I felt too old for any of it. We sat on the rear bumper while I caught my breath.

"Should I go inside and say goodbye at least?" Bobby wondered.

I knew how fond he was of Cloe, but I shook my head. "I'm guessing she knows you're out here. I think what she had in mind was a clean getaway. As if there were such a thing."

Bobby looked thoughtful. "I ever tell you what Tana said?"

I raised an eyebrow at him.

"That I should be married to Cloe and you to her?"

"How did she figure that?"

"She said Cloe and I are nice people, whereas basically you and she are assholes."

"And you responded?"

"I said you weren't an asshole."

Not a bad line. I gave it a chuckle. "A minority view as it turns out, but thanks."

"Actually," he said, cocking his head thoughtfully, "I may have said you weren't that *big* of an asshole."

"Again. Minority opinion."

"So . . . I gather you saw this coming?"

"Yep."

"For how long?"

"From about the time we said I do. We were best friends. We should've left it at that."

"Still, twenty years together isn't nothing."

"This last one's really been for shit, though." In fact, I'd known we were finished since February, the day I came home and found her staring into the medicine cabinet. She'd had gallbladder surgery that January and been given a prescription for pain. She had a jock's suspicion of narcotics, though, so as soon as the hurt began to subside she'd set about weaning herself. When she quit taking the pills the plastic vial was still half full. Closing the medicine cabinet, she saw me standing behind her in the mirror and shook her head in disgust.

"What?" I said.

When she brushed angrily past me, I followed her into the kitchen. "What?"

"Nothing," she said, yanking open the fridge, then quickly closing it again, as if it contained something she didn't want me to see.

"Cloe, I'm serious. What?"

She leaned her head against the top of the fridge. "Tell me you didn't sell them."

"Sell what?"

"Don't play stupid, Guy. The Oxys. You know as well as I do how much those pills are worth on the street."

"You think I would do that?"

"I notice you haven't denied it."

"I can't believe you're accusing me."

"Yeah? You should see the look on your face."

"You should see the look on your own."

"*Did* you sell them?"

"No."

"Did you take them?"

"You mean swallow them?"

"No, I mean did you take them from the cabinet?"

"No. I just told you I didn't."

"No, you said you didn't *sell* them. Did you give them to someone?"

"No."

"Your new girlfriend, maybe? Because that would be just like you."

"I don't have a new girlfriend," I told her, which was true.

"Yeah, but you've said that before, Guy. And there was."

In the end I'd convinced her I was telling the truth, at least about the missing pills. But it was over, and I think we both knew it.

"Well," Bobby said, getting back to his feet, "if you want to talk, I'm around."

"I appreciate that."

"*Except*," he said, a pained expression on his face, "that's only partly true. I'm just around until the end of the week."

This was news. "Where are you off to?"

"Vermont. Both of us, in fact."

"Yeah? For how long?"

"The whole summer, we hope. Tana's got an old college friend who scored some sort of fellowship in Italy, so she offered to let us house-sit. Escape the heat."

"Sounds nice. When did all this happen?"

"The offer was made a few weeks ago, but we just decided last night. Actually?"

I waited. You did well to pay attention to Bobby's *actually*s.

"Yours is not the only messed-up marriage."

This wasn't news, but I pretended it was.

"We're hoping a month or two in the Vermont woods, just the two of us, might get us back on track."

I nodded. "Well, good luck. Even if it doesn't work out, at least you'll be cooler."

He looked worried. "Rotten timing, though. Will you be okay here by yourself?"

"Me? Sure."

He didn't look all that convinced, but we shook on it.

Cloe must've been watching us from inside because as soon as Bobby drove off, she came out and handed me the keys to her hatchback. I took the keys to the SUV off their ring and handed them to her. "Zip me an email when you get where you're going?"

"Please don't do that."

"Do what?"

"Pretend you care."

"I'm not pretending. I do care. Are you going to be all right?"

She shrugged. "We'll see. I'll have family and friends around. I won't be lonely, at least." Like she was here with me, no need to put that into words.

Sliding in behind the wheel, she inserted her key in the ignition. When she didn't immediately turn it, I said, "Did Tana tell you she and Bobby were heading to Vermont for the summer?"

"I knew she was thinking about it. She's decided to let Bobby come too?"

"She was thinking about going alone?"

"I shouldn't have told you that. It was spoken in confidence."

I thought about telling her what Bobby said, about all of us being married to the wrong people, make a joke out of it, but decided against it. Instead, I said, "What about this place?"

"What about it?"

"I don't really need a house if it's just me."

"Right," she said. "Except it's not just you."

It was nearly midnight when the gate swung open on its creaky hinge. A moment later Tana joined me on the patio where for the last several hours I'd been sitting in darkness that would've been complete but for a neighbor's yellow patio light. Lifting the whiskey bottle to gauge how much was left, she poured some into the extra glass I'd brought out just in case. "You're up late," I ventured.

"Bobby's snoring."

"What if he wakes up and finds you gone?"

"Oh, he'll definitely wake up. He has to pee at least three times a night. First time's usually around one-thirty, though." She sighed mightily. "How many people do you suppose would get married if they knew that in the end it all comes down to peeing and snoring?" She chuckled. "So. No bar fight? No three-hundred-pound woman in a MAGA hat?"

"Nope. Lacrosse ball."

"Sorry?"

"Cloe was using it to rehab her rotator cuff. It must've been handy, because I came into the bedroom and the next thing I knew I was sitting on my ass out in the hall." When Tana didn't say anything, I glanced over and saw that her shoulders were shaking.

"I'm sorry," she said finally. "It's just that her being such a jock was always what you liked best about her."

Which was true. The Cloe I'd fallen for was Cloe in motion. She was most herself with a ball or racquet in her hand. "I don't think she'd made up her mind to leave until she saw what she'd done. It scared her, was my impression."

"Bobby tells me you saw it coming?"

"The lacrosse ball or her leaving?"

"Her leaving, idiot."

"Yeah, I did. You don't seem that surprised."

"She told me a while back that she was thinking about it."

"Thanks for the heads-up."

We sat quietly, both of us staring at the dark second-story window of their house on the other side of the fence that separated their cul-de-sac from ours. If Bobby did wake up to pee, we'd see the light go on. The proximity of our houses had been nice, at least in the beginning. They'd see Cloe and me having a glass of wine on the back deck and call to see if we wanted company. We usually did. We made a fun, if oddly configured, foursome, Cloe and Bobby enjoying their straightforward, earnest conversations, Tana and I trading snark. Then one night they came to dinner and Tana touched my wrist—to get my attention, I thought, since Bobby and I were arguing about baseball, the only sport either of us cared much about—but the touch lingered, and later that night, after they'd gone home, I went upstairs and noticed the light on in their bedroom window. The curtain was pulled back

and a moment later Tana appeared, naked from the waist up, and stood looking across our dark yards, a good long beat before pulling the curtain closed. That was how it had begun. So no, I hadn't really lied to Cloe. It wasn't a *new* girlfriend I had.

"So," I said. "Vermont?"

"Yep."

"When were you planning to tell me?"

"Tonight. Right now."

The neighbor's patio light happened to switch off right then, and suddenly Tana's hair wasn't red anymore, which for some reason sent a wave of panic over me, as if at that moment I'd looked down and seen that the deck was writhing with serpents. I must've made some sort of noise because Tana looked over at me and said, "What?"

"Nothing."

Taking out her phone, she brought up the flashlight feature and shined it on me. "You're sweating."

"I know," I said. In fact, just that quickly I'd soaked through my shirt. In the reflected light of her phone I could see that her hair was still red, that neither it nor she had winked out, and for some reason this calmed me. I could feel my breathing return to normal.

"Are you having a heart attack?"

"No," I said. "At least I don't think so."

"You're a mess, Guy." When she turned off the phone's flashlight app, her hair went black again, and I waited for the panic to return, but it didn't. "Maybe we should go inside," she suggested.

Later, after we'd had sex, we lay in the dark, staring at the ceiling, until I said, "So how do you see this all working out?"

"What working out?"

"When you and Bobby return in the fall. Do we just start up again?"

"Maybe. Probably. I mean, there's nobody else, right?"

Since she really seemed to want to know, I told her no, there was nobody else. Not with Cloe gone.

"Maybe," I said, "we should just surrender the pretense."

"Which?"

"Of being decent people."

"Absolutely not," she said with surprising conviction.

"Really? I mean, look at us."

She shrugged. "Think of it as a choice. My husband chooses to be happy. I choose to think of myself as a good person."

"But—"

She reached over and put a finger on my lips. "The next thing you say will be very, very wrong."

Little did she know. Because it had been on the tip of my tongue to ask if she was the one who swiped the Oxys. How many evenings this spring had we come together here, the four of us, for drinks or dinner, each of these an opportunity. My first thought had been that we'd been burgled, but it made more sense for the thief to be someone who not only had access but knowledge of Cloe's recent surgery. Add to that the fact that she and Bobby, as a result of having bought more house than they could really afford, were always strapped for cash, always having to ask either her parents or his for a loan, and, well . . .

She rose and pulled on her panties, and I smiled, remembering our first time, how pleased I'd been that her collars and cuffs matched. "You should get some sleep," she suggested.

"You're right," I said, though Bobby's earlier diagnosis—that what I needed was to get my head examined—seemed equally valid.

When she was gone I went over to the window. In the darkness I could make out just the line of their roof until a minute later a light came on downstairs, Tana returning. At almost the

same instant a light went on upstairs in their curtained bedroom window. I checked my watch and, sure enough: one-thirty on the dot; Bobby waking up to pee. Somewhere, from the general direction of downtown, there were sirens, a bunch of them.

Pulling the curtains shut, I climbed back into bed and was about to switch off the lamp when my phone buzzed with an incoming text, which read: *He tells people he was in a bar fight because it's less ridiculous than the truth. I imagine he's probably been telling lies like this most of his life, which is why he's fun to be around. Still, I feel kind of sorry for him.*

I thought about writing *Me, too*, but couldn't decide if that was true.

The next morning I awoke to another text, this one from Bobby: *Well, you were right. We're going to have to find a new place to drink next fall.*

What little was left of the Sweet Spot was still smoking by the time I arrived. The fire had apparently started in the men's room around closing. There'd been just a few stragglers drinking at the bar after last call, and despite being shit-faced they'd all managed to make it out of the burning building. Everybody thought there'd been no casualties until somebody noticed Raymond's Harley in the otherwise empty parking lot. The bike had been customized so it could be driven by a guy with hooks for hands. I'd seen him around and it was wonderful what he could do with those hooks of his. There are some things, though, that no man wants others to witness, and in the men's room Raymond always used the only stall that had a door. That was where the firefighters found his charred remains. Had he closed the door behind him and in his panic been unable to work the latch that opened it? Or had he nodded off on the commode?

"I'm sorry, Professor," said a voice at my elbow. A student, one of Tana's poets, or maybe Bobby's. I must've looked confused, because he said, "You own the place, right?"

"You shouldn't believe everything you hear," I told him.

"Everybody says you do," he pointed out.

I started to explain that default mode for any decent writer should be curiosity, a need to verify the truth of what "everybody" believes. Instead I just said, "Trust me, I don't."

The look he gave me then was both sly and knowing. "Then how come you're crying?" was what he wanted to know. Had he been one of my fiction students, I'd have told him to write me a story that would answer this question, but he wasn't, so I just let him believe what he wanted.

ROBIN COSTE LEWIS,
the winner of the National
Book Award for *Voyage of
the Sable Venus,* is the poet
laureate of Los Angeles.
She is writer-in-residence
at the University of South-
ern California and a Gug-
genheim Fellow.

High Fidelity:
Los Angeles, 1960

ROBIN COSTE LEWIS

They fuck for a Hi-Fi. A pine console
of photographic veneer inlaid with glittering

plastic. That was the deal. When he got home
she'd whined like a girl—always his signal

(or was it hers?) that she would be generous
if he gave in to the new electronic

appliance she wanted. That's how stove-top
toast became a toaster; how the icebox

became a Frigidaire. As she goes to work
on top of him, she's not thinking. Her body

is a Quad, a Klipsch, or the H.H.
Scott. She's a Clairtone with a built-in Electro-Voice

speaker, and each button and knob—when tuned
or pushed—adjusts her sounds automatically.

In the time it takes to exhaust him,
she's narrowed it down. Either she wants

the new McIntosh or a Magnavox
because there's one down at the Goodwill,

slightly used. It has a record changer
that can play their seventy-eights

but still spin the new little forty-fives.
She is sweating in her new slip, the one

she got on her new peach-colored credit
card, downtown at the Sears & Roebuck's.

He's wearing his undershirt, one
of many she pressed over the weekend

with starch whisked quick
from flour and water. He's done.

She's proud. The boys sleep on
the sofa bed in the living

room. He lights two Pall Malls, passes
her the most lit. She takes a hit.

I know which one I want, she says.
He nuzzles his nose into his armpit.

Which one what? he asks, and rolls
over, chuckling.

OLGA TOKARCZUK is the winner of the 2018 Nobel Prize in Literature, co-winner of the International Booker Prize, and a finalist for the National Book Award in Translated Literature, as well as repeat recipient of Poland's highest literary honor, the Nike. She is the author of eight novels and two short story collections, and has been translated into forty languages.

JENNIFER CROFT is the author of *Homesick* and *Serpientes y escaleras* and the co-winner with Olga Tokarczuk of the 2018 International Booker Prize for *Flights*.

Seams

OLGA TOKARCZUK
TRANSLATED FROM THE POLISH
BY JENNIFER CROFT

The whole thing started one morning when B., having wrestled the sheets off himself, toddled as usual to the bathroom. He had slept poorly of late, nights breaking him apart into pieces as small as the beads on his wife's necklace that he'd found in a drawer after she'd died. He had held that necklace in the palm of his hand, and the ancient string had broken, and the faded spheres had scattered, tiny, all across the floor. Most of them he had not managed to find, and ever since, during his sleepless nights, he had often wondered where they might be leading their globular, insensate lives, in what clumps of dust they might have nested, which minute crevices might have become their lodgings now.

That morning, as he was sitting on the toilet, he noticed that each of his socks had a seam that ran down its middle—an expertly done seam, machine-made, that led from the toe to the cuff.

It seemed like a small thing, but it did intrigue him. Evidently he had put them on without paying much attention, allowing this quirk to escape him. Socks with full-length seams, from the toes up through the insteps all the way to the cuffs. And so, once he

had done with his morning ablutions, he stomped straight over to the wardrobe, where his socks resided in the bottom drawer in a dense gray-black clump. He disentangled the first one he came upon, brought it up to eye level, and unfurled it. He had landed on a black one, and the room was fairly dark, so he could not quite discern it. He had to go back to his bedroom to get his glasses, and only then was he able to see that the black sock, too, had the same kind of seam. Soon he had pulled all his socks out, taking the opportunity to try and find their mates—each and every one of them had a seam that ran from the toe to the cuff. Suddenly it felt as though this seam must be inherent to the sock, an obvious part of it, inseparable from the idea of sockhood.

At first he felt angry—whether at himself or at the socks, he wasn't sure. Total strangers to him were such socks, with such seams, spanning their entireties. As far as he had ever known, socks had seams that ran crosswise at toenail level, but beyond that, they were smooth. Smooth! He put the black one on, but it looked so odd he threw it aside in disgust. He started to try on others, but he tired fast, and for a second he felt he could not breathe. Never before had he seen such a seam on a sock. How could this be happening?

He decided to forget about the whole thing with the socks; lately he had done so often: whatever overwhelmed him, he took care to store in the attic of his mind, knowing it wasn't likely he'd need access to it again, anyway. Now he began the complicated ritual of brewing his morning tea, into which he sprinkled herbs for his prostate. The blend overflowed its strainer twice. While the liquid trickled through, B. cut bread and spread butter over two meager pieces. The strawberry jam he'd made himself had spoiled—the mold's blue-gray eye gazed out at him provocatively, shamelessly from inside the jar. He ate his bread with butter alone.

208

He did think of the thing with the socks several more times, but he was already treating it as merely a necessary evil, just like the leaky faucet, the torn-off cupboard handle, or the broken zipper on his jacket. Handling such matters would have been beyond him now. When he was finished with breakfast he marked what he planned to watch later on the television schedule. He tried to occupy the day completely, leaving only a little empty time to cook lunch and go to the store. Though he almost never managed to comply with the TV's regime. Instead, he'd fall asleep in his chair and come to suddenly, without any awareness of the hour, attempting to orient himself according to whatever was then on the screen, to see what part of the day he had landed in that time.

At the store on the corner where he bought his groceries there was a woman who was called the Manager. She was a big, strong woman with very light-colored skin and well-defined eyebrows that were as thin as threads. He was already bagging his bread and a can of pasztet when he suddenly felt an urge. He asked, almost in spite of himself, for socks.

"I'd recommend the non-constricting," said the Manager, handing him a pair of brown socks tightly packed in cellophane. B. clumsily turned them over and over in his hands, trying to see if he could tell through the packaging. The Manager took them from him, swiftly stripped them of their cellophane. Then she lay out one of the socks in the palm of her manicured hand with its attractive artificial nails and held it up for B. to see.

"Look at that, they don't have cuffs, they don't constrict, so the blood flows normally through your legs into your feet. At your age . . .," she began, but she didn't finish, no doubt realizing that age was not a good subject for small talk.

B. leaned over her hand like he intended to kiss it.

Down the middle of the sock ran a seam.

"You don't have any without that seam there, do you?" he asked, as though as an afterthought, as he paid.

"What do you mean, without a seam?" The Manager startled.

"Just for them to be completely smooth."

"But what do you mean? That's impossible. How would that work? How would the sock stay together?"

So he decided to definitively leave the thing alone. As a person starts to age, there are lots of things they miss—the world goes full steam ahead, people always coming up with something new, the next amenities. When socks had changed, he hadn't noticed. Who knew, maybe they had been this way a while. You can't be an expert in everything, he cheered himself as he toddled on home. His trolley bag rattled after him, joyful on its wheels, and the sun was shining, and the neighbor woman from down below was washing her windows, and that reminded him he was meaning to ask her if she could recommend a window washer for his place. Now he saw his windows from the outside—gray, just like the curtains. You might think the person who lived in his apartment had already passed. But he chased those silly thoughts away and made small talk with the neighbor lady for a bit.

Seeing her spring cleaning made him anxious that he ought to be doing something, too. He set his groceries down on the kitchen floor and went into his wife's room, where he slept now, his own room having been relegated to storage: old TV schedules, and boxes, and empty yogurt containers, and other things that might yet come in handy.

He glanced around. It was pleasant and still feminine, and he found that everything was as it ought to be: the curtains were drawn, the light was low, and the bed was neatly made, with just one corner of the comforter turned down, as though he slept motionless. In the glossy cabinet stood the teacups with their

decorative gold and cobalt bands, the crystal glasses, the barometer brought back from the seaside. His blood pressure monitor lay on the bedside table. On the other side of the bed, the large wardrobe had been calling him for months, but since her death, he'd hardly even opened it. Her clothing was still hanging there, and he had promised himself time and time again that he'd get rid of it, but it was a thing he'd not quite managed yet. But now a brave new thought came to him: what if he just gave these things to the woman who lived downstairs? And he could take the opportunity to ask about a window washer.

For lunch, he made himself some instant soup—asparagus—that was actually really good. As main course, yesterday's new potatoes, fried, which he washed down with kefir. After the nap that naturally followed from lunch, B. went into his room, and over the next two frenzied hours, he cleaned up all the old television schedules that had been set in there week after week, fifty-something of them yearly; and so some four hundred issues had gathered in those wobbly, dusty stacks. Throwing them away would be symbolic: B. needed to kick off this year—years began in the spring, after all, not on some number on a calendar—with an act of cleansing, like a ritual bath. He managed to get all of them out to the dumpster and to heave them over the side of the yellow container labeled "paper," but then he panicked—he'd just eliminated a part of his life, amputated his time, his own history. On tiptoe, he peered down desperately, trying to spot his TV schedules. But they had vanished into oblivion. On the staircase, as he climbed back up to his floor, he sobbed—briefly, shamefully—and then he felt weak, which must have meant his blood pressure had shot up.

The next morning, when he sat down after breakfast as usual to mark the television programs worth watching, he found his pen was really getting on his nerves. The mark it left was

brown, was ugly. At first he thought it was the paper's fault, so he grabbed a different page from something else and furiously started trying to circle stuff, but those circles, too, came out brown. He decided the ink in this pen must have changed color, from old age or for some other reason. Upset that he had to disrupt his favorite ritual to go and find something else to write with, he stomped over to the glossy cabinet where he and his wife had amassed many pens over the years. There were an awful lot of them, and of course many were no longer usable—the ink had dried up, the little pathways in their cartridges had clogged. He rummaged around in that trove awhile, till he had amassed two handfuls, returning to his paper certain he would find at least one that would write as it was supposed to: in blue, in black, push come to shove in red or green. But none of them did. All of them left behind them a hideous trail the color of crap or rotting leaves or floor polish or moist rust, a color to make a person vomit. B. sat for a long time without moving, except that his hands trembled slightly. Then he leaped up and swung open the cubby in the old wall unit where he kept his documents; he grabbed the first letter from the row but instantly set it back down; it and all the rest of them—statements, bills, notices—had been written on computers. Only when he had managed to pull out some hand-addressed envelope from the very end did he understand that he had to give up: the ink on this envelope, too, was brown.

He sat down in his favorite armchair for watching TV, pulled out the leg rest and sat still like that, breathing and gazing up at the indifferent white of the ceiling. Only after a while did other thoughts begin to storm his mind; he entertained and discarded them in turn:

—that there might be something in the ink of pens that loses its true color with time and turns brown;

—that there was something in the air now, some toxin, that made the ink change color;

and finally:

—that it was his eyesight that had changed, maybe that yellow spot, and if not, cataracts, and that that was causing him to see color in a different way.

But the ceiling was still white. B. stood and went about marking his programs—the color didn't really matter, after all. It turned out *Secrets of the Second World War* was going to be on later, along with a movie about bees on Planète+. He had wanted to keep bees, once.

Next it was the stamps. One day he pulled his letters out of the mailbox and froze, seeing that all the stamps on them were round. Dentate, colorful, the size of a zloty coin. He felt hot. Without concern for his knee pain, he raced up the stairs, opened the door, and without even taking off his shoes ran to the cubby where he kept his correspondence. He got dizzy. He saw the stamps were round on all the envelopes, even the older ones.

He sat down in his armchair and riffled through his memories trying to find one true picture of a stamp. He knew he hadn't lost his mind—so why did these round stamps look so outrageous? Maybe he simply hadn't paid attention to stamps before now. The tongue, that sweet adhesive, that little piece of paper his fingers would attach onto an envelope . . . Letters had been fat once, even bulging. Envelopes had been light blue, and your tongue would follow along their adhesive trail, and then you'd press the two halves of the envelope together with your fingers. You'd turn over the envelope and . . . —yes, the stamp had been square. That was certain. And now it was round. How was that possible? He covered his face in his hands and sat like that for a moment in the soothing emptiness that was always there under

his eyelids, just waiting to be summoned back. Then he went into the kitchen and put away his groceries.

The neighbor was hesitant to accept his gift. Suspiciously, she examined the sweaters and silk blouses so carefully folded and placed in a box. But she could not conceal the flash of lust when her gaze fell on the fur. B. hung it up for her from the door.

When they had sat down at the table and eaten their pieces of cake and drunk their tea, B. got up the courage.

"Stasia," he began dramatically, in a hushed tone. The woman looked up at him, her curiosity piqued, though her lively brown eyes were drowning in the depths of her wrinkles. "Stasia," he continued. "Something is wrong. Can you tell me whether socks are supposed to have seams—that is, seams that run all up and down them?"

She said nothing, apparently taken aback by the question, reclining slightly in her chair.

"What are you talking about, friend? What do you mean, do they have seams? Of course they do."

"But have they always?"

"But what are you talking about, 'have they always'? Of course they always have."

In a somewhat nervous motion, the woman flicked some cake crumbs off the table and smoothed out the cloth.

"Stasia, what color do pens write in?" he asked now.

She hadn't had time to reply when he added impatiently:

"Blue, right? Pens, ever since they were invented, have always written in blue."

The smile was slowly disappearing from the woman's rumpled face.

"It's nothing to get so worked up over. They can also write in red and green."

"Oh, I know that, but they're usually blue, aren't they?"

"Do you want something a little stronger? A little liqueur, maybe?"

He was about to say no because he wasn't supposed to drink alcohol, but of course he realized the situation was exceptional. He said yes.

The woman turned to the wall unit and took a bottle out from the cubby there. She meted out two glasses' worth. Her hands trembled slightly. In this room of hers everything was white and light blue: wallpaper with thin blue stripes, a white cover and white throw pillows on the sofa. On the table stood a bouquet of fake blue and white flowers. The liqueur released a sweetness in their mouths, sent back dangerous words into the depths of their bodies.

With great caution, he began again. "Tell me, though. Doesn't it seem to you the world has changed? That"—he sought out the right words—"it's hard to get ahold of it these days?"

She smiled again now, as though in relief.

"Of course, my dear, but of course. Time has sped up, that's why. That is, it has not sped up, but our minds have worn out, and we can't catch the time as it goes by like we could have, once."

He shook his head helplessly, and this showed her he didn't understand.

"We're like old hourglasses, you know? I've read on this. The grains of sand get rounder the more they trickle, and they slowly rub away, which makes the sand flow faster. Old hourglasses always run fast. Did you know that? It's the same with our nervous system, it's also used up, you know, tired out, and stimuli flow through it like through a sieve that's filled with holes, and that's what makes us feel like time is flowing faster."

"And other things?"

"What other things?"

"Oh, you know . . ." He tried to come up with some ruse, but nothing came to mind, so he came out with it directly: "Have you ever heard of rectangular postage stamps?"

"Interesting," she answered, refilling their glasses. "No, I never have."

"Or of glasses that have spouts on them. I mean, well, you know, like this one. They didn't use to have those . . ."

"But—" she started, but he interrupted her.

"Or jars that open if you turn to the left, or clocks having a zero now instead of a twelve, or, and also . . ." He fell silent, too distraught to finish his list.

She was sitting across from him with her hands folded on her lap, suddenly resigned, polite, correct, as though all the wind had been taken out of her. Only her furrowed brow suggested how very uncomfortable it was for her to be in this position, and her eyes, which gazed out at him in stress and disappointment.

In the evening, as usual, he lay down in his wife's bed, which was where he had slept since her funeral. He pulled the duvet up to his nose and lay on his back, gazing into the darkness and listening to his own heartbeat. Sleep was not forthcoming, so he stood up to open the wardrobe and take out his wife's pink nightgown. He held it to his chest, and one short sob burst out of his throat. The nightgown helped—but then sleep came and annihilated everything.

ANDREW McMILLAN's debut collection, *physical*, was the first ever poetry collection to win the Guardian First Book Award. It also won a Somerset Maugham Award and was short-listed for the Dylan Thomas Prize and the Forward Prize for Best First Collection. In 2019 it was named as one of the top twenty-five poetry books of the last twenty-five years by the Booksellers Association (UK). His second collection, *playtime*, was published by Jonathan Cape in 2018; it was a Poetry Book Society Recommendation for Autumn 2018, a Poetry Book of the Month in both the *Observer* and the *Telegraph*, a Poetry Book of the Year in the *Sunday Times*, and won the Polari Prize. McMillan is a senior lecturer at the Manchester Writing School at Manchester Metropolitan University. He lives in Manchester.

swan

ANDREW McMILLAN

i)

the lake is calm tonight
 the moon has dropped white feathers on the water

tonight the lake is calm
 the wavelets lap like rustling wings

the lake tonight is calm
 but look who is coming in to land

to tear the peace asunder

ii)

my first time in water
I was unnaturally good heavier somehow
so much power inside me
arms forcing the water away
like prising someone's mouth apart
to take out what's inside

only ever more water that comes through

iii)

then the year everything was swan

 feathers on my pillow on the floor
 wet prints in the hallway where I'd walked
 men in white coats little pellets in their hands
 the shadow of my back curved against the wall

iv)

the black swan of debt
the black swan of my own body of my mum
the black swan of sex
the black swan of the house of the wall the loft the damp
the black swan of rain
the black swan of the dog
the black swan of weddings
the black swan of the neighbours of him

each one fury-footed in my stomach

v)

then the year everything was darkness
 the red beak of my longing

the wedge of men in flight from club to club
banked in at every bar
loneliness as though I'm dying of thirst
I think the men must be where water is
I always go face-first to drink

vi) queen

sing a swan of sixpence
a brokenhearted guy
four and twenty whoopers
kept locked up inside
when the door was opened
the swans began to hiss
what is the solution
for such a man as this?
your dad is in the living room
saying things are wrong
your mum is napping fitfully
all her strength is gone
your mind is in the puddle now
soaking up the rain
they're coming now to peck at it
your damp and ruined brain

vii)

mother don't eat me
mother I'm trying so hard to get better
I'm sorry I'm a queer

remember how small I was mother
newly hatched cygnet like a cloud fallen down on the water
now it's only rain mother so much of it

hitting the lake bringing it to the boil

viii)

I plucked each feather from myself
slight resistance and then a rising out
like pulling up a weed when I was bald
I beheld myself in the mirror of the water's edge
my neck looked ridiculous
my eyes the only part of me that still had life
I raised each failed wing just flesh now
nothing for the wind to get up under
the mirror cracked with the tides
I reared up I jumped I watched myself
broken fall towards myself

Contributor Notes

Sam Bett is a writer and a translator. His translation of *Star* by Yukio Mishima (New Directions, 2019) won the 2019/2020 Japan-U.S. Friendship Commission Prize for the Translation of Japanese Literature. Awarded the Grand Prize in the 2nd Japanese Literature Publishing Project's International Translation Competition, he has translated work by Yoko Ogawa, Fuminori Nakamura, Haruomi Hosono, and NisiOisiN. With David Boyd, he is co-translating the novels of Mieko Kawakami for Europa Editions.

David Boyd is Assistant Professor of Japanese at the University of North Carolina at Charlotte. He has translated novels and stories by Hiroko Oyamada, Masatsugu Ono, and Toh EnJoe, among others. His translation of Hideo Furukawa's *Slow Boat* won the 2017/2018 Japan-U.S. Friendship Commission Prize for the Translation of Japanese Literature. With Sam Bett, he is co-translating the novels of Mieko Kawakami for Europa Editions.

Anne Carson was born in Canada and teaches ancient Greek for a living.

Sandra Cisneros is a poet, short story writer, novelist, essayist, and visual artist whose work explores the lives of Mexicans and Mexican-Americans. Her numerous awards include a MacArthur Fellowship, the National Medal of Arts, a Ford Foundation Art of Change Fellowship, and the PEN/Nabokov Award for Achievement in International Literature. Her novel *The House on Mango Street* has sold over six million copies, has been translated into over twenty-five languages, and is required reading in schools and universities across the nation.

Jennifer Croft is the author of *Homesick* and *Serpientes y escaleras* and the co-winner with Olga Tokarczuk of the International Booker Prize for *Flights*.

Becky L. Crook is a literary translator who has translated the children's poems of Norwegian writer Inger Hagerup. She is the founder of *Sand*, a literary journal in Berlin. She recently finished writing her first novel. When not dealing in words, she can otherwise be found in the woods, in her garden, in a book, or in conversation (with food!) with those she loves. She lives on an island near Seattle with her husband, daughter, and cat Momo.

Niels Fredrik Dahl is a Norwegian writer, born in 1957, whose work has been translated into several languages. He is the author of five novels and seven poetry collections. A book of selected poetry, *Dette er et stille sted* ("This is a quiet place"), was published in 2017.

Kari Dickson is a literary translator from the Norwegian. Her work includes crime fiction, literary fiction, children's books, drama, and nonfiction. She is also an occasional tutor in Norwegian language, literature, and translation at the University of Edinburgh,

and has worked with the British Centre for Literary Translation and the National Centre for Writing.

Mariana Enriquez was born in Buenos Aires and published her first novel in 1995. Since then she has worked as a journalist and teacher, and has published novels and several collections of short stories and nonfiction. Her story collection *Things We Lost In the Fire* has been translated into twenty-five languages.

Louise Erdrich is the author of seventeen novels, as well as volumes of short stories and poetry, children's books, and a memoir of early motherhood. Her fiction has won the National Book Award and the National Book Critics Circle Award (twice), and she has been a finalist for the Pulitzer Prize. A member of the Turtle Mountain band of Chippewa, Erdrich lives in Minnesota with her daughters and is the owner of Birchbark Books, a small independent store.

Philip Gabriel is Professor of Japanese literature at the University of Arizona. He has translated many novels and short stories by the writer Haruki Murakami, including *Kafka on the Shore*, *1Q84* (co-translation), *Colorless Tsukuru Tazaki and His Years of Pilgrimage*, and most recently *Killing Commendatore* (co-translation). He was the recipient of the 2006 PEN/Book-of-the-Month Club Translation Prize for his translation of *Kafka on the Shore*.

Celia Hawkesworth taught Serbian and Croatian language and literature at the School of Slavonic and East European Studies, University of London, from 1971 to 2002. Since retiring she has devoted much of her time to translating fiction from the language now widely known as Bosnian-Croatian-Serbian and to date has published some forty volumes of translations in addition to other scholarly works.

Daisy Johnson is the author of a short story collection, *Fen*, and two novels. Her first, *Everything Under*, was short-listed for the Booker Prize (making her the youngest author ever to be short-listed for the prize); her second is *Sisters*, published in 2020 by Jonathan Cape in the United Kingdom and Riverhead in the United States. Johnson lives in Oxford, England.

Born in Osaka Prefecture in Japan, **Mieko Kawakami** made her literary debut as a poet in 2006. Her first novella *My Ego, My Teeth, and the World*, published in 2007, was awarded the Tsubouchi Shoyo Prize for Young Emerging Writers. The following year, Kawakami published *Breasts and Eggs* as a novella, and won Japan's most prestigious literary award, the Akutagawa Prize. In 2016, she was selected by *Granta* Japan for the Best of Young Japanese Novelists issue. Kawakami is also the author of the novels *Heaven*, *The Night Belongs to Lovers*, and the newly expanded *Breasts and Eggs*, her first novel to be published in English. She lives in Tokyo.

Deborah Levy writes fiction, plays, and poetry. Her work has been staged by the Royal Shakespeare Company, broadcast on the BBC, and widely translated. Levy is the author of the highly praised novels *Hot Milk* and *Swimming Home* (both Man Booker Prize finalists), as well as *The Unloved* and *Billy and Girl*. She has also published the acclaimed story collection *Black Vodka* and two parts of her autobiography: *Things I Don't Want to Know* and *The Cost of Living*. She lives in London. Levy is a fellow of the Royal Society of Literature.

Robin Coste Lewis, the winner of the National Book Award for *Voyage of the Sable Venus*, is the poet laureate of Los Angeles. She is writer-in-residence at the University of Southern California and a Guggenheim Fellow.

230

Megan McDowell's translations include books by Alejandro Zambra, Samanta Schweblin, Mariana Enriquez, Lina Meruane, and Carlos Fonseca. Her short story translations have been featured in the *New Yorker*, *Paris Review*, *Tin House*, *McSweeney's*, *Harper's*, and *Granta*, among others. She has won the Valle-Inclán translation prize, an American Academy of Arts and Letters Award in Literature, and been short- and long-listed for the International Booker Prize. She lives in Santiago, Chile.

Andrew McMillan's debut collection, *physical*, was the first ever poetry collection to win the Guardian First Book Award. It also won a Somerset Maugham Award and was short-listed for the Dylan Thomas Prize and the Forward Prize for Best First Collection. In 2019 it was named as one of the top twenty-five poetry books of the last twenty-five years by the Booksellers Association (UK). His second collection, *playtime*, was published by Jonathan Cape in 2018; it was a Poetry Book Society Recommendation for Autumn 2018, a Poetry Book of the Month in both the *Observer* and the *Telegraph*, a Poetry Book of the Year in the *Sunday Times*, and won the Polari Prize. McMillan is a senior lecturer at the Manchester Writing School at Manchester Metropolitan University. He lives in Manchester.

Semezdin Mehmedinović was born in Tuzla, Bosnia, in 1960. He graduated with a degree in literature from the University of Sarajevo. He has published nine books. After the Bosnian war, in 1996, he moved to the United States. And after twenty-four years, he returned to Bosnia in 2019.

Daniel Mendelsohn is a longtime contributor to the *New Yorker* and the *New York Review of Books*, where he is Editor-at-Large, and has been a columnist on books, film, TV, and culture for

BBC Culture, *New York*, *Harper's*, and the *New York Times Book Review*. His books include two memoirs: *An Odyssey: A Father, a Son, and an Epic* (2017), and the internationally bestselling Holocaust family saga, *The Lost: A Search for Six of Six Million* (2006); and three collections of essays, most recently *Ecstasy and Terror: From the Greeks to* Game of Thrones (2019). His newest book is *Three Rings: A Tale of Exile, Narrative, and Fate* (2020).

Maaza Mengiste is the author of the novels *Beneath the Lion's Gaze*, selected by the *Guardian* as one of the ten best contemporary African books, and *The Shadow King*, called "a brilliant novel . . . compulsively readable" by Salman Rushdie and selected by the *New York Times* as one of its 2019 Notable Books. She is the recipient of fellowships from the Fulbright Scholar Program, the National Endowment for the Arts, Creative Capital, and Literaturhaus Zurich. She is at work on her next novel.

Valzhyna Mort was born in Minsk, Belarus, and writes in Belarusian and English. Her newest book is *Music for the Dead and Resurrected*, published in 2020 by Farrar, Straus and Giroux. Mort is the author of *Factory of Tears* and *Collected Body* (both from Copper Canyon Press) and a recipient of the Lannan Foundation Fellowship, the Amy Clampitt Residency, the Bess Hokin Prize from *Poetry*, the Gulf Coast Prize in Translation, and, most recently, a National Endowment for the Arts grant for translation. She teaches at Cornell University.

Haruki Murakami was born in Kyoto in 1949 and now lives near Tokyo. His work has been translated into more than fifty languages, and the most recent of his many international honors is the Hans Christian Andersen Literature Award, whose previous

recipients include J. K. Rowling, Isabel Allende, and Salman Rushdie.

Tommy Orange was born and raised in Oakland, California. He is an enrolled member of the Cheyenne and Arapaho Tribes of Oklahoma. His first novel, *There There*, was published by Alfred A. Knopf in June 2018 and rights have been sold in twenty-seven countries. It was a *New York Times* bestseller and is under option to HBO as a TV series. He is at work on his next novel, "Wandering Star."

Gunnhild Øyehaug was born in Norway in 1975 and is an author, as well as a teacher at the Academy of Creative Writing in Vestland, Norway. She has an MA in comparative literature from the University of Bergen, and has written poetry, novels, short stories, and essays. She has also scripted a feature film and a short film. Her novel *Wait, Blink* was long listed for the National Book Award in 2018. Her most recent publication is the novel *Presens Maskin* (Kolon, 2018; "Present Tense Machine").

Thilo Reinhard is a translator and musician. In 1985, following studies at the University of California, Berkeley, he moved to Oslo, Norway, where he still makes his home. Reinhard translates from Norwegian, Swedish, Danish, and German into English.

Richard Russo is the author of nine novels, two story collections, one book of essays, and the memoir, *Elsewhere*. In 2002, he received the Pulitzer Prize for *Empire Falls*, which, like *Nobody's Fool*, was adapted into a film, in a multiple-award-winning HBO miniseries; his latest book is the novel *Chances Are . . .* In 2016 he was given the Indie Champion Award by the American

Booksellers Association, and in 2017 he received France's Grand Prix de Littérature Américaine. He lives in Portland, Maine.

Matt Sumell is a graduate of the University of California, Irvine's MFA Program in Writing. His short fiction has since appeared in the *Paris Review*, *Esquire*, *McSweeney's*, Electric Literature, *Noon*, *Freeman's*, and elsewhere. His first story collection, *Making Nice*, is currently being adapted for a comedic series by WBTV.

Olga Tokarczuk is the winner of the 2018 Nobel Prize in Literature and co-winner of the International Booker Prize, and a finalist for the National Book Award in Translated Literature, as well as repeat recipient of Poland's highest literary honor, the Nike. She is the author of eight novels and two short story collections, and has been translated into a dozen languages.

An Yu, the author of *Braised Pork*, was born and raised in Beijing, and left at the age of eighteen to study in New York at NYU. A graduate of the NYU MFA in creative writing, she writes her fiction in English. She lives in Beijing.

About the Editor

John Freeman was the editor of *Granta* until 2013. His books include *Dictionary of the Undoing*, *How to Read a Novelist*, *Tales of Two Cities*, and *Tales of Two Planets*. He has also published two collections of poetry, *Maps* and *The Park*. He is the executive editor at *Literary Hub* and teaches at the New School and New York University. His work has appeared in the *New Yorker* and the *Paris Review* and has been translated into twenty-two languages.